wing and Painti

'ude

ns

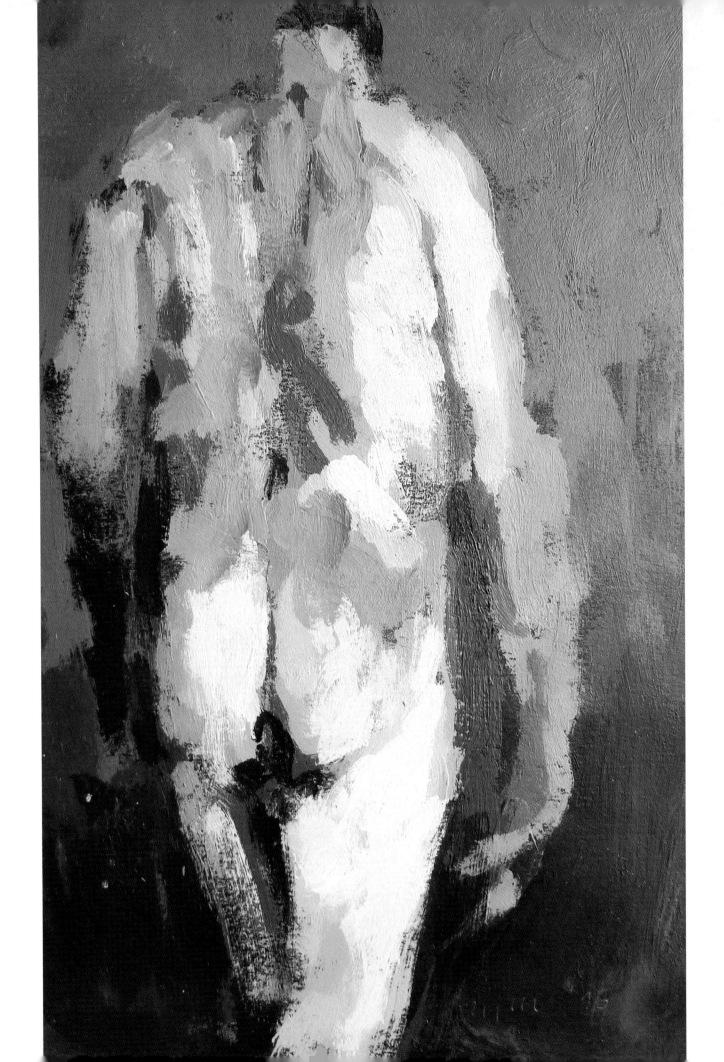

Drawing and Painting the Nude

A course of 50 lessons

Philip Tyler

THE CROWOOD PRESS

First published in 2015 by
The Crowood Press Ltd
Ramsbury, Marlborough
Wiltshire SN8 2HR

www.crowood.com

British Library Cataloguing-in-Publication Data
A catalogue record for this book is available from the British Library.

ISBN 978 1 78500 000 0

Dedication
The book is dedicated to my dad, Bob Tyler 1933–2015.

Acknowledgements
I owe an enormous debt of gratitude to Chris Taylor and Trevor Sowden for showing me the way at school and opening the door to my life and for introducing me to Euan Uglow and Andrew Wyeth. To Arthur Ruff who taught my first life drawing classes during my A levels. Bill Randall, who taught me more about drawing than anyone I know, an astonishing teacher and to this day an extraordinary draughtsman. I must thank my models who brought so much energy and excitement to the sessions; in particular, Lou, Johanna, Lindsey, Ottavio, Felix, Frankie and Emma. Without them, none of this book could have happened and a good model is a joy to work with. I must thank Tim Benson, Shaun Ferguson, Alex Kanevsky, David Longo, Piers Ottey, Jake Spicer (www.draw-brighton.co.uk) and Julian Vilarrubi, who continue to teach the craft, and for their support, guidance and wise words on the problems of drawing and painting. I want to thank the author of *The Hidden Place* (http://thehiddenplace. wordpress.com/), whose blog entries introduced me to so many new painters, led me on the journey to find more, and made me realize that I am not alone. I thank you all, but equally I cannot list the thousands of artists whose work I have peered at, dissected and absorbed over the last thirty years. Thanks also to Seawhite for allowing me to photograph their art materials.

Teaching is about sharing knowledge, and those individuals whom I respect the most have told me all they know. By empowering students with skills, knowledge and understanding one equips them sufficiently to let them explore for themselves. To use the analogy of music, one doesn't lead the student to a piano and say, 'compose a concerto.'
I have to thank Emily Ball for giving me the encouragement to contact the Crowood Press in the first place.

Finally I have to thank my wife Louise, whose support I cannot live without. She is my rock and brings me back to earth when sometimes my head is in the clouds.

Graphic design and layout by Peggy Issenman, Peggy & Co. Design
Printed and bound in Malaysia by Times Offset (M) Sdn Bhd

Contents

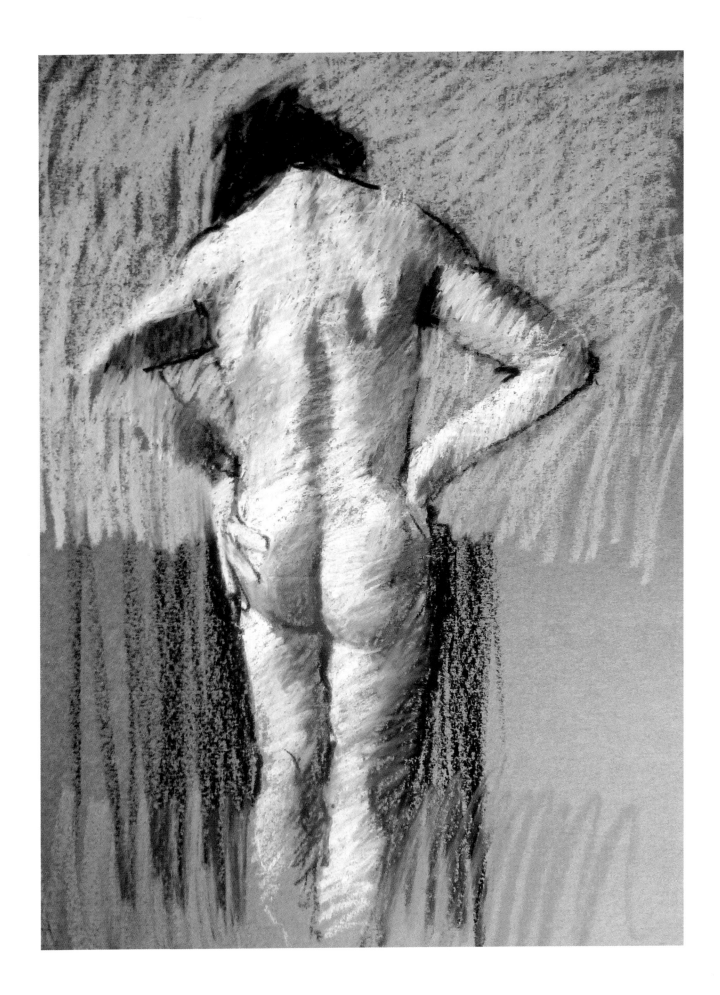

Preface

hat does it mean to paint figuratively? What does it take to paint the figure well? I had to learn how to paint the figure from scratch – whilst I had a fairly good foundation in drawing from my early art training at school, my painting career had followed a different path and the problem of painting the nude had to be faced alone. I trawled through old books, peered at paintings and explored all sorts of approaches, techniques and media until I found a method that I was happy with. Through the conversations I have had in preparing this book, I have discovered that I am not alone: many artists, despite studying at art school, have had to pursue a path of self-tuition to discover how to paint the nude.

For about six years my studio was my 6' × 9' bathroom, which had no windows. I would convert my bathroom into a studio on a Saturday night by placing an 8' × 4' plywood board on top of the bath (my palette) and rest another on top of that, leaning against the wall (my easel). Onto the top corner of this board I would clamp my anglepoise lamp and place a large mirror on top of the small basin. I would then rest another mirror on the laundry basket, so that I could see a reflection of myself from behind. In that converted studio I painted about 900 nude self-portraits.

To this day I do not have the perfect studio and am rarely in the studio when it is light. I have limited space and limited time in which to paint, with a full-time teaching job, but I am in no doubt that I must not use these things as an excuse. Instead, one must try to understand what can be done with what one has, rather than what one cannot have. I want my own work to pin down reality, informed through the process of observation, to achieve a certain kind of physicality of gesture and energy. I am astounded by the potential beauty of the human form, both male and female, with its grace, poise and dynamism. I hope that I can capture some small fragment of that experience. When I draw and paint I become completely lost in the moment, losing sight of time, speech and sometimes even conscious thought. It seems to be an almost trance-like state, where, for a brief moment, all one's concerns and doubts can disappear. I hope to share my enthusiasm for drawing and painting the nude in this book, to explain some of the techniques and processes that I have discovered over the years, and to lead you on the path to your own discoveries.

Some questions that we all have to address include: How can an artist bring something new to the subject? How can you paint a nude that has vitality and relevance without resorting to gimmickry or sensationalism? How can you avoid making titillating or voyeuristic imagery that is exploitative? And how might you embrace all that twenty-first-century technology has to offer without being a slave to it? This last question I have raised with the artists who have contributed works to this book. I hope that their responses, as well as mine, might throw some light onto these questions.

The Internet is a wonderful thing and through it are many insightful tutorials and demonstrations. It opens the door to the work of many new artists and has not only opened my eyes to the infinite number of possibilities that the nude presents: it has also brought me into contact with some fantastic artists too – Tim Benson, Alex Kanevsky, and David Longo, to name three. I am grateful to them for sharing their ideas and allowing me to get some insight into their working practice; I hope it will be informative for the reader too.

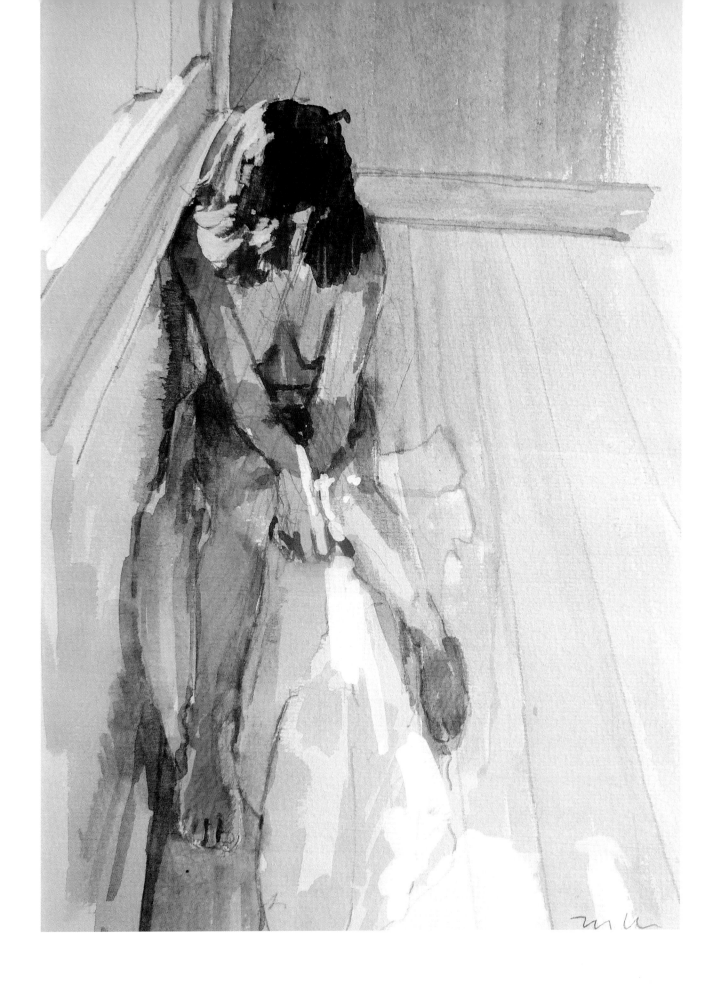

Introduction

ainting and drawing the nude successfully is not an unattainable goal, and it should be an immensely satisfying journey. The lessons set out in this book will give you a focus and draw your attention to key themes and ideas. Painting can be broken down into a series of visual problems:

- drawing (perception, observation, proportion, shape)
- tonal value
- scale
- medium and material
- composition
- colour
- facture

Once all of those aspects have been understood then there is the problem of subject. What are you trying to convey, with the nude? What are you trying to say? The exercises in this book have been designed to take you step by step toward your own set of choices and intentions. The primary concern is to provide you with further insight into the discipline. Evidently, nothing can actually replace the activity of drawing itself. But you can go a lot further if at least you have some pointers to help you on your way.

Where to begin?

Kimon Nicolaïdes stated in his book, *The Natural Way to Draw*: 'Learning to draw is really a matter of learning to see – to see correctly – and that means a good deal more than merely looking with the eye.' When we first learn to draw, the marks we make bear little resemblance to the world we see; yet these drawings are the things they represent. The box-like drawing of a house, the triangular drawing of mum, these are all symbolic of the thing being drawn. It is plain to see that children's drawings are very similar, yet to each child these images are very personal and can often have rich narratives. As we get older we try to perfect our symbols for things – eyes, ears, noses, etc. – and we tend to strive to produce something more and more realistic. We often draw the same things over and over, constantly perfecting and recreating our symbols. Comic books are an obvious example of this symbolic language perfected, and often prove to be invaluable for the young, as this language can be appropriated and incorporated into their own schema (Gombrich's term for a visual symbolic language used by that individual). For most people, their symbolic language stops developing at the age of about twelve, and from that age onwards the student focuses on a particular image, which they continually redraw, perfecting the image.

However, we live in a three-dimensional world, seen through two eyes. These receive reflected light images from an object, which fall upside down on the back of the retina and these two inverted images are constantly being bounced around. Each eye has a blind spot and sees two slightly different views of the same thing. This information is encoded into electrical signals, which are then decoded by the brain. With all this confusing information, is it any wonder that actually *seeing* is a difficult thing? Seeing is not so much a function of the eyes but the interpretation of the brain.

The way we see the world is governed by our experience of it. From childbirth we have been collecting sensory information, by placing things in our mouths and feeling them, and this information, coupled with our vision, jointly forms this miniature universe in our minds. But this information is encoded into symbols: although we know what chairs, cups and saucers, etc. look like, we don't really *see* them. Instead, when we look at a familiar image, we are actually seeing an interpretation of the object through the symbol we have for it. Similarly, if we write a word, we do not see the word as a series of letters; instead we see the thing it represents. DOG conjures up an image of a dog, not the quality of the three letterforms G, D and O.

Most of our looking is really scanning. When we look at something, we are not really seeing its exactitude at all. Betty Edwards gives a good example of this in her book *Drawing on the Right Side of the Brain*. She suggests that you measure the size of your reflection from a number of distances from the mirror. If you try this yourself you will probably be very surprised to discover that your reflection is half the size of your head. If you draw around your reflection with a permanent marker, as you walk away from the mirror your head will still fit into that shape, no matter how far away you are. So what you see every day is not as easily understood as you might think.

Fundamental to any introduction to drawing is re-educating the way we see, teaching the student how to look at the world in such a way that they do not recognize the thing they draw. If this is achieved then the transformation can be almost instantaneous.

One of the 900 self-portrait male nudes I painted in the early 1990s. At this time the figure became a central motif in my work whilst trying to convey ideas about grief.

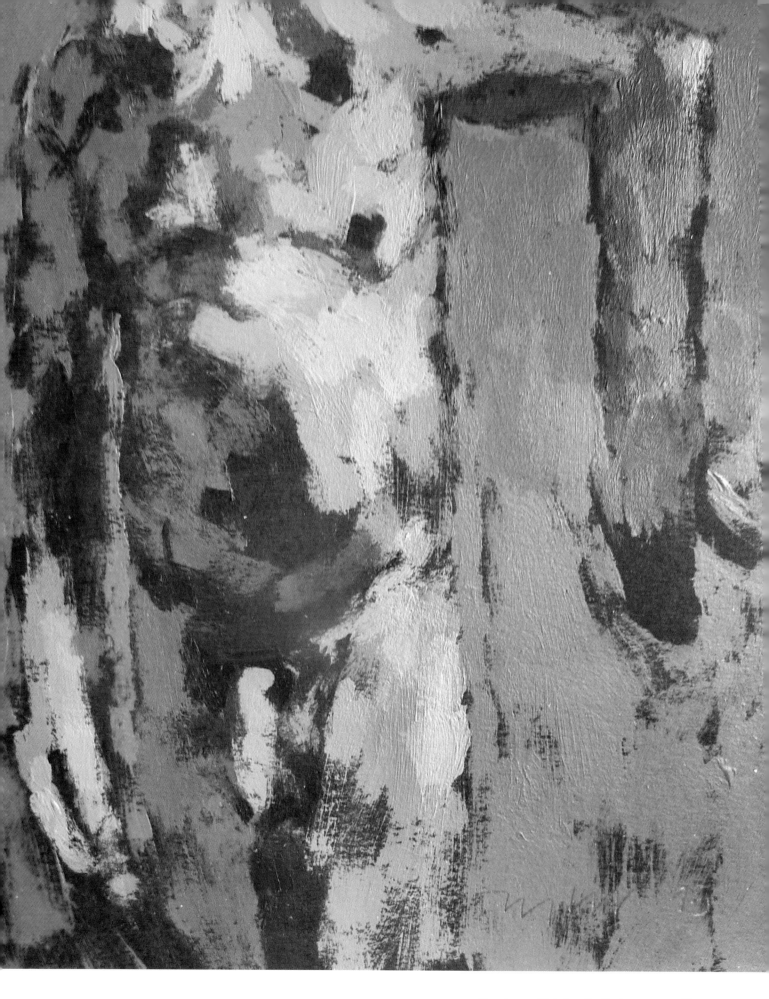

Materials.

Materials

verything capable of making a mark on paper can be used to construct a drawing. Any media can be used for drawing the nude but there is an intimate relationship between the artist, the material, the support they work on and the scale at which they work. Through your own exploration you might find that one medium is better for the kind of drawing you want to make. One might feel more resistant, more gestural, more controlled or easier to remove if you get something wrong. It is worth remembering that children scribble for many years before they begin to make meaningful marks. To become familiar with the different media, you have to use them and understand their inherent nature.

Good quality paper suitable for sustained drawing and paintings in acrylic or oil.

Drawing tool kit

You should get yourself a basic tool kit for drawing: a small sketchbook, preferably one that is fairly cheap so that you do not feel under pressure when using it. (Sketchbooks can be really intimidating: the more expensive the book the more intimidating it becomes, so a cheap sketchbook is a great start.) Buy a scrapbook as they are really cheap and the coloured paper has a lovely texture for charcoal, pencil, graphite and watercolour, as well as pastel drawing and coloured pencil studies of the figure. Photocopier paper is excellent for basic monoprint, relief print, pen and ink, biro and compressed charcoal studies. It is good for making quick studies from the figure and can be used for lots of other things too.

Buy some cheap biros too, preferably some red and black ones, a long clear plastic ruler and a cheap stationery kit with a compass and a 45° set square. You can use a red biro to draw the figure – the warmth of its tone suits flesh. Use different coloured biros to draw darker tones. You can see through a clear plastic ruler when you are measuring the figure and your set square can help with proportion. The compass is useful too, especially if you are trying to scale up an image. A plastic rubber is also a valuable purchase.

A trip to an art shop will enable you to buy some larger A1 sheets of cartridge paper (Seawhite supply an excellent 130gsm paper and a very good 220gsm acid-free). The weightier 220gsm paper is great for painting as it is less likely to cockle (deform) when wet. You can buy individual sheets as needed from your local art shop or you could order a pack, but if your budget doesn't stretch that far you could buy a roll

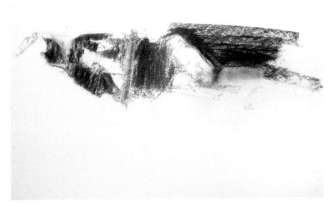

Charcoal study. Charcoal can be used on its side to broadly establish the large areas of shadow in the figure.

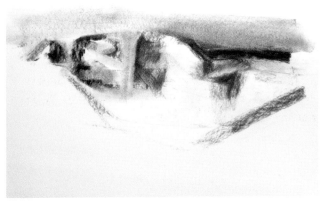

A finger or cloth can be used to smudge the charcoal to create more delicate tones and begin to locate the figure and model the form.

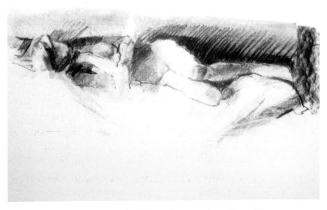

The tip of the charcoal can begin to discover the edges of forms defining the placement of limbs and hinting at the features.

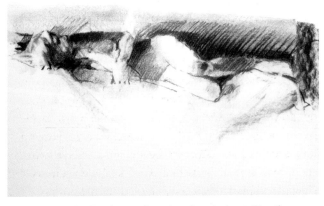

The drawing is finally taken to the point of resolution, taking the drawing to its extremes of light and dark, manipulating the forms with both charcoal and an eraser.

of lining paper from your local DIY shop. Buy the heaviest weight you can. These come in roll form and will need attaching to a board with masking tape or board clips.

Get a sheet of plywood approx. 1cm deep and slightly larger than A1 paper (approx. 70 × 100cm). You will also need a craft knife with spare blades (a retractable one is best for cutting paper and sharpening pencils) and a roll of black insulation tape.

It is not necessary to go out and spend a fortune on materials. Look at each exercise and buy what you need as you go along; eventually you may need to buy some more specialized drawing and painting media.

Charcoal

When twigs from a willow tree are placed in a sealed container in the centre of a fire, the wood cooks and blackens; this carbonized wood is charcoal and comes in thin and thick varieties according to the part of the branch that has been used. Charcoal can produce very delicate subtle greys as well as rich, dark tones. The texture of the paper is very important in the depth of tone that is possible.

One of the common mistakes of using charcoal is to try to draw with it like a pencil. Because it can be easily moved around, areas of tone can be put down and very quickly removed, so the drawing can transform and grow in a much more organic way. Charcoal is impermanent and subsequently it needs to be fixed, either with fixative (a shellac-based aerosol which is also carcinogenic), hairspray,

or PVA mixed with water and applied using a spray diffuser. The potential of charcoal as a drawing medium of the figure is limitless, from the atmospheric gestural figures of Sophie Jodoin to the elegant and subtle tonal studies of Singer Sargent and Nicolai Fechin. The fugitive nature of the medium can be used gesturally to capture the fleeting dynamic movements of the figure or the nuances of half tone running across the body into the light.

Clutch pencil, in this illustration holding black compressed charcoal and sanguine.

Clutch pencil

Clutch pencils are lead holders and will grip a thin tube of graphite, compressed charcoal or pastel. Caran d'Ache created the first spring clutch push-button type in 1929 and they now come in a variety of sizes, weights and costs. The very thin leads can break easily and are only really capable of a very fine line. The weight of the tool and how it feels in the hand is an important part of the drawing symbiosis. Clutch pencils, with the ability to hold a thicker lead, mean that you have the scope to render the figure with a more dynamic range of marks. Your mark-making can be expressive, frenetic or delicate. You can change leads easily and that means that you can draw with pencil, compressed charcoal and Conté using the same tool. A soft lead, a sanguine colour Conté and a black compressed charcoal set of leads, will offer a great scope of possibilities with the figure from quick poses and gestural responses to subtle tonal rendering.

Compressed charcoal. These usually come in a unified stick form, either cylindrical or square ended.

Compressed charcoal

Mixing crushed charcoal and gum arabic produces compressed charcoal. Charcoal pencils tend to be compressed charcoal and they can come in different grades. Usually uniform in their shape, compressed charcoal produces a very strong black and tends to stick to a greater variety of papers than normal charcoal. Compressed charcoal can be used with water to produce washes (gum arabic is also used in gouache and watercolour). It can yield dark and emotive figures and light and airy ones too. It is difficult to erase, however, and when held in the hand transfers itself easily. Compressed charcoal can come in a variety of tones from black through to white where you can produce lighter tone without needing to dilute. This works particularly well when you are drawing the figure on toned or coloured paper.

Because of its glue content, it is less likely to need fixing than normal charcoal. It can also be rubbed onto the back of photocopy paper to make transfer paper.

Conté

This was originally invented by the French as a response to the pencil. Rather like compressed charcoal, it is a combination of pigment and gums with some waxes too, which makes it somewhat harder than pastel. Conté comes in a wide range of colours and can also be used with water.

Toned compressed charcoal. Like pastel, these sticks come in a variety of tones and hues. The initial drawing is done on coloured paper, lightly marking out the main directions of the figure and considering the angle between each pair of forms.

A light grey is added to the drawing, thinking about fleshing out the figure but establishing tones that are darker than the paper.

Crayon

Wax crayons tend to be combinations of various waxes and pigment. The pigment content is usually low, so colours tend to be pale. Chunky crayons make excellent tools for frottage and wax resist especially when combined with an ink wash. Pencil crayons come in a much wider and richer variety of hues, and some are water-soluble.

WAX RESIST

This technique involves drawing with a wax candle (oil pastel or white spirit) and then laying a wash over the drawing; the grease repels the wash. Stan Smith's drawings often incorporated mixed media with wax resist, but it is Henry Moore's drawings during the Second World War that are some of the best examples of the technique.

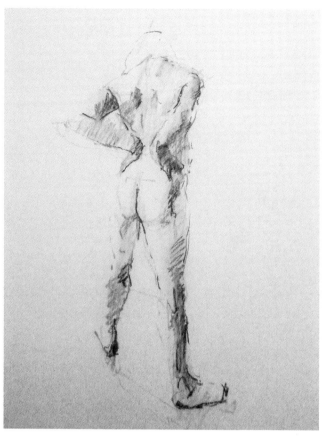

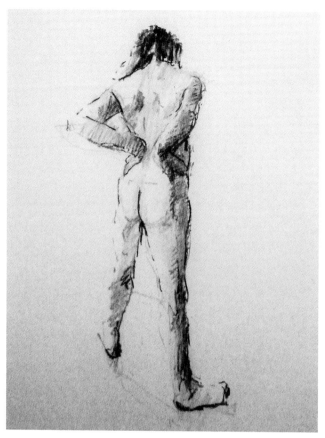

Now a mid-grey and a dark-grey are added, working down to the darkest values of the drawing. This helps to establish the form and make the figure more solid as well as correcting any errors in the earlier drawing.

Finally black is added and the full range of tonal and visual contrast is established to make the drawing more visually dynamic.

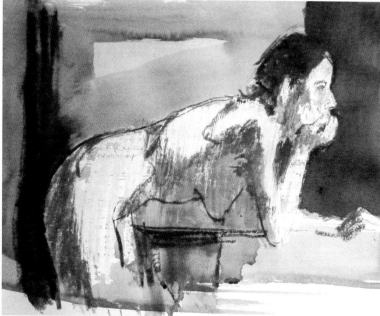

Wax resist: the first drawing marks were made with a wax crayon, the highlights on the figure. Then a light wash was applied, which the crayon resisted.

Further drawing was done with an oil pastel and more washes applied to create depth of tone and a context for the figure.

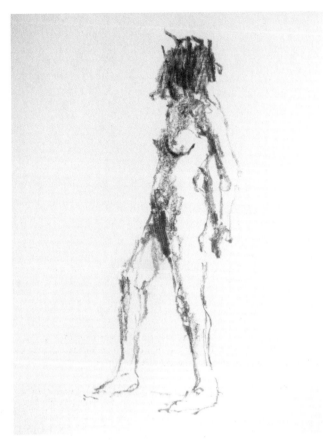

Graphite offers a wide scope of expressive marks and is an excellent tool for quick gestural studies of the figure in short poses. This drawing was made from a two-minute pose.

Eraser

Usually made from rubber, the eraser can be both a destructive and constructive tool. Paper can be covered with a layer of charcoal and smudged in with a rag or the back of your hand to create an overall grey. The light tones of the figure can then be erased out of the grey making the drawing (rather like a *bistre* study, *see* Chapter 7), before further tones are added to make the darks.

BREAD

A humble slice of bread can be kneaded into a small ball. Stale bread is best. This can be used as a rubber in tonal figure studies of the nude. As you will see in Chapter 5 you can make a reductive tonal drawing using the rubber as a drawing medium removing a charcoal ground to describe light on the form.

PUTTY RUBBER

This is a soft kneadable rubber, and can be manipulated to erase small detailed areas as well as larger expanses. It can also be used to lift out oil paint in *bistre* painting where the oil is applied thinly onto primed canvas.

Graphite

Graphite is a form of carbon. It is found in pencils and the degree to which it is combined with clay creates the various tones available (B for black and H for hard). Graphite can also come in stick form. Soft pencils are great for immediate and tonally rich figure drawing; graphite sticks can make filling large areas of a drawing more economical but are also good for fast drawings, which capture the energy and dynamism of the figure.

Pencil is one of the most widely used media and having a broad range of pencil grades extends its scope: softer Bs can yield rich blacks and a broad range of tones; harder H pencils can yield crisp lines, which are perfect in conjunction with watercolour. Dirk Dzimirsky's photorealist pencil drawings demonstrate the range of tones that are possible but take a look at Kent Williams' and Jake Spicer's life drawing to see the pencil used with great sensitivity to the subject.

Indian ink

The blackest of the inks, Indian ink is made by combining soot with shellac. It can be diluted with water and you should use distilled water, as normal water causes the pigment to break down and scatter into the wash. When dry, Indian ink is waterproof and lends itself to line and wash, which can produce luminous figure studies. Indian ink was a standard medium for illustrators using a dip pen at the turn of the century. Ink drawings by Phil May and Charles Keene are well worth looking at, as are those by Jason Shawn Alexander and David Foldvari.

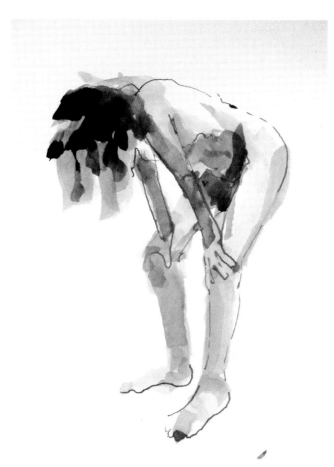

Diluted with distilled water you can create beautiful washes with Indian ink. In this figure study the ink was applied with a brush and a stick.

Oil bar

Rather like an oil pastel but somewhat larger, the oil bar can be used for drawing. It leaves a wet mark on the support, which can be worked like oil paint with a brush and solvent. This can lead to exciting gestural and painterly marks, which lean toward a more expressive interpretation of the figure.

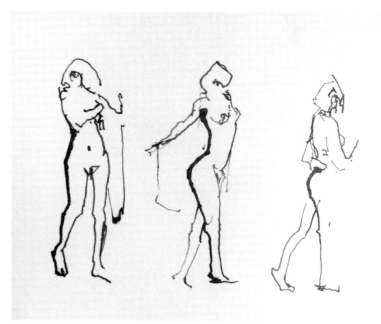

Stick and ink: with a stick you can also make expressive drawings. The stick can yield rich darks and as the stick continues to draw you will be left with ink residue, which creates subtle grey lines.

Oil bar is half-way between oil pastel and oil paint. It comes in thick tubes like an over-large pastel but it has a very soft and fluid touch. The bar tends to form an outer skin much like oil paint when it dries, which has to be broken. This can be done with a knife to create a finer edge.

First layer: in this figure study the yellow was lightly skimmed over the surface of the paper creating a sense of the pose and trying to establish the main direction of the limbs.

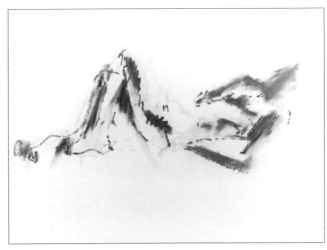

Second layer: red was used next and blended together with a finger.

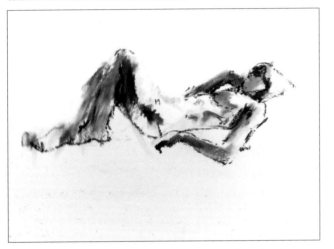

Two further colours were added – blue and brown. These dominant hues were identified before white was layered over the top to unify the form.

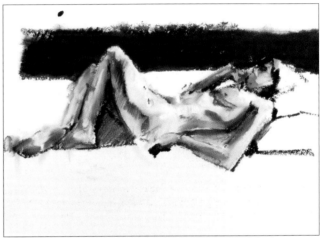

The piece is brought to a conclusion; consideration was given to the space the figure sits in.

Oil pastel

A combination of pigment and oils, pastel comes in small stick form and a variety of rich colours. They can be mixed with white spirit to produce more painterly effects, but equally they can be used either flat, blended or mixed using hatching, cross-hatching or stippling. The range of the medium, and the scope for its manipulation can yield a wide range of figure interpretations. As with all pastels, if you can, go larger: working on bigger paper – especially coloured paper – gives you more scope to build up detail and subtle rendering of form and colour nuances.

Pastel

Chalk pastel is pigment mixed with gums. Powdery in its nature, it too can be blended, or mixed together with cross-hatching, etc. However, unlike oil pastel, chalk pastel can be erased. Like oil pastel, the scope of chalk pastel is immense. R.B. Kitaj, Crawfurd Adamson, Paula Rego and of course, Degas demonstrate true mastery of the medium and it is worth noting that pastel drawings are often referred to as paintings.

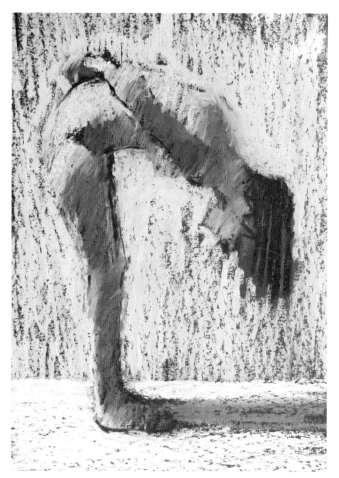

This twenty-minute oil pastel drawing was made on black paper. The weave of the pastel was kept open, hatching the colours next to each other and over the top of each colour to create a rich surface.

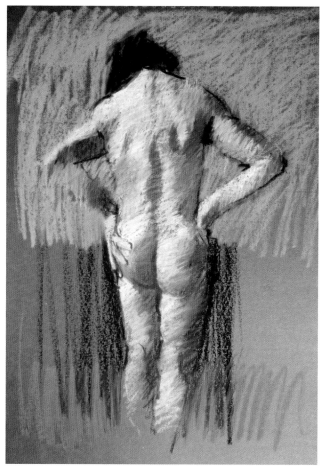

Felix was hunched, but was bringing his shoulder blades upwards and his head downwards, exaggerating the size of his back. This oil pastel study was made on a light grey Ingres paper ground with the open weave of the pastel kept loose to build up form and richness of colour.

In this drawing with a black ballpoint pen the figure is rendered using hatching and cross-hatching, which changes direction to describe the underlying form. Care was given to exploit the touch of the hand to yield lines of varying thicknesses to help describe the third dimension.

Pen

A biro or ballpoint pen has a greasy, viscous ink that is transferred onto the paper with a steel ball. A fibre tip pen and felt tip pen transfer a solvent-based ink, which dries quickly. Some artists use water-based pens, which can create washes when combined with water. Dryden Goodwin and Juan Francisco Casas offer two very different approaches to the humble ballpoint. A dip pen has a split steel tip with a small hole at its mid-point, held in a handle. The tip is immersed in ink and through capillary action, ink is held in the hole and travels down the split to reach the paper. You can dip your

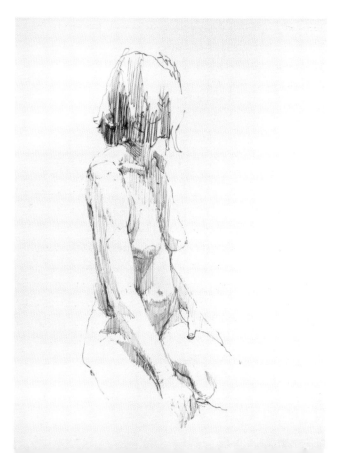

A linear drawing using coloured felt tips.

A water soluble felt tip drawing was made in line and then areas of tone were added. The water was added to create the coloured washes.

pen into traditional ink, but you can also draw with strong coffee, food colouring or diluted gouache. A fine fountain pen can also be used for drawing purposes. Some have mechanisms that allow you to suck up ink and some have ink cartridges. A fine-tipped fountain pen offers a lot of the same possibilities as a dip pen and can yield touch-sensitive lines. It can be used to build up hatching, cross-hatching and stippled areas of tone. The combination of the line and the dispersion of colour into water from the black make for sumptuous and evocative life drawing. It has the advantage over a dip pen that you do not need to constantly refill your pen.

Although associated with children, felt tips can also be used for drawing purposes. They are inexpensive and come in a vast array of colours. Some of them use water-based inks that will disperse into washes when mixed with water. However, the inks used fade in light so would need to be used for sketchbook work rather than as drawings to exhibit.

Quink ink

Black Quink is designed to be used with fountain pens and is a trichromatic ink made up of colour. If diluted, the colour is revealed and can produce some rich effects. Quink is water-soluble when it is dry so a line made with it might disappear if a wash is applied over it.

Pencil sharpener

Generally speaking pencil sharpeners are designed to sharpen HB pencils. Softer pencils tend to snap inside them so it is often better to sharpen pencils with either a craft knife or scalpel so that the angle of cut can be changed to suit the pencil. A small piece of sandpaper may be used to define a tip and can be used to sharpen vine charcoal.

Painting tool kit

Brushes

These can vary considerably in terms of quality, type and cost. Ideally you want brushes that you can control and ones that are capable of a wide variety of marks so that you can efficiently yield the large masses of the figure as well as describe the subtle nuances across the form. You need a brush that has resistance against the paint, so you need a stiff brush if you want to use acrylic or oil with impasto or scumbling techniques, and softer brushes for more fluid paint like watercolour or gouache (but you still need that tension in the bristles). A large brush can hold a small point and can give you a good reservoir of paint; a medium round synthetic or sable type brush can give you the freedom to make gesture drawings and ink wash drawings.

Brushes come in different shapes: round, flat, filbert and fan. Each one will give you a different mark so it is worth experimenting to find out what suits you. Brush handles vary in length and it is recommended that you buy long-handled brushes and hold them at their ends so that you can stand back from your painting and see both the figure and your painting simultaneously, to help you understand the proportions and colours on the figure.

Acrylic

Originally used for mural painting, acrylic is one of the most recent paints to be developed. It comes in both tube and tub form and is usually found in two types. Daler Rowney make Cryla which is a very stiff, buttery paint which has excellent impasto qualities and a high density of pigment. More widely used are Daler Rowney's System 3 flow formula acrylics, which tend to be less viscous and more fluid. Daler Rowney also produce an inexpensive graduate range; these are more easily thinned down to be used with either airbrush or glazes, but are suitable for most of the techniques outlined in Chapter 7. These thinner colours can of course be mixed with Cryla to make a much more dense paint.

A wide range of inexpensive brushes can be a good starting point for experimentation in terms of scale of mark and edge quality. Feel the resistance and spring of the bristles so that you have the control you need when painting.

This small acrylic sketch was made quickly with a very dry paint scumbled over the surface of black paper.

In this small painting study the gouache is used thinly like watercolour and in a more gestural way in areas on the body.

Acrylic can be used with different painting techniques and applications, and can be mixed with different types of medium to either thicken the paint or transform the surface quality. Acrylic medium is white in its liquid form and becomes transparent when it dries. So a colour mixed in acrylic will invariably darken when it dries and will become more transparent. Acrylic is water-based, but once dry it is waterproof. It has a fast drying time but this can be altered with retarder. Because acrylic is fast drying, you can paint quickly in lots of layers – perfect for short, strenuous poses. You can break all the rules associated with oils and can combine many techniques in the same image. It is capable of a broad range of approaches, from expressive and gestural figure studies to meticulous rendering. Have a look at Shaun Ferguson's figure painting to see just what can be done with acrylic. Winsor and Newton sell Artists' quality paint, which will usually signify the best quality paint, as well as a Galeria range; Liquitex has a comprehensive range of acrylics too.

Gouache

Gouache can be used in a variety of ways, from thin water-colour-type glazes to thick impasto, but the paint always remains water soluble, which means that new layers can mix with earlier ones, and impasto tends to be rather brittle. Egon Schiele used gouache in combination with pencil in his powerfully moving nudes. Gouache dries flat and can be an exciting paint to explore. Humphrey Ocean made some stunning gouache studies of people which, although somewhat exaggerated, have a real sense of pose and personality.

Oil paint

A combination of pigment and linseed oil, oil paint was developed in Northern Europe by Jan Van Eyck. It was said that oil paint was invented to paint flesh and it is true that no other paint is as successful at rendering the subtle modulations of colour and light on flesh (as well as a myriad of other surfaces). Oils can be used both thinly and thickly, but the drying time for oil is lengthy, especially if the paint film gets thicker.

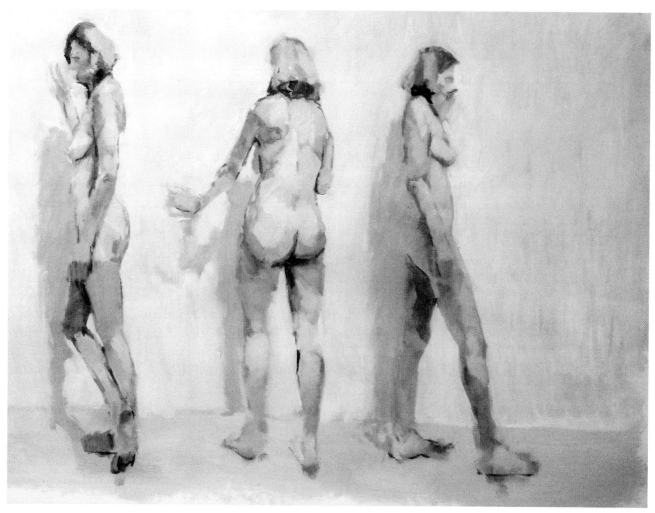

Three-figure study using an initial *grisaille* underpainting. Oil on paper, 70 × 90cm.

When painting from life you will need to take into consideration the drying time of oil. Depending on the scale of the work a medium sized painting can take anywhere between two and four hours to construct if one is working *alla prima*. A small oil study could take about one to one and a half hours so the nature of the pose that is set needs to have this taken into consideration.

Palette

You will need a big palette, so that you have a place for mixing your colour, a place where you can leave an amount of pre-mixed paint, and a place where you can wipe off excess paint to leave the right amount at the end of your brush. Walter Sickert would look at a student's palette and point out that their painting resembled their palette. In other words, if your palette is a mess of muddy colour then it should hardly be surprising that your painting will be muddy too.

A palette should be the same size as the image you are working on. Maximize the space available for mixing by putting your colour at the top edge, leaving most of the palette free. Clean colour should not be sullied when it is put onto the palette so the palette must be cleaned or refreshed in some way. Organize your colour so that it is logically put down and so that you can find what you are looking for.

Ideally a palette should be non-absorbent. You can use melamine, glass or a sheet of acrylic as a palette. A piece of thin ply can be varnished and it can be cut with a jigsaw to make a space for the hand and thumb. In that way, you have a palette that can be hand-held when standing up to paint. If you prefer to paint sitting down it could be placed on a table or stool near to where you are painting.

Laying out your colours in a systemized way will develop good practice and will maximize the space for mixing.

Dried acrylic can build up into mountains quite quickly if left to dry. Cover with cling film to reduce the drying time and keep your paint useable.

If you dislike cleaning, a table-top or board can be covered with cellophane or even newspaper. These can then be thrown away instead of cleaning. You can also use ready-made tear off palettes, which are made from waxed paper, and behave in the same way.

The colour of the palette itself is an important consideration, as it will influence how you perceive the colour you are mixing. An ideal would be a transparent palette. If you are going to use a coloured ground, you can paint up some paper with that colour and place it underneath your palette.

PALETTES FOR ACRYLIC

Acrylic dries quickly so you might want to consider the build-up of acrylic colour on your palette. Working with a shiny palette means that after a big build-up the acrylic can be peeled off when it is dry. However, this can lead to bits of dried acrylic skin mixing with your wet paint. Air causes acrylic to dry so at the end of a painting session you can cover your acrylic with cling film; this will keep the paint wet for days rather than hours. Alternatively you can use a large tupperware box or a 'stay wet' palette; both of these have sealable lids to keep the air out, but this can cause the acrylic to smell.

WATERCOLOUR PALETTES

If you are using watercolour the box of paint usually has its own built-in palette. This is perfectly adequate for most painting but it is useful to supplement this with either a dinner plate or those plastic takeaway boxes as this will give you much more room to mix up enough watercolour for a large wash. You might also wish to use well palettes – the kind with deep recesses.

Watercolour palette. The space attached to the box will enable you to mix a wide variety of colours, and can be detached for cleaning. Supplement with a plate for large washes.

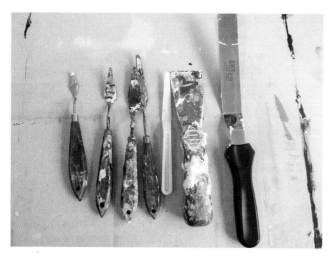
A range of painting and palette knives with a wallpaper scraper and kitchenware too – all capable of being used in the painting.

A direct watercolour study using a Japanese calligraphy brush.

Palette knife

The palette knife and painting knife are incredibly useful tools to have in the studio. The painting knife is usually shaped like a triangle and comes in a variety of sizes. A palette knife is usually more like a rounded knife blade and can be straight or cranked. The traditional use of the palette knife is to apply paint to the palette (if the paint comes in a tin), to scrape up the residue paint from the palette to aid cleaning, to mix colour on the palette and to scrape back a painting. But many artists use the palette knife and painting knife in a more creative way. Household spatulas and squeegees can also yield larger-scale marks similar to painting knives and can also be used in the production of a painting (see the work of Alex Kanevsky).

Watercolour

With the highest concentration of pigment, watercolour is simply pigment and gum acacia. Watercolour is applied as a thin wash and colour can be manipulated through subsequent glazes, although if too many are applied the colour becomes muddy. Although the basic watercolour sets seem relatively simple, watercolour is one of the hardest techniques to perfect because you cannot cover up your mistakes. When combined with white gouache it is called bodycolour. Watercolour can be used broadly to capture fleeting poses, and is beautifully demonstrated in the studies by Wendy Artin, as well as the highly resolved paintings by Dante Gabriel Rossetti.

Water-soluble oil paint

With a growing awareness of health and safety, scientists have modified linseed oil in order to make it soluble in water. There are a number of brands of water-soluble oil paints including Artisan (Winsor and Newton), Cobra and the Berlin range from Lukas. They display all the advantages of oil: slow drying, excellent colour retention, etc., without having to clean brushes in white spirit. Paint can be thinned with water but some of the ranges also come with mediums too. If your studio is small and you want all of the advantages of oil but not the smell or the laborious brush cleaning, this is your medium. Again it can be used to create fluid and immediate figure studies or highly resolved modelling.

Some of the Cobra range of water-soluble oil paints. These are becoming increasingly popular.

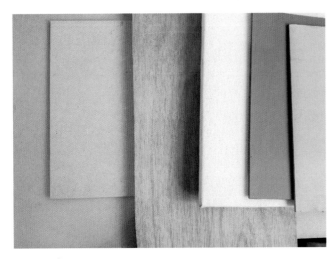

A range of supports.

Supports

If you are about to make a painting you need to paint on something. Paper, card, board, wood, metal or canvas – these are all supports for your painting. Cartridge paper is a good support for painting; however, it has some drawbacks. If you paint on paper it will absorb the paint almost immediately. The mark that you make will be impossible to eradicate (although you can make marks over the top of it later on). If you are using a water-based paint, then the water content causes the fibres of the paper to expand, causing the paper to enlarge unevenly and undulate (cockle). If this happens and you are using watercolour, then you will have created little troughs that your paint will run into.

When stretching paper, cut your gummed tape 20cm longer than the dimensions of your paper. Do this when everything is dry and away from any water.

Stretching the paper

Stretching your paper involves wetting a whole sheet of paper, taping it to a board and leaving it to dry. The paper is held under tension and cannot expand any further. Wet your paper on both sides using a clean sponge and use gummed tape (brown paper tape with a gum-arabic-based glue) to attach the paper to the board. You need to ensure that the tape adheres well to the board and paper otherwise the tape will lift. Do not stretch your paper onto thin hardboard or MDF, as the tension in the paper will cause the board to warp; a 1cm deep plywood drawing board is better. Put a staple or a drawing pin into the corners of your paper and into your board to reduce the tension on the tape. When the paper has dried (leave it overnight), it is ready to use. Heavier weight paper is much less likely to cockle and so too is sized paper ('size' is the glue that holds the paper fibres together). Size reduces absorbency; a watercolour paper is heavily sized whereas blotting paper has no size in it at all.

Stretching paper. Pressing the tape onto the paper and board ensures good adhesion.

Absorbency

When painting the figure, the absorbency of the paper affects the kind of mark you make with a brush and the speed that it flows over the paper. This is useful to consider if you are going to take your time building up layer by layer, modelling the figure, or if you are trying to pin down a gesture study in a few minutes. If you are working on paper with paint you might want to consider two different strategies: with watercolour, you might start with a pencil drawing and then build up the colour and tone into this; alternatively you might apply the watercolour directly, drawing with the brush itself.

To reduce the absorbency of the support, you could paint the paper with acrylic, coat it with gum or place another ground onto it. Painting it with anything will alter its texture and might introduce unwanted brush marks, but equally building up the texture might be something that adds another dimension to your work.

You might wish to create a coloured ground to work on rather than staying with white. Paint the surface with white Cryla mixed with a little colour. It is a good idea to use a shallow tray – the kind you get from a takeaway is ideal. Use a decorators' brush (approx. 5cm wide) and mix the two colours together as well as you can without adding very much water. Try to get the colour on quickly using a scrubbing action so it is the elbow rather than the water that gives you a thin film of colour. This will dry more quickly than a thick layer and you can then build up another thin layer on top of that. If you have enough left over, then paint up some more paper until you have used all of your paint (so nothing is wasted). You might decide that for different sheets of paper you could add a little of another colour to create a series of coloured grounds for painting, or you might be making up some papers for collage or drawing. Try creating some highly textured surfaces for exciting visual effects. This technique is used by Julian Vilarrubi in his figure studies.

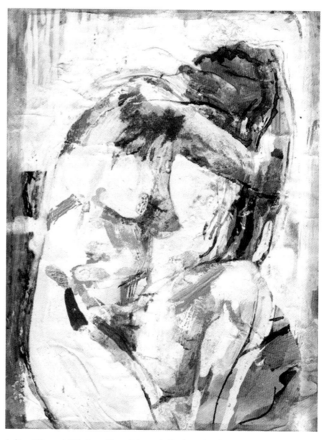

Julian Vilarrubi (julianvilarrubi.com), *Nude,* mixed media on board, 18 × 13cm, 2003.

Board

Cardboard gives you a robust surface to paint on and you could give it a coat of acrylic if you want to introduce texture or reduce the absorbency, or indeed to create a coloured ground especially if

Solid wood panel.

you intend to work in oil. Too absorbent a surface will create a patchy painting, although this didn't stop Lautrec from using it as a support. Greyboard is a fairly inexpensive card support (it is the same kind of board you get on the back of sketchbooks) and is a fairly good surface to work on directly with acrylic. It does have an acidic content, however, so it will yellow somewhat with age; not great if you want to sell your work, but fine for experimenting. Mountboard comes in large sheet sizes and can come in a number of colours but it is more expensive, it is a soft material and can be easily damaged, especially the corners.

Hardboard comes in 5mm thickness and has a textured and a smooth side. The textured side can be painted on but the surface is quite coarse. The other side is very smooth and paint has a tendency to slide off it. Hardboard is made up of compressed paper-like layers, so if the corners get knocked, it can become fluffy and may need to be trimmed down with a sharp craft knife.

MDF is made from wood dust mixed with glue and formaldehyde. The material is much more dense than hardboard but it should not be sanded or sawn in the studio due to the risk of dust inhalation. These boards can be sealed with acrylic or gesso or rabbit skin glue size (if you are using oil).

Marine ply makes for an excellent support. The cross-ply nature of the thin veneers of wood tends to counter warping; blockboard can be used successfully as well.

Hardboard

Hardboard (Masonite in America) and MDF can be bought from your local wood yard. It comes in sheets 120 × 240cm, but some wood yards have a cutting service and will quickly and efficiently cut your boards to size. So, one sheet of wood could give you eighteen 40 × 40cm boards to paint on, coming in at about £1 per sheet. This means that it makes it much less intimidating to paint figure studies on, but the boards are robust enough for you to make significant changes to the artwork without damaging the support.

MDF

MDF (medium density fibreboard) comes in a variety of thicknesses; 3mm is a good thickness in that it is very similar to card in terms of weight and how much space it will take up in the studio but has a somewhat more matt surface which takes the paint better. It also has the advantage that if the painting does bow, due to the shrinkage of its surface caused by the application of paint, it can be bent back into shape, but thicker boards cannot. Bigger boards need to be supported by cradling the back with a wooden frame, which can be pinned and glued to the back. Also, the larger board can be painted on both sides which tends to counteract warping.

You can buy off the shelf a host of ready made and primed canvases. They do vary considerably in quality and some of the cheapest contain more primer than fabric.

Chipboard

Chipboard is not a suitable wood for painting.

Canvas

Traditionally paintings were made on wooden panels (sometimes a number of panels joined together) but canvas was developed to enable artists to make larger paintings. The wooden framework that holds the canvas is called a stretcher or a strainer, depending on whether the corners can be pushed outwards to re-stretch the canvas if it goes saggy, or whether its dimensions are fixed. The cheap ones are usually very lightweight and can warp easily on the larger scale.

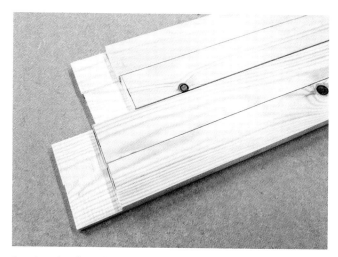

Four lengths of wood are cut to size out of two-by-one pine. These have then been cut into simple lap joints. A mitre saw kit from your local DIY shop is a useful purchase.

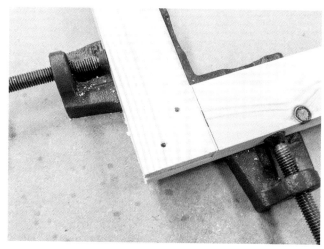

Squaring up: using a right-angled clamp the two lengths are put together and pilot holes drilled to reduce the chances of the wood splitting.

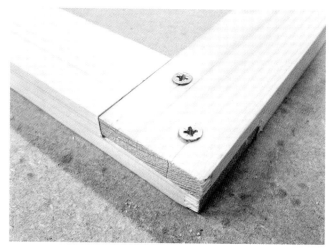

The corners are screwed together so that if the canvas is taken off the stretcher the strainer bars can be taken apart and new lengths added, and a new canvas stretched.

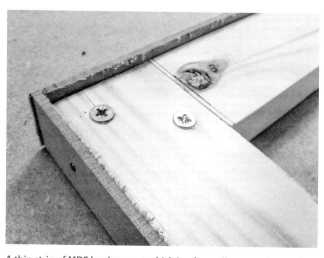

A thin strip of MDF has been cut which is a few millimetres deeper that the depth of the pine. This is tacked into the strainer so that the canvas sits above the frame. Moulding could also be glued to the top of the strainer.

The better pre-bought canvases are artists' quality and they are made of cotton duck or linen. Linen is usually a much finer fabric but is much more expensive. Some stretchers are made of aluminium rather than wood; these are more or less museum quality and do not warp. Alustretch produces stretchers for some of the top artists in the world.

MAKING A STRAINER

You can make your own strainer from four or five pieces of 2.5cm pine from the wood yard. Depending on your woodworking skills you can make mitre joints or half lap joints. However, this wood tends to be green (new) and can warp considerably, especially once it is made and has a stretched canvas on it. The tension that this creates in a centrally heated house can alter the shape considerably. It is a good idea to attach beading to the top outer edge of the strainer so that when you stretch your canvas, it is not in contact with the frame, otherwise you will get the impression of the strainer bars on the painting. Depending on the size of the painting, a fifth piece of wood can be added to create a central crossbar which reduces the warp in the strainer. Triangular corners can be pinned to the back of the strainer as well to reduce twist.

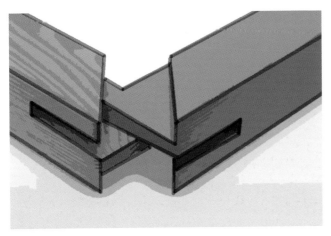

Stretcher bars slot together and can be wedged outward to increase the tension in a sagging canvas.

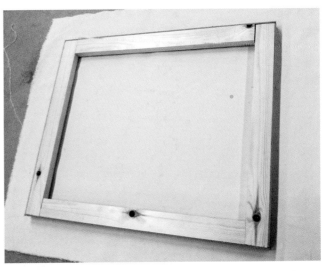

Preparing the canvas. The canvas is cut approx 25cm larger than the strainer in each dimension.

Creating the tension. Three staples are attached to the middle of the strainer and the same repeated on the other side. This is repeated on the adjacent sides whilst pulling the canvas outward creating the tension.

STRETCHER BARS

If you buy ready-made stretcher bars, these have a raised bevelled edge, which raises the canvas above the bars so that they are not left with the impression of the bar on the finished painting. Ready-made stretcher bars have tongue and groove joints. When piecing together the stretcher you still need to tack the joint together with a panel pin and rest the joint against a carpenters' square to ensure that the bars are at right angles to each other. You also need to measure the diagonals of the stretcher to make sure they are the same.

PREPARING CANVAS

Canvas bought on the roll can have a certain amount of resistance to priming (the primer sits on top of the canvas rather than integrating into it). This can be alleviated by washing the canvas first, but care has to be taken that the canvas does not become creased. The best way to do this is to place a roll of canvas into a bath of water and then hang it out to dry. This not only reduces the starch and makes the canvas absorb the primer more readily, it also causes the canvas to shrink a little. Warped canvases are often caused by too much tension on the stretcher due to the shrinkage of the canvas. When making your own canvases, ensure that your canvas is approx. 25cm bigger in both dimensions than your stretcher. This will allow enough room to pull the canvas over the stretcher bars on the other side.

STRETCHING A CANVAS

Start at the middle and place three staples through the canvas into the stretcher. Move to the opposite side and repeat, this time pulling the canvas towards you and bringing it over the stretcher to create tension. You can use your hand to do this or you might want to use canvas pliers. Now move to the

adjacent side and repeat, pulling the canvas towards you and stapling before moving to the opposite side and repeating the process. Working from the middle outward towards the corners, insert staples approx. 10cm apart. When you finally reach the corners try to pull the canvas taut and neatly fold over the back.

PRIMING

Once the canvas is stretched it can be primed with acrylic primer, acrylic gesso primer or rabbit-skin glue size. (Traditional gesso should not be put onto the canvas as the movement of the support will cause it to crack; acrylic gesso is more flexible.) Rabbit-skin glue size is the traditional way for priming a support for oil. It requires soaking the dried

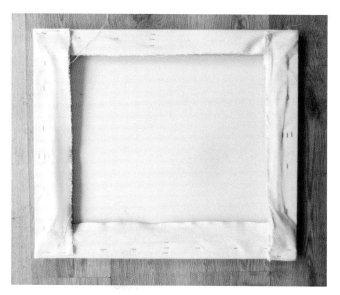

Stretching outwards: more staples are added, gradually working outward to the corners.

The corners are pulled diagonally outward and stapled. The canvas edges are tucked neatly into the back of the strainer.

pellets in water before placing in a double boiler to heat up. This hot liquid is applied to the canvas and left to cool and dry for about twelve hours. If whiting (very finely crushed chalk) is mixed with rabbit-skin glue size to create a cream-like liquid, you have created true gesso. Acrylic gesso is like a chalky acrylic and will provide you with a sealed surface but also a key for your paint to adhere to. If you require a very smooth surface, this can be created by building up more layers of gesso, which are sanded down between coats. Aim to seal your boards or canvases with at least three layers. It is a good idea to paint your boards in one direction and then to change direction for the next layer (horizontal brushing and vertical brushing); this helps to achieve an even coating.

Apply your primer with a stiff decorators' brush to ensure that you get the primer into the warp and weft of the canvas. Once covered you can use a thin scraper to drag the gesso into the surface, filling up the crevices and sanding in between coats to create a smoother surface if you wish. Alternatively you may wish to use a much coarser canvas for the texture (like Sickert's figure studies). Painting on canvas can be really exciting especially when working on a larger scale, but the cost and effort involved can be quite intimidating – you will feel under pressure to do something worthwhile on it.

Priming. A stiff brush is used to apply the acrylic gesso into the weave of the canvas. Subsequent layers can be scraped over.

You can also prime your supports with PVA, a clear acrylic primer, any acrylic colour – or you may choose to work on an unprimed support if you want the resistance of surface. Some hardboards have an oil content which could leach into your paint, and exposed areas of board may yellow due to air exposure, but you should experiment with the preparation of your support because it can make a huge difference as to how the paint feels when you use it.

Marouflage

If you find that you like working on the texture of canvas but find the movement of the support frustrating then consider a marouflage. This is where you glue muslin or fine cotton to a board. If you are working in acrylic, PVA will adhere your canvas fairly well and rabbit-skin glue works very well for oil. Apply your hot glue to the support and add your muslin, which should be approx. 10cm bigger than the support, wrapping the edges around the back of the board. Seal the muslin with a further coat of rabbit-skin glue, ensuring that it goes over the front and is pressed down. Ensure that there are no air holes and that the fabric corners are covered too.

Alternatively you can make a cradled board and stretch your canvas over it in the same way you would do a strainer. This means that if the painting doesn't work you can simply remove the canvas and start again. It also removes the problem of the board and the muslin drying at different rates and becoming detached.

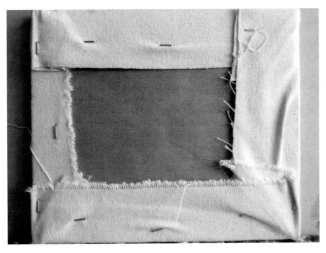

A marouflage board.

Ground colour

Once you have primed your board you might want to consider the ground that your painting is going to be made on. Do you use white? Would it be more appropriate to choose the dominant colour of the painting (yellow ochre or burnt sienna for the figure) and stain your canvas or board that colour? Do you identify the complementary colour of the subject and paint your canvas in that colour (the Impressionists would sometimes paint their landscapes on a red ground) – then the colours on top will create interesting colour effects.

The colour of the ground can have a significant impact on the painting so experiment with the following: grey, yellow ochre, raw umber, blue, green and black grounds. Try to make two paintings at the same time. Set up two supports with two radically different coloured grounds. When you make your mark on one painting, try to make the same mark on the other. Do not always put the first mark on the same support each time: alternate to keep the vision of each fresh. Think about how the same colour appears to be quite different according to its background.

Imprimatura is the application of a small amount of oil paint mixed with solvent and linseed oil, which is loosely brushed onto a support and then after a period of time rubbed off, leaving a thin stain of colour. Alternatively you might wish to mix some oil into oil-based undercoat to achieve an opaque ground colour.

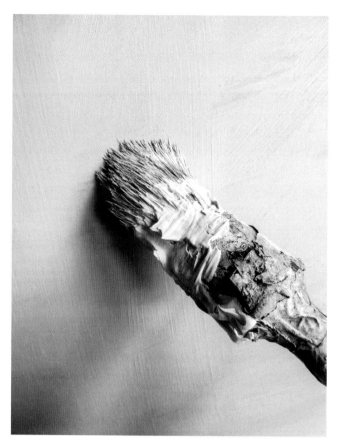

A grey ground has been applied with a stiff brush to a board to create an underlying texture to paint over.

Imprimatura: a thin application of oil, turps and linseed can be applied to the primed canvas and rubbed in with a cloth to achieve a thin ground colour.

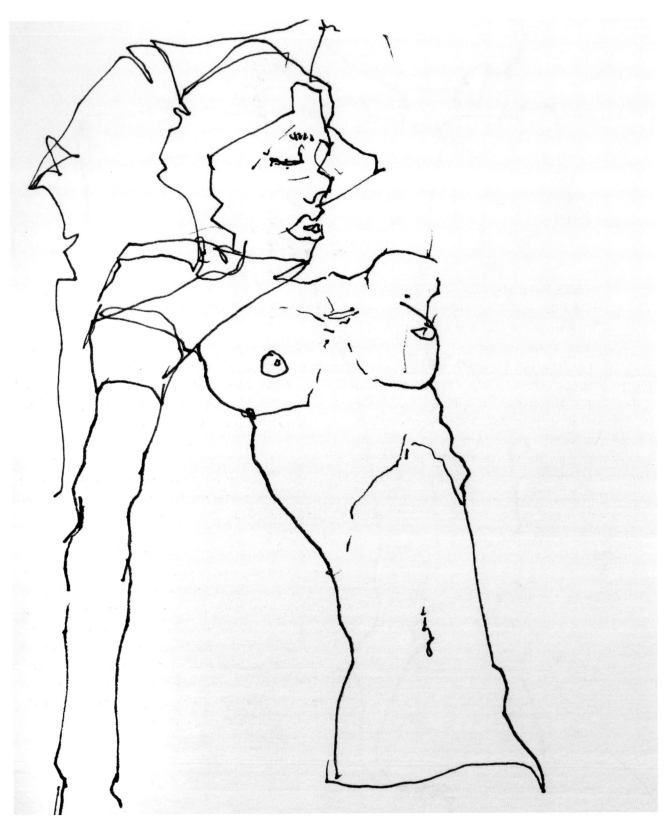

Study after Egon Schiele.

Chapter 2

Linear drawing exercises

ou learn how to play the piano by practising your scales, which develop your muscle memory and teach you how the notes interrelate to each other. In much the same way you can use drawing exercises to loosen up and 'get your eye in', or simply explore new ways of drawing. A long life-drawing session can start off with some quick drawing to give you a quick overview of the pose. Blind drawing (described later in this chapter) can allow you the time to really look at the figure and begin to understand the tiny changes in direction of form and contour. Thinking across the figure can improve your understanding of proportion. All of the exercises in this chapter are aimed at improving your perception of the figure, to allow you to see it more objectively.

LESSON 1
The fallibility of memory

Before you read on, open a sketchbook and turn to the last page. Everyone feels that the first page of the sketchbook is intimidating, as you feel that you have to do something good in it. So turn to the back and think of this as the place where you can put your reflections about your drawing activities.

Now draw a parent from memory (or some other significant relative). Take about five minutes for the exercise. It might be interesting to give this challenge to a few friends and, if they are willing, compare your results with theirs.

Does your drawing look like your parent (or this other relative)? Is your drawing a photo-realistic rendition? Or perhaps does this drawing look like the kind of drawing that a ten-year-old might do? Are there similarities between your drawing and your friends' drawings? Despite the years you may have known that parent, your visual memory is poor; this proves that when drawing you really need to minimize the time spent between looking at the figure and looking at your paper and back again to the figure. In fact, you should spend longer looking at the figure and less time looking at the paper.

LESSON 2
Shape drawing

The key point in this exercise is to try to see differently and to stop thinking, 'I am drawing an arm, so I need to work out how to draw an arm.' Instead the focus should be, 'I am drawing this shape, so what kind of shape is this?'

Materials:
- Biro
- Sketchbook

Look at the image at the beginning of the chapter and try to make a copy of it using your biro. Give yourself ten minutes for this exercise. When you have finished make a note by the side of the drawing of the date, the time you took to complete it, and the technique you used on the drawing. Now turn this book upside down and repeat the exercise. Try to give yourself the same time and use the same media. Once you have finished the drawing, once again make a note of the time, duration and technique used.

Now photocopy your drawing. Take a pencil and a ruler and draw through the diagonals.

Place a sheet of your paper on top of this page. Mark off the height and the width of the image by resting your paper against the original and transfer the dimensions to find the exact size of the rectangle. Lightly divide this box on your paper with pencil divisions to match the same divisions in this illustration. Working triangle by triangle, what shape is in each one? Think carefully about the line and how and where it bisects each diagonal, horizontal and vertical. Try to spend about fifteen minutes on drawing this again, using a biro. In the back of your sketchbook look at your three drawings the right way up: is there a difference, and if so what is it? Have you learned something in the process? Is one drawing more accurate than another? You will see that each drawing has improved and that your level of observational accuracy is already better.

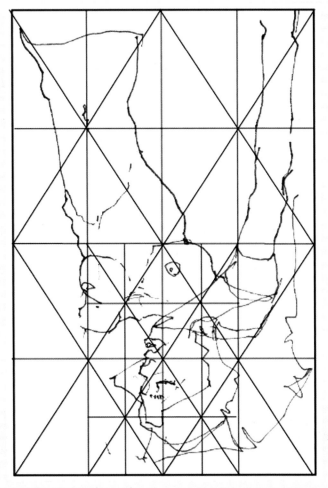

Study after Egon Schiele.

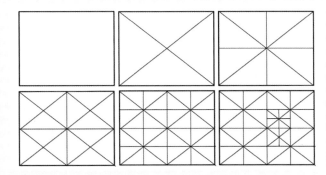

Dividing up: at the intersection of the diagonal, draw a vertical and a horizontal. Where these bisect the top and bottom and left and right sides, join these up, forming four more sets of diagonals. Construct more vertical and horizontal divisions. Look at the boxes and consider their complexity. Continue this process of diagonal divisions forming horizontal and vertical grids. Note that not all boxes need to be divided.

On copying

We learn to speak by copying the sounds emitted by our parents' mouths. From our initial 'ga-ga' noises we begin to articulate words and also make connections between the meanings of those sounds. We can learn a lot about drawing in the same way. Not only do we need to learn the fundamental visual perception skills to enable us to see and therefore be able to draw, we need to look at a lot of drawings and paintings and learn from them.

Picasso said, 'Good artists copy, great artists steal.' The real trick then is not to just copy, but to consider what you learn from looking at others work and apply it to your own visual problems.

Tape drawing and enlarging

You can draw with many things, and it can be really challenging to draw with a material that is not usually used to make a drawing. In this exercise you are going to draw with electrical tape. A good linear drawing is a great source for this. It is also important to learn how you can enlarge or reduce your work for transcription to another support. Although all rectangles are quadrilaterals, each rectangle has a specific ratio between the shorter and longer side.

Materials:
- Black electrical tape
- Pencil
- 1m ruler or some cotton thread
- Masking tape
- Scissors
- Scalpel
- Cutting mat
- Set square

Time: approx. 2–3 hours

Choose a suitable drawing and grid it up, using the example as a guide. Produce an enlarged version of the rectangle by taping thread to one corner and extending it outward so that it is the same angle as the diagonal in the original. Now draw the opposite diagonal to find the centre of this bigger rectangle. Construct your perpendicular horizontal and vertical divisions as before (a T square is really useful here) until you have made either in pencil or thread a grid that resembles the grid on your original. Now really concentrate on the white shapes made by the line and the triangles. Try to recreate the positive line made in the drawing by cutting the insulation tape so that it resembles the line and sticking it down on the paper. Be careful not to pull the tape too taut when you stick it down as the tension in it will cause it to lift.

A five-minute partial peek drawing has been chosen from which to make a tape drawing.

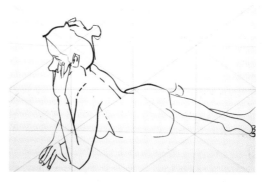

Tape drawing: thread has been used to create the grid and the black insulation tape has been cut and shaped to mimic the line quality.

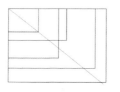

None of these rectangles share the same diagonal so they are all in a different proportion to each other.

When rectangles share the same proportion they all share the same diagonal. Using your copy paper, place the paper against an illustration in this book. Mark off the rectangle using your set square. Place this rectangle into the top left corner of some A1 paper (or top right if you are left-handed). Place cotton thread through the diagonal of your little rectangle and extend it outwards until you create an enlarged rectangle, which is in the same proportion as the smaller one.

Negative painting

It is important early on to link the idea that 'drawing is painting and painting is drawing' (Piers Ottey in conversation with the author). A larger brush can produce a very fine line if you paint the spaces either side of the line leaving a gap for the line to appear. In this exercise we will explore the idea of negative painting, i.e. something can be painted by painting the space around it rather than the thing itself.

Materials:
- Heavier weight cartridge paper
- Black and white acrylic paint
- Pencil
- Brush
- Small geometry set square
- Photocopy of a linear drawing

First, paint up a piece of paper in black, about A4 size (approx. 20 × 30cm). Once this is dry, place your set square on the top edge and draw your vertical and horizontal corners and lengths.

Now place the photocopy into the corner and lay your ruler across the diagonal of this image to transcribe this rectangle. Transfer the same grid and paint only the white shapes of the image, leaving a gap between the areas of black to create the lines. Once again look at the two drawings you have made. You can take a photograph of your big drawing and put a printout of it in your sketchbook alongside your white space painting. What was challenging about the task? Was one easier than the other? How do these drawings compare with your first attempts? Look back at the original drawing you worked from. Are there discrepancies that have been magnified in the negative painting because of working from the tape drawing? Now correct the negative painting by repainting with both black and white paint.

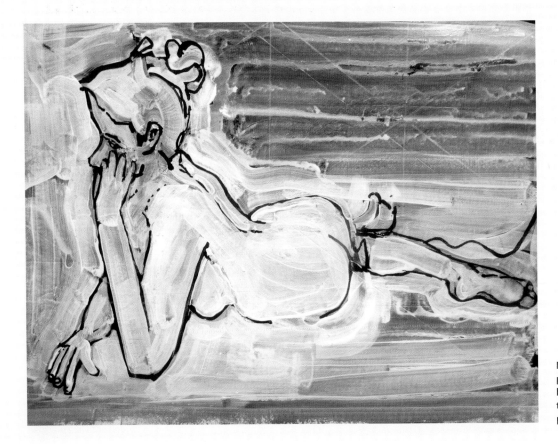

Negative painting: the paper was painted with black acrylic and then the negative space was painted with white paint.

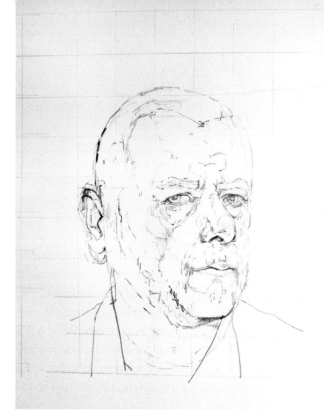

Self portrait. In this instance the mirror was gridded using a marker pen. Care was taken to ensure that the head lined up with the grid every time a measurement was taken.

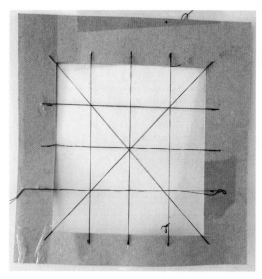

Cut out of the cereal packet card a square about 25cm × 25cm. In the middle of this cut out an aperture, 20 × 20cm. Cut out a square of acetate about 21cm × 21cm and stick it down behind this aperture with your tape. With your pin or compass scratch into your acetate the same diagonal divisions and grids to make a grid with 2cm squares. Alternatively, you can sew thread into this card frame so that the thread forms the grid.

LESSON 5
Self portrait

It is not always easy to have access to a model, but with a mirror you have a model everywhere you go. You can work using more than one mirror, which will give you access to your true reflection and your back view. You can of course strip and paint yourself in the nude if you want to get to grips with your own physicality, but in this instance the author drew the face.

Materials:

- Compass or a pin
- Ruler
- Set square
- Sheet of acetate
- Sewing needle and thread
- Piece of cereal box card
- Masking tape
- Pencil
- Permanent marker (fine)
- Sketchbook

Time: 30 minutes

Hold up your viewfinder (the method is described above) in front of you and look through the grid to a reflection of yourself. Like the exercise before, concentrate on the shape made by you and the rectangle. Rather than thinking about what you are actually drawing (i.e. body parts), think about the white paint exercise. If you find this very difficult with the double reflection of the grid, then rule onto your mirror a grid of 2cm squares with your permanent marker (a fine one is best). Then lightly draw in pencil a similar grid onto your sketchbook, which can be the same size or larger. When you have completed this exercise you can repeat it again, this time from someone sitting in front of you. Try to think of the grid as a map; you are trying to navigate your way across it. At the end of this exercise, take some time to sit down and reflect on what was easy, and what was difficult. Consider the differences between working from life and a 2D image.

You might have found this last exercise really challenging. Why? First, you are dealing with a much more complex task of translating 3D into 2D. Last time you were copying shapes; now you are translating form. Second, you have to shift focus from the object being drawn to the grid and then to the paper.

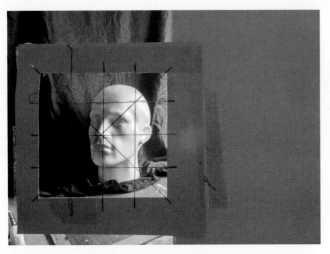

Your viewfinder can be attached to your drawing board so that it remains fixed during the drawing process.

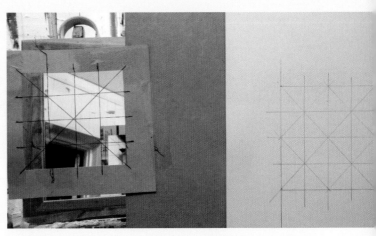

If you create a grid on your paper you can look through the grid onto your subject and use that information on your drawing, virtually tracing the subject. The viewfinder might vary in size according to the distance you are away from the model. For a few feet away your viewfinder can be approx 20 × 20cm but if the model is a few metres away this might need to be much smaller. However, the gridding of the diagonals and finding the centres is a useful way of helping you scale your drawing, as the drawing can be much bigger than the grid.

Your head might be in different positions each time you come to draw. If your head changes position, everything that you are trying to draw will have altered. In the self-portrait you may also be dealing with the problem of looking through the viewfinder at a reflection of the viewfinder and then your cropped head beyond that. To help you with this exercise think about Victorian photography: remember in the early days of photography, the new middle classes had family portraits taken that always looked stiff because the light sensitivity of those early plates was poor – the exposures took minutes rather than fractions of a second. To keep the sitters still, they were clamped into position. You need to think about what things can move and try to find a way of minimizing that movement.

If you have an easel, then you can tape your viewfinder to it. Make sure that your mirror, your easel and you are in the same position. Are you moving backwards and forwards, up and down or side to side? You can cut and stick masking tape on the floor round the legs of your chair to ensure that you know the position of your chair. To help keep your body in position, you need to line up something from the foreground with the background.

Of course this will mean that the process of making the drawing is slowed down but take your time. If you have the space, set up this still life arrangement and do half an hour each day. Do not worry if you change clothes. Just be prepared to change the drawing. At the end of each session, photograph your drawing. Sit back and ask, 'Is it working? What needs attention?' Try looking at the drawing in the mirror, as this will help you see it afresh. A small make-up mirror is really useful for this. Photograph your work and print off a small contact print version of your image. This can go into the back of your sketchbook to help you consider what you have done. Write down the thoughts that you have next to the image. When you come back to do the next sitting, read through your notes to remind yourself of your thoughts and to set your agenda. Don't despair and don't give up.

LESSON 6
Transitions

Materials:
- Magazine
- Biro
- Sketchbook

Try making a linear drawing from a fashion or music magazine, or any other book with good photographs of people. Use the same technique, only this time lay your viewfinder over the image and draw what you see through the square. Try one the right way up and another upside down. Your challenge is to think about using line – the difference being that previously you had a line to copy. So are you going to think about how you will convert the outline, or creases and folds, edges and prominent structures into lines? Try not to worry about colour or changes in tone. Think only about the shapes you can see.

These are strategies to help you see the figure as a series of interconnected shapes and not to think about drawing an arm or a leg, where you might draw what you *know* rather than what you *see*.

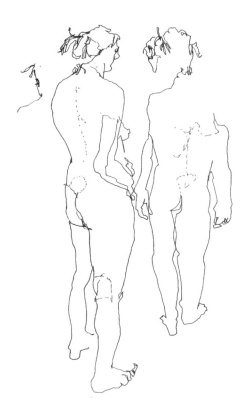

Blind drawing moves you in the right direction of really looking at the figure and reducing the tendency to make assumptions about what you are seeing.

Crossing the terrain: the meandering line

Choose another found image. Consider the idea of 'journey' between pairs of body parts. What network of connections needs to be bridged in order to connect two hands or two feet? Don't try to rush it. Don't be worried about the notion of an unfinished drawing. Instead start with one hand and draw all the shapes that you can see within it, finding the next shape adjacent to it and the next slowly bridging the space. For this exercise do not take your pen off the paper. Then connect these hands to the uppermost point of the head to the lowest part of a toe. Then move from one shoulder to the next until you have navigated your way backwards and forwards across the figure many times.

So what have you learned so far?

- You have learned about upside down drawing; about using grids, about scaling up and down, about taking care of the small shapes and letting the big shapes find themselves.
- You have learnt to distrust the outline and instead to think about the small details.
- You need to be prepared to make mistakes.
- You need to be prepared to make a mess.
- You need to be prepared to get frustrated.
- You need to be prepared to make changes.
- You need to rise to the challenge of

giving yourself new goals all the time in order to learn and develop.

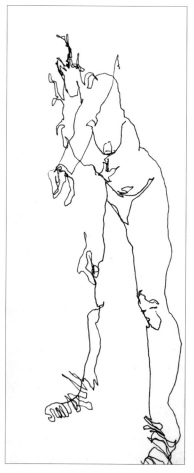

Here the eye moves in and out through the creases of the socks, up through the shin, across the knee, back and forth across the groin, in and out of the breast, etc.

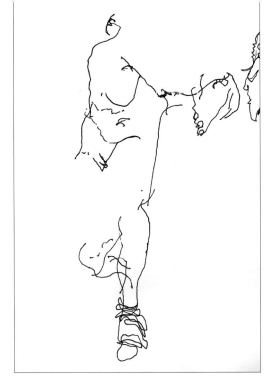

Blind drawing moves you in the right direction of really looking at the figure and reducing the tendency to make assumptions about what you are seeing.

Blind drawing

We have a tendency to scan what we are looking at and not really notice details. Mistakes are often made by trying to draw too much, too quickly (we will deal with quick drawing later on). You need to learn to slow down, to look very carefully and really notice all the minutiae of what you are looking at to become absolutely absorbed in the landscape of the body, to notice every crevice and hill, every crease and fold.

For this you ideally would have access to a life model. But quite frankly you could look at your partner on the sofa of an evening, or again return to the mirror or select another one of the images from a magazine.

You have to become lost. Rather than drawing up and down a leg, you have to navigate across, trying to see how each small part connects to the whole (think of the hands exercise). You have to think about this type of drawing rather like a jigsaw in that you start with a piece right in the centre and gradually work out which shape connects to that building outward until you eventually find the edges. One of the things that you should have realized is that copying a 2D image is a lot easier than working from a person.

Really looking by drawing blind

Materials:
- Biro
- Sketchbook

Time: 5 minutes

You must get your body positioning right. If you are drawing your partner, sit at a table and place your sketchbook on the table but turn your whole body away from the sketchbook and point yourself at your partner.

Do not produce a line by making a series of short strokes that join together. You must work with the biro really slowly and use a strong, definitive line. Imagine an ant: it is very small and if it were crawling across the figure it would move very slowly. Imagine that your eye is following the journey of the ant, travelling at the same speed as the ant, and your hand is following your eye, *noticing* every change in direction. By drawing without looking at the paper, you have to really look at your subject. You have to focus on the tiny details and get lost in them. You should not be tempted to look at your drawing; you will probably laugh at your results. This type of drawing is not about getting the proportions right, it's about really noticing the figure and really seeing the details. Produce five blind drawings.

Visualize the ant on a trapeze: the ant cannot jump very far, so minimize the gap that it has to make if you are going to move from one point to the next. Once you become familiar with the process you will begin to feel that you can enjoy the process of really becoming engrossed in looking and you lose a sense of time, place and language. It's a wonderful place to be. It's also a great way to draw really complicated pieces on information (think of shoelaces). Start another blind drawing, only this time give yourself ten minutes, and repeat the exercise again.

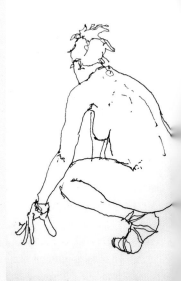

Although the proportions may be incorrect, there is a *rightness* to the observation in these drawings. You may want to keep your pen on the paper all the time. You want to move it, but think about that ant again!

Partial peek

So if blind drawing has allowed you to slow down and really notice the observed world, how can you use this technique but produce more realistic life drawing? The answer is simple but highly effective: you actually look a little bit. You have to trust in the process, and what seems like an alien thing will eventually become second nature. Start anywhere on the body but preferably at a complex part. Where there is complexity, there is a network of shapes and interconnections. Remember that we are interested in the idea of shape drawing rather than person drawing.

Start with the clothed figure. Clothing can have a fantastic shape and add an incredible dynamism to a pose. It also gives time for the heaters to warm the room up.

Think about the creases and folds again. Stop making that knitted line the line that you have formed a habit over. Keep the line crisp and assured. Again stick with biro, fine fountain pen (Lamys's are great) or fine liner. It keeps your attention more focused, as you have to really think about your line and try to make it work. It is this focus and determination that make the drawings work.

Changing speed

You have by now done a number of drawings where you have slowed your looking down and spent a lot of time looking very carefully, training your hand to follow what your eye is seeing. Now get the model to change the pace of their poses. You may find that through this exercise the model will be prepared to introduce much more dynamic and challenging poses, exploring weight distribution, balance and movement. It might be useful to get them to think about a movement through space that you might ask them to freeze frame into a sequence of events. And each event might be held for two minutes or less.

Of course the right way of seeing has been established but now you will need to take in less of the detail and more of the whole. Think of the essence of the pose; try to visualize it as a series of key movements and changes of direction through the figure. Try to make a drawing that is assured but still responsive to the subject. By far the most important thing is to keep looking at the subject, so as each pose moves on and potentially gets shorter in duration then the balance between

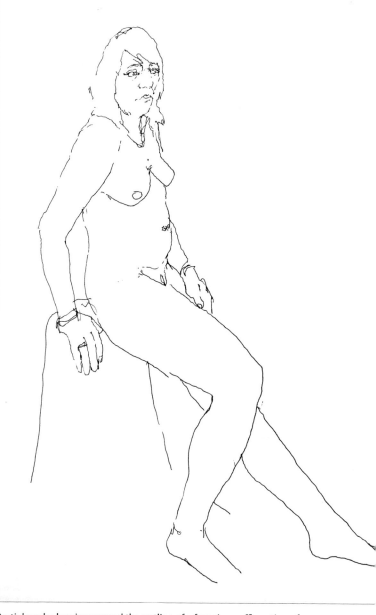

Partial peek: drawing around the outline of a form is an affirmation of its identity. You need to consciously try to avoid this way of drawing. Instead you need to break up the big form into its interconnected parts.

looking at the model to the paper should increase, so that in the end you might be doing virtually no looking at the paper at all. If you have a smartphone, set your timer to five minutes. Otherwise make sure you can see your watch in the corner of your eye.

A valuable point to note here is to change not only the speed of your looking and your assertiveness (these are not indecisive drawings) but also to make your drawings smaller. A

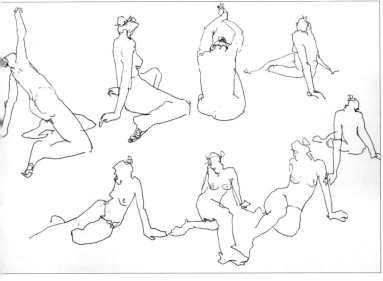

Two-minute drawings of the nude in biro. Think about the negative space and a partial peek approach. As the time frame decreases so the amount of time looking at the figure increases.

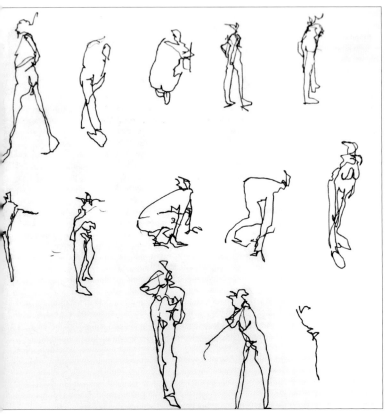

Drawing quickly. When you have much less time to make a drawing you have to significantly reduce the amount of information you include in your drawing.

These drawings were made from fifteen-second poses. To capture the whole figure you need to significantly reduce the size of your drawing so these figures are only a few centimetres high.

The Croquis Cafe is an online resource for artists and students and offers its own version of life drawing sessions that have short five-minute poses at the start.

Try doing some linear drawing on coloured paper with coloured pencils. Experiment with those different biro colours and felt tips.

five-minute figure drawing might be 20cm high, a two-minute drawing 15cm, a one-minute drawing 10cm, about 5 cm for thirty-second drawings and even smaller for fifteen seconds. Whilst you may find these changes of scale difficult to master at first, if you keep finding unfinished drawings then change scale to complete the drawing in time. Also if you practise drawing people at the train station, on the beach or across the road, visually they are that small (sight size) and that will certainly help you get used to that scale.

Try making your first two poses fifteen minutes, then drop down to two ten-minute and three five-minute poses. Of course one of the big temptations is to fall back into the habit of your old way of looking. Try to really focus on that figure. Keep your eyes closely focused on the subject and not on your paper. If you take a wrong turn and you feel that you are in the wrong place, make a new line. Don't be worried about it but use the knowledge that you gained to help you place the new line correctly. Think about how often you peek. Try different peek rates every minute: every thirty seconds, every ten, etc. See if there is an optimum time to get the best results. Not looking enough may send your drawing backward, too blind, and the proportions might go amiss. You will probably see that areas of the body where a lot of things are happening may be larger on your drawing than areas of great simplicity. Pay attention to the relative scale of each component.

LESSON 8
Changing hands

Now that you have done some partial peek drawing you are getting your eye used to looking in the right way. Start another drawing, but this time change hands. Keep the approach the same where you are mostly looking at the subject. Whilst the line may lack confidence, you have to really concentrate on how you are going to make the mark. It's this level of concentration that you need to make the drawing. Also you mentally assume that your drawing will not be any good so you let yourself off the hook. You don't create any unrealistic expectations. And this lack of concern helps. When you feel under pressure to produce a masterpiece, you invariably buckle under the stress.

Materials:
- Fine line pen
- Sketchbook

Make two fifteen-minute wrong-handed drawings in line.

Wrong-handed drawing is a useful exercise as the drawings can be surprisingly good (sometimes even better than your normal drawing hand).

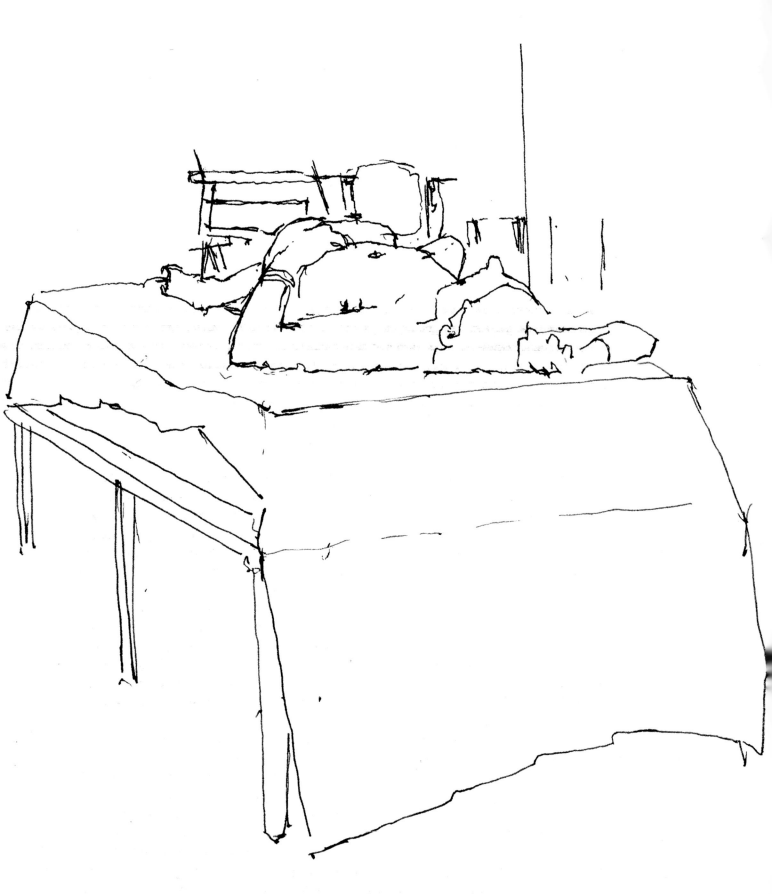

This measured drawing started with the easels and chairs in the background.
The spaces in between these located the top of the figure. The small horizontal
measurements were used to calculate the larger vertical depths.

Measurement and proportion

ou have spent a lot of time thinking about improving your ability to look. But how can you develop a more robust approach to life drawing that will get all the parts of the body in proportion and in the right place relative to each other, as well as getting your drawing to fit the paper?

Measurement is a device to help you see more objectively. The less confident you are as a draughtsman the more you measure. Measurement is not the subject of the drawing, it is simply a tool to help one make it. There are many different ways to measure, some of which are outlined below. Although they are described separately, they can be intermixed as needed. You may find one technique easier than another, so it is worth giving them all a try.

Relational measurement

You need to think about the figure as if it is a piece of sculpture, which has been shipped abroad. Imagine the wooden crate that it is in. What would be the height of the crate, and what would be its width? To stop this sculpture rolling around, the box has been made to perfectly fit the maximum width and height of the figure. So draw the box containing the figure, or rather the rectangle that contains the figure. You might want to use your viewfinder to help you see the proportions. As it is based on a square you can move it backwards and forwards until the longest length is visually the same size as what you are drawing. You can then look at how the shorter length compares to the square divisions on it.

Relational measurement

Materials:
- Charcoal pencil
- Clear plastic ruler
- Compass
- 45° set square

Get your plastic ruler and lay it along the top edge of this image. Slowly lower it until it touches the topmost part of the figure. Do the same from below so that you identify the maximum height of the figure. Hold the ruler to a vertical and bring it in from the left and right sides until you have touched the extremities on each side. Work out the length of the shortest side (you could measure it with the ruler, you could lay a sheet of photocopy paper and mark off the distance on it, or if you have a compass you can open it up until it is the same length). Now place this measurement along the edge and mark off how far it reaches across the longer length. You could also use your 45° set square to mark off a diagonal. Measure the part left over. How many times does it fit into the length?

Now construct an enlarged version of this image using charcoal. Charcoal can be used very aggressively with rich velvety blacks but it can also be used with great sensitivity of touch. Avoid holding it like a pencil; instead rest the charcoal in your hand as you would a hosepipe. Rest your fingers onto the paper with your palm pointing towards you, that way the weight of your arm is taken by your hand and not the charcoal, or outstretch your little finger so that it comes into contact with the paper and takes the weight of your hand onto it. This will help you make those lines light.

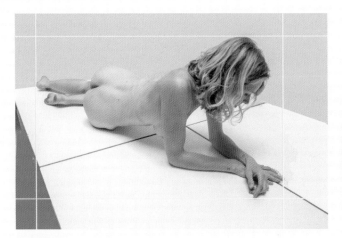

What is the proportion of this figure? Locate the maximum dimensions in both the vertical and horizontal planes and think about the kind of rectangle that is created.

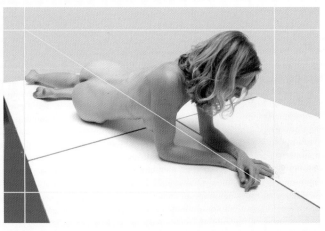

What is the diagonal of this rectangle? Any rectangle that shares this diagonal is in the same proportion as the original.

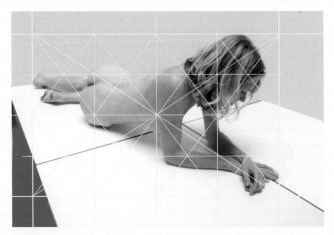

Halves and quarters: divide the box on the diagonal to find the centre. Construct a vertical and horizontal division and then divide these rectangles too.

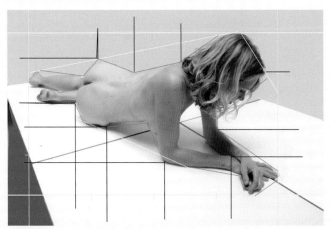

Identify where the figure touches the edges of the box and use these reference points to calculate the basic shape of the model and how these points relate to the edges of the whole rectangle.

As you are making your marks continue to make reference to the points on the figure in relationship to the surrounding rectangle but also consider the network of visual connections and alignments that occur across the figure. For this it is useful to hold up your clear plastic ruler and align it to a key point on the figure. Is it vertically above or below another key point? Hold your ruler to a horizontal and see what lines up with that too.

Enlarging: first construct your rectangle in the right proportion using the diagonal and extending this outward until you have one the desired size.

Basic mapping. Charcoal is fugitive and mutable. It can be easily erased so you are building a subtle framework to help you find the main dimensions.

Consider the negative space and how you can locate the figure in relationship to the grid.

Refining the edges. Once you have established the main shapes then you can strengthen your line and consider the direction of the planes you are drawing.

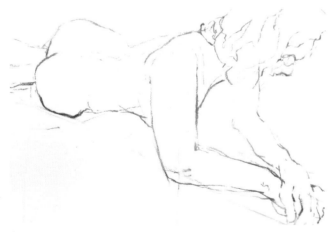

Spatial line: what form is in front of what? Which lines should be heavy and which kept light? Which lines are broken and non-continuous? You can finally erase any unwanted lines, giving your drawing clarity.

Working with a model offers its own challenges and these should be considered when working from life. Who is your model? You are about to enter into a symbiotic relationship with them. What energy they bring to the room is as important as how you respond to them. Are you going to go to an existing life drawing class, which may be tutored? In this case the tutor will set the parameters of what is going to happen in the class, set the poses and the time frames for each. You may not have the vantage point you would like, and you may not have the duration of pose that you would like, so you need to be open to the experience and be adaptable. It might be an untutored class, in which case will you be able to voice your ideas? Someone in the group might be trying to direct the class, so explore the potential of the situation. You may prefer to hire your own model through an agency. Contact your local art schools or art clubs to see where they get their models. Alternatively *you* might be the model or a friend/partner might volunteer to sit for you.

Consider the following: heat, ventilation, comfort, windows and dignity. You may be clothed but your model might be naked. How cold is it for them in the room? Do you have fan heaters that can be directed at the model? Is there a draught but also is there sufficient air in the room? Can other people look in through a window or walk in through a door whilst the life class is taking place? Cover up windows and put notices on the door to knock and wait. The life room can get very hot and people have been known to faint so can a window be opened a little if needed? Are you wearing layers so that if you are hot you can at least take some layers off?

Does the model have somewhere safe where they can leave their things? Whilst a model may be happy to stand in front of you without clothes, the state of undressing requires a transition, which should not be public. Do they have a screen or a separate space in which to change? Do they have clean sheets to use, and pillows, blankets or a mattress to lie on? Do you want props, masks, fancy dress, etc. for the model to use for a particular pose? These can all bring exciting nuances to the life room. Do you draw in silence or create an ambience or tension with music? Consider the length of time for a pose: short warm-up drawing or longer, more considered poses? Ensure that the model feels able to break when they need it and be prepared to guide the model back into position afterwards. Finally, it is important to note that good models are part of the creative process: they can really bring the room alive. Ensure that they will want to work for you again.

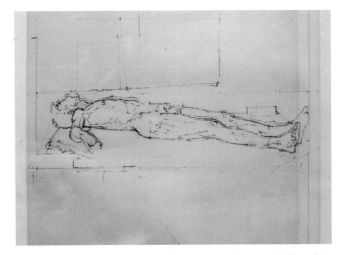

Whilst at Chelsea School of Art in the 1970s Piers Ottey worked on this drawing for 110 hours. Over the years the drawing has yellowed, yet its surface contains the history of its making. A drawing is a summation of corrections and indecisions.

The easel

Whenever possible draw on an easel so that the drawing is perpendicular to your line of sight. Position yourself where you can see both the model and the drawing without moving your head. In order to help you do this, minimize the distance that your eye travels between the subject and the paper. If you do this you can virtually trace the object onto your paper out of the corner of your eye. If you are working in a sketchbook, try to elevate your sketchbook so that it is fairly perpendicular to your line of sight. Alternatively, think about using a piece of MDF or ply slightly larger than the paper you are drawing on and about 1cm thick resting on a chair in front of you. Hold the paper down with either bulldog clips or masking tape.

At first one has to set up the easel at the correct height. With a sight-size drawing one can take vertical heights directly across from the figure to the drawing, so the important thing is to make sure that the top and bottom of the figure fits on the paper. If it doesn't then it is a simple matter to move the easel further away (if the image is too large), or get in closer if the image is too small. If you have a drawing board on your lap then you will need to bring the horizontal measurements downwards toward your drawing, so make sure that the extremities of the figure at the left and right fit on the paper.

With measurement there needs to be consistency throughout the whole process. Here the artist rests his arm against the drawing board so that he is always equidistant from the figure. The pen is held vertically and measurements are calculated by running the thumb up and down its length until the distance is captured.

Draw millimetre by millimetre; the majority of mistakes are made when students try to draw too much in one go. Draw small distances rather than large ones. Break up larger ones by drawing the background instead. The eye is better at judging shorter distances accurately than longer ones: the longer the length, the bigger the potential error.

Callipers

With one arm of the callipers held at either a horizontal or vertical, the other arm can be opened out to match the angle you are trying to draw. This can then be transferred to the drawing. If one cuts away the ends of the label to form two points which meet (like the end of scissors), the callipers can also be used to measure distances between objects etc. By manipulating the pivot point it is possible to create scale callipers as well (the distance between the pivot and either of the two ends defines the scale). Another useful measuring device is a pencil held at arm's length and a thumb or even a ruler.

Sight-size measurement

Align a part of the figure with the background. Although spatially these things do not touch, if you make sure you return your head to the position where you can see this alignment then you will always be viewing the figure from the same position.

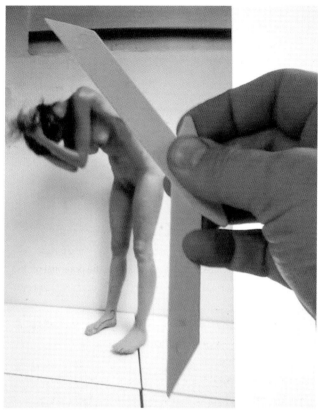

A useful tool to help you judge angles, these measuring callipers consist of two plastic plant labels, joined together with a paper fastener. The arms can be opened to capture an angle and the tips can capture a measurement. Consider an angle against either the horizontal or vertical. Never draw an angle against another angle. Even though the angle between them might be correct their true angle will probably be wrong.

DOMINANT EYE

To draw a figure accurately you need a constant frame of reference. What this means in practice is a fixed eye and body position. Although we have two eyes, which see different things, we actually have one vision. This means that one eye provides the dominant view and the other adds the three-dimensional element to this. In order to produce a measured drawing only this dominant eye can be used, as the other will give false readings of distance and angles. In order to identify this dominant eye, hold your arm out in front of you and point at an object so that your finger visually touches a particular feature. Now open and close each eye in turn. When the finger doesn't appear to move, you have discovered your dominant eye.

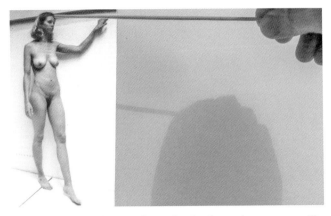

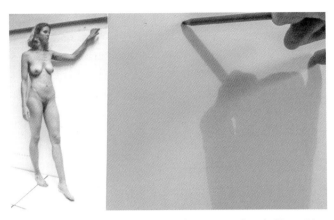

You need to ensure that your figure drawing fits on the paper you will be working on. Turn your measuring stick to a horizontal and bring it down until it rests on the highest point of the figure.

Take this height horizontally across to the paper and mark this position on your paper.

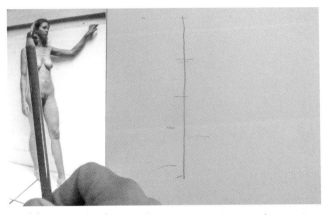

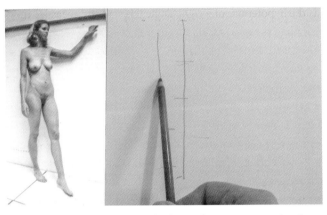

Consider the main angles against the vertical or horizontal and capture this angle.

Using your measuring stick transfer this angle across to your drawing.

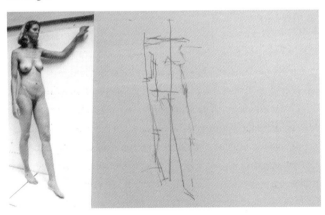

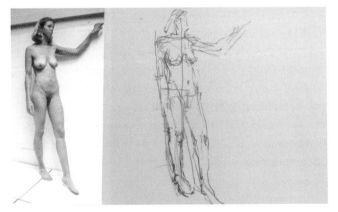

Mark off the key points where the skeleton touches the surface onto this axis and think about the main pairings of hips to hips, knees to knees, elbows to elbows.

A basic map. Begin to mark in more of the drawing and remember to compare width to height.

Place your easel at arm's length so that you can hold your arm out straight, at right angles to your body, and move between the subject and the easel without the need to bend it. Hold a pencil or brush in your hand so that the handle is at a right angle to your arm and proffer it visually against the object. Slide your thumb up and down the shaft until the thumb records the length of the object; then record your findings on the drawing.

In order to record an angle, hold the pencil to the angle and move this across to your drawing. Any turning action of the arm can be felt in the forearm muscles, which will tell you that the angle has changed. This does take some practice though. Another way of calculating an angle is to consider it as the hypotenuse of a right-angle triangle and measure the length of the opposite and adjacent sides. This means that one measures the vertical distance travelled by the angle and then the horizontal distance, which will give the angle once these two points are connected.

Plumb lines are often incorporated into measured drawing as well as a piece of string strung between two uprights to form a horizontal (the meeting point of both being the position of the eye). This is certainly the system that Uglow employed, as well as drawing chalk lines on the floor, which diverge outward from the eye in such a way that they appear parallel. You can attach a length of bamboo to your easel and hang your plumb line off it so that it provides you with a true vertical reference for the drawing. One can also use measuring callipers or other drawing tools to help you make the drawing.

All vertical measurements from the figure can be taken horizontally across to the paper. Try to position yourself so that you can see the model and your drawing without needing to move your head.

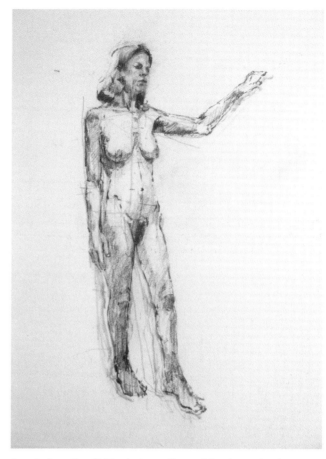

Spend a long time flicking between the model and your drawing, making direct visual comparisons between the two, making alterations and corrections as you go until the drawing is resolved.

Turn the measuring stick to a vertical and bring this up to the extreme left side of the figure and mark a similar vertical on your paper by pulling the pencil downward looking at the edge of your paper. Compare the width of the figure against the height and place a similar vertical to identify the extreme right side of the figure. Mark with your pencil along this stick to plot the main angle of the figure. Repeat this with the next main angle.

Do not be frightened to erase and make radical changes to the drawing. Compare a vertical running through the figure to see what elements line up. Transfer this information to the drawing. Do the same with a horizontal. Complete the drawing.

LESSON 10
Sight-size measurement

Materials:
- Pencil
- Rubber
- Measuring callipers (made from plant labels and a paper fastener)
- Bamboo skewer

Make a sight-size measured drawing of the figure. Allow at least three hours for this exercise and concentrate on recording the measurements the same size as you see them. If you are far away from the figure this may result in a small drawing on a large piece of paper, but do not scale up the drawing.

Proportional measurement. The key to this drawing was the measurement of the head. Once a decision was made about how big the head measurement was going to be, this measurement was captured and compared to the rest of the body. One head down and where are you? One more head measurement down and where are you? In this instance it is important to compare the live model with this unit of measure, and stick to it throughout the whole drawing. This will allow you to draw at any scale.

You can also use a bamboo skewer as a measuring stick to take measurements. It can be marked at regular intervals along its length to help you scale the figure.

Measuring alone is not sufficient to produce an accurate drawing. One has to look at a point in space and compare it with other points. What exists at the same height on the horizontal, what lies above or below? It is only when this network of comparisons is made that the accurate drawing emerges. Like a process of triangulation (a process used in navigation to locate the exact location of a point in space), each key element of the figure is locked into position by comparing it to at least two other points. For this to work, you need to consider the whole of the figure and how it relates to the space surrounding it. The cardboard grid described in the previous chapter is a useful tool here, in that it gives you a grid reference to compare the figure against. As we have already identified, your head needs to be in a constant position throughout for this to work.

When one familiarizes oneself with this system, it then makes sense to realize that one can draw at any scale as long as the relative positions of objects are observed. In order to make a drawing larger than sight size, it is important to calculate a scale for the drawing, which means that all the important elements are contained within the work. There is nothing worse than parts of the subject being missed off the page. It is imperative that the maximum dimensions in both the horizontal and vertical axes fall within the paper. Once a scale has been arrived at, it is then a case of choosing a part of the object being drawn that is of sufficient size to use as the key to the drawing. By measuring the real distance and seeing how many multiples of this there are in the whole subject, it is simply a matter of repeating this in the drawing. What is important about this system though is that the one measurement becomes the key for the whole. Once other elements are used then inaccuracies are introduced.

Another thing that is often employed is the multiplication of sight-size measurements into a convenient scale. However, the problem with this is made clear when one realizes that not only are you multiplying the measurement, you are also multiplying the errors too.

Once these measuring skills are perfected the reins of measurement can be loosened, but it is still a useful tool when one struggles with seeing clearly. As Sickert said, 'Any fool can paint, but drawing is the thing and drawing is the test.'

Relational and proportional measurement

Materials:
- Pencil
- Rubber
- Measuring callipers (made from plant labels and a paper fastener)
- Bamboo skewer

Make your own relational measured drawing. Use your measuring stick and move it backwards and forwards until it is as big as the figure. Mark a top and bottom measurement on your paper, attempting to fill the sheet.

As the stick has marks on it, telling you where the thirds and quarters are, it will begin to indicate how big the head is. Now divide your drawing to work out the scale of your head. Now construct your drawing based on these head measurements.

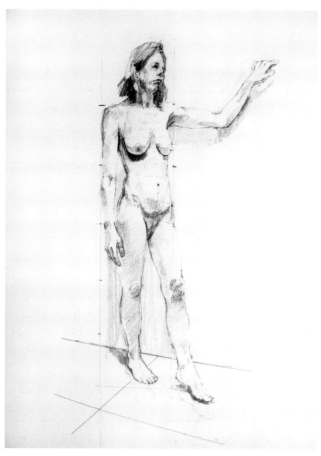

Measured drawing based on head measurements ruled off a plumbline.

Negative space

Negative space is simply the shape surrounding objects, in other words the shape of the background. Negative space helps you see objectively and is of vital importance when you consider issues like composition, because successful composition is not just what you draw, but what you leave out. Your eye is much better at perceiving the difference between two triangles – the height, angle, proportion, etc., but it is much more difficult for a person to draw an arm without drawing what they *think* it looks like. So by focusing wholly on the myriad number of shapes behind the figure, you are forced to see in a way that allows you to be more objective. It will improve your perception and stop you making assumptions about what you are seeing. You end up drawing the figure accidentally as a consequence of not thinking about it at all. As the drawing begins with a complex section and you build outward, you can begin to take measurements. Looking at a shape in space you have drawn, consider what else is at the same height. This can be done by holding your measuring tool at a horizontal and seeing what lines up with that. The same can be done with verticals too. Gradually the pieces fit into place and the drawing comes together.

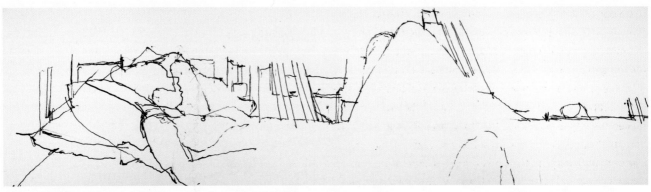

Another example of a negative space drawing made from the build up of small gaps and intervals.

LESSON 12
Negative space

Materials:
- Fine line pen
- Tippex
- Measuring callipers (made from plant labels and a paper fastener)

It is sometimes useful to create a nest of tables with a mattress and surround it with a complicated set up of easels and upturned furniture. Spend a great deal of time drawing this space, looking about 50cm above the table, looking at all the intersections to find the rectangles, triangles and trapeziums you can see. Draw everything (as long as you can see it). Use the measuring callipers and pay particular attention to the really complicated areas of the drawing, where the most objects overlap. Only when these spaces are connected then get the model to lie down in the space. You can consider the idea of a layered negative space. The furthest object that you see creates a negative space with the objects in front of it. When you concentrate on these shapes, you are in fact drawing the object in front, but your attention is offset away from them. These objects will themselves be a negative space for something else. Like a jigsaw puzzle, you piece together each shape until you reach your destination. Never draw an object in isolation. A lone table leg looks easy to draw, the big expanse of table turned on its side the same, but it is at these very points that you can make those assumptions again. You have to get yourself into a very quiet and controlled head-space where you become obsessed by everything. It is important not to rush: better to have a 1-inch square that is right than a whole drawing that is badly seen. You could spend four hours drawing the space before the life model takes up position. What you can do is see how much of the figure occupies this space and erase those parts of the drawing that are now no longer visible. You can use tippex and ink for this exercise and you end up with crusty drawings, which retain the history of their making.

This is the kind of drawing that usually takes at least eight hours to make, with lots of distress and grief along the way. However, the *Gestalt* moment comes when the figure just fits in. You ideally need a few days at it where you can leave the set-up overnight. You can also extend this by placing tracing paper over the drawing and get the model to move around the set-up. Once the right network is in place, it is easy to locate the new position of the figure.

Once you have placed the model, the space of the drawing will have become much more dense and confused, so you can lay masking tape over the lines of the background. Although this may seem odd, as you are actually building up the physical surface of the drawing, the masking tape causes the line to look fainter which makes it recede. With a careful decision about the edges of the space that you include or push back you can make a beautiful drawing. You may find that you have a small drawing on a large piece of paper. Don't be alarmed and do not cut it down; when the drawing is finished it will have an incredible presence that holds the empty space.

If you look at drawings by Euan Uglow, you will sometimes see that he has placed his model in front of something with a regular grid, a map or a radiator. In this instance, Uglow could draw the map to find out the space of the model. If you are drawing the model without this complicated arrangement, you could return to your cardboard viewfinder and look through that onto your subject. As before, you need to ensure

that your head stays as still as it can throughout the whole drawing. It is useful to remember to align something from the middle ground with something in the background. Only by doing this will you ensure that you are always sighting from the same point. It is worth noting that Uglow identified the exact position of his eye, with the intersection of two pieces of string, a plumb line (giving him an absolute vertical) hanging from the ceiling of his studio and a horizontal, strung between two uprights. Depending how elaborate you want to make it you could attach a plumb line to your drawing board or hang it from the ceiling and mark a point on it to identify your eye position.

Nicholas Beer describes a different approach to sight-size drawing, which relates much more closely to the nineteenth-century method of sight size. In this instance, the sitter and the easel are next to each other and the artist stands back from both at a distance of about 3–4 metres (you need enough space for this). The sitter and the support are equidistant from the artist so any image drawn on the support must be made the same size as the sitter.

The artist looks at both from a distance and then walks forward to make a mark on the support. The artist then moves away to check that the mark is in the right place (vertical heights would be the best starting point) and this backwards-and-forwards process continues until enough marks are made to describe the figure.

This technique uses a plumb line also to check the central axis of the figure. Angles are compared with the vertical and horizontals are established by holding a piece of string in front of the motif. A similar thing could be done with your clear plastic ruler. Someone writing about Singer Sargent stated, 'To watch the head develop from the start was like the sudden lifting of a blind in a dark room. Every stage was a revelation. For one thing he often moved his easel next to the sitter so that when he walked back from it he saw the canvas and the original in the same light, at the same distance, at the same angle of vision.'

Here the space behind the figure was drawn, connecting together all the small shapes to then discover the figure. Other body parts could then be located by establishing their proximity to the background. In the same way, Uglow would place his model in front of a radiator to see her against a series of verticals. Depths can be calculated by comparing to the horizontals that have already been drawn.

Interestingly with this method, like measuring your reflection in a mirror, when you walk away from the sitter, you are also walking away from the drawing. The further you are from the sitter, the visually smaller your sitter seems, but the size of your drawing has shrunk by the same amount too. So the distance away can vary, but the measurements will always be relatively accurate as long as you keep your height the same (i.e. standing up). It is for this reason that it was common practice to elevate the sitter by placing them on a stand so that their eye level was more or less at a similar height to your own, otherwise you would be looking down at the sitter. It is useful with this approach to drawing to work from the general to the specific; work broadly and find the main dimensions before honing the forms.

Cone of vision

Whatever you look at, your vision can be thought of as being a cone of perception. You see a certain amount of information in focus and at the edges of this cone your vision becomes blurred. When you stand in front of the figure, hold your arm out in front of you with a pencil or pen in your hand. Hold this horizontally and proffer it up to the subject. Looking straight ahead hold your pen until the outer edge of it touches the blurry peripheral and see how many pens fit into the distance that will take you to the other side. An average pen will probably fit into this width five times. This distance will be the same top to bottom and side to side and forms the cone of vision.

If you are drawing in a small sketchbook, look at the shorter side of the book and divide it into four. This quarter distance represents the scaled version of your pen, so when you measure part of the motif by seeing how far that part of the distance comes up the pen, you can calculate how big this distance should be in your drawing. You could use your bamboo measuring tool as this already has some scaled measurements on it which will help calculate the scale of these smaller distances.

It may also be useful to use a scaling tool; if you have made a set of measuring callipers, you can think about the relationship between the pivot point and the two separate ends. If the distance between the pivot point to the short ends is one unit and to the other is three units, then any measurement that you capture with the long end is reduced at the other end to a third of that distance. Change the position of the pivot point and change the reduction ratio. Of course you can buy off-the-shelf scaling tools where the pivot point can be moved to allow for reduction or enlargement.

Once you have your scale, it is also easy to see how this measurement can be divided into quarters and thirds too. Map out the big proportions, lightly. You can place the big shapes in the drawing. By applying what you have learnt from negative space to really understand the relationship of the parts to the whole, you can find the actual shapes occupied by the figure.

You might also now consider the weight of a line. From the negative space drawing you have seen that fainter lines can recede, so what about doing that with your line anyway? When you are making your linear drawing, change the weight that you use on the line, which will cause forms to come forward or recede. Consider how these forms relate to each other.

Cone of vision and scaling

Materials:

- Small sketchbook
- Pencil
- Pen

Make a series of drawings in your sketchbook, and on A1 paper. Try to ensure that the whole figure fits as well as the surrounding space. Take care not to chop off hands and feet!

Alex Kanevsky, *L.D.V.5*. The artist is making a series of life drawings, each one on top of the last. As the model shifts and changes direction, so too these movements are recorded.

Measured drawing of the figure in preparation for a painting.

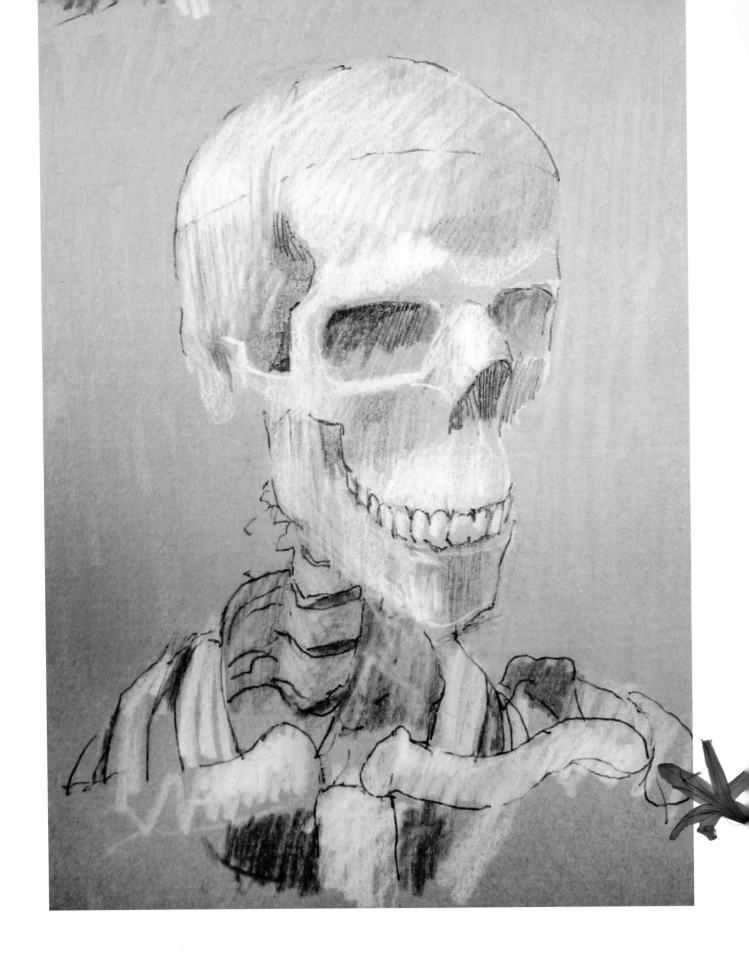

Basic anatomy

The skeleton

he human body is a complex machine (*Gray's Anatomy* demonstrates the breadth and the complexity of it). Peel away the surface of the skin and there is subcutaneous fat, muscle, bone, veins, arteries and vital organs. All of these have a vital role in making us human: breathing, moving, eating, sleeping and being. For the most part we need to decide whether we want to know about the contents of our bodies. You will be able to make perfectly satisfactory drawings and paintings without that knowledge. A working knowledge of some anatomical information will help you understand what the lumps and bumps mean, but there also has to be a point where anatomical knowledge does not take over and you end up drawing what you know, rather than what you see. When you look at *atelier* drawing from the turn of the century the male models had heavily defined musculature, which resembled the Greek statues that the students had been working from in the previous year. The female models also had bodies that resembled Greek goddesses. They were basically archetypes, idealized versions of the nude. Attend any life drawing class today and the body you will be confronted with might be far from this notion of the idealized nude. The human body is so interesting to draw because of the very fact that no one is the same. Toes can vary considerably; the shape of an arm, chest and stomach can alter from individual to individual; even the same model can subtly alter their whole body simply by shifting weight from one foot to the other. Each new drawing experience must focus on the truth in front of your eyes, but as that truth does have an underlying structure then it is worthwhile to pay heed to it.

Anatomy is not simply a list of names. It is more important to consider the body as a series of different masses. Understanding these masses and how they relate to each other will help you see what you are looking at in the live model. For example, look at the angle of the head and how this affects the features: the way in which the box-like form of the head relates to the egg-like form of the chest describes the essence of a pose. The box-like form of the pelvis and how the thighs emerge out of this space tells you a great deal about the lower portion of the body. George Bridgman wrote the definitive text, *Constructive Anatomy*, which reduces the figure into a series of cubic forms. Even *How to Draw Comics the Marvel Way*, by Stan Lee and John Buscema, offers valuable insight into creating an invented figure in space. The focus in this chapter, however, is concerned with looking and deciphering what you see.

The skull

The *frontal* bone is the part of the skull that forms the forehead and the eyebrow ridges. Either side of that are the *parietal* bones, which form the left and the right sides of the skull, and the *occipital* bone forms the lower back portion of the head. The *temporal* bones are just above the ears and form the flat sides of the skull; attached to the front temporal bone is the *zygomatic* arch, which forms the cheek bone and one half of the lower eye socket. The *maxillae* form the upper jaw and the remaining half of the eye socket. At its apex is the *nasal* bone, just at the top of the nose and underneath the forehead. Finally, the *mandible* is the only moving part of the skull, which moves to chew food. The skull is connected to the spine at the *atlas*. Male skulls tend to have flatter frontal

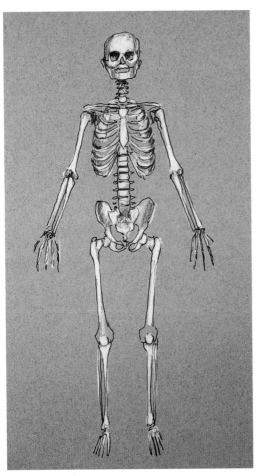

Skeleton 1: The skeleton seen from the front (anterior).

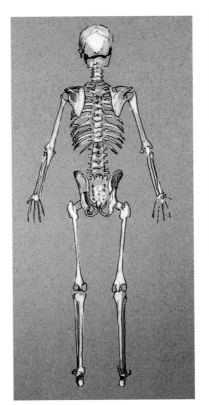

Skeleton 2: The skeleton seen from behind (posterior).

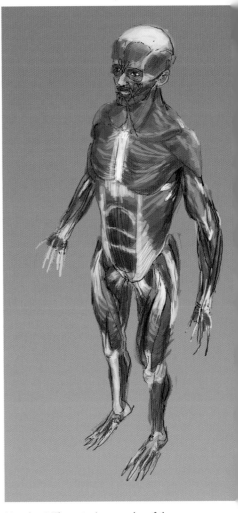

Muscles 1: The anterior muscles of the body.

bones that are somewhat more angular and pronounced around the eye sockets. In drawing a head it is much better to look at the underlying skull and see how these forms are in evidence. Looking for these forms on the live model and trying to describe them will go a long way towards producing a convincing head, rather than drawing the features.

The spine

Each individual vertebra has a small amount of movement and combines with the other twenty-three to allow the flexibility of movement the body can perform. The spine is not one continuous cylinder but a series of curves, which enable the forces of gravity to be distributed more evenly through the body. At the top are the seven cervical vertebrae, which curve inwards from the skull. These smaller bones allow the head its movement. The seventh vertebra has the longest

of the spinous processes, and can be felt at the back of your neck as a bony protuberance. The next twelve are called the thoracic or dorsal vertebrae. These are connected to the rib cage and allow for a certain degree of rotation within the torso, but their connection with the thorax or rib cage prevents much flexion. These curve concavely outward until they reach the lumbar area. Finally the lumbar vertebrae are the largest of the vertebrae and provide the largest amount of flexion and rotation, extension and some side bending for the body. These curve convexly, forming the deepest curve, which can vary according to race, gender and changes during pregnancy. The nature of these curves and their position on the body tells us a great deal about the figure. The spine is clearly seen from the rear as it moves through the neck right down to the tail bone. From the front, you look for the angle of the thorax, which is parallel with the angle of the spine, to help you understand the pose.

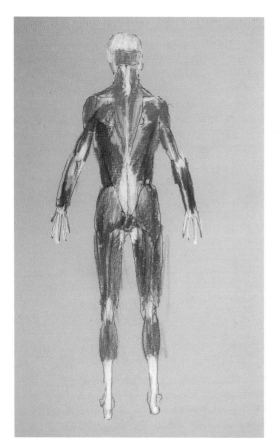

Muscles 2: The posterior muscles of the body.

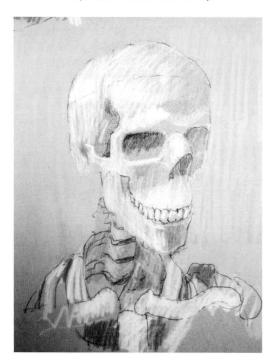

The human skull is made up of twenty-one individual bones, which work as a single joined unit.

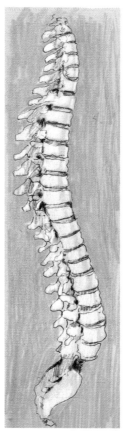

The vertebral (spinal) column is made up of twenty-four separate bones called vertebrae. There are a further five vertebrae which are fused together to form the sacrum and a further three to five fused bones called the coccyx, which is the residual tailbone. The vertebrae are separated from each other by an intervertebral disc, which is cartilage material that acts as a shock absorber.

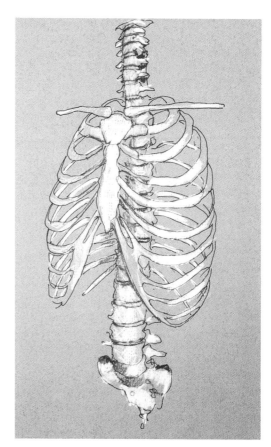

Connected to the thoracic vertebrae are the ribs, twelve in all down the left side and the other twelve down the right. These ribs form the cage, which protects the majority of the vital organs of the body. The first seven are known as 'true ribs' in that they are directly connected to the sternum or chest bone through the costal cartilage. The following five false ribs are next and three of these share a common connection to the sternum through cartilage. Finally there are two or three (it can vary) floating ribs.

The torso

At the front of the thorax is the sternum, which is in fact three fused bones, the manubrium, the body and the xiphoid process, which is the small bony prominence which can be felt at the opening of the thorax where the stomach starts to protrude. The cage-like structure of the thorax is somewhat egg-like in form. It gently tips backwards and varies a great deal according to gender and build, being somewhat short and wide in stocky builds and longer and thinner in more slender frames. The angle of the ribs is not parallel to the ground but slopes downwards

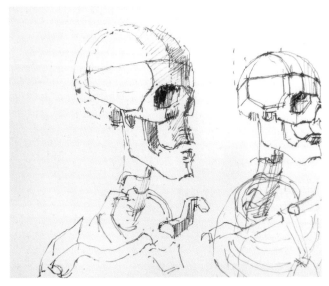

The clavicle. The manubrium is connected to the two clavicles or collarbones, which is also connected to the scapula (shoulder blade), a free floating bone which forms the ball and socket joint for the humerus. It is this freedom that allows the upper arm so much movement.

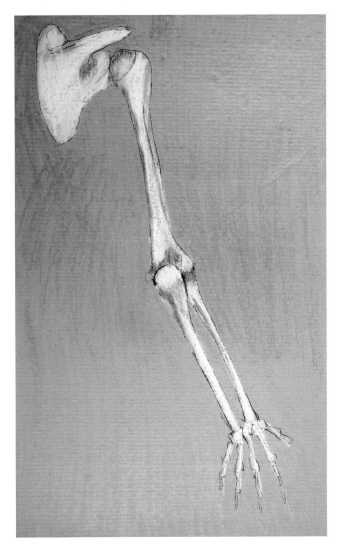

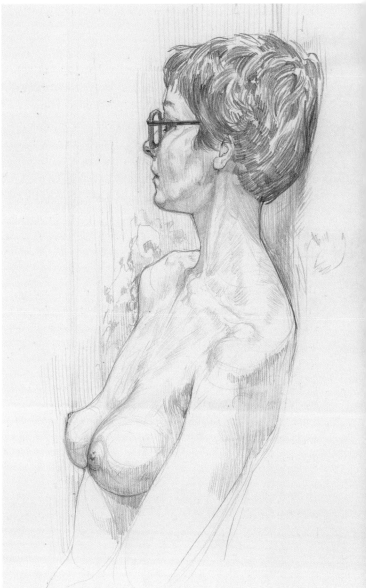

In this beautiful drawing by Jake Spicer you can clearly see the way in which Jake has carefully articulated the bones of the shoulder girdle and through the subtle manipulation of tone and contour hatching has described the various planes of the clavicles, shoulder blade and sternum.

Connected to the humerus are the two bones of the forearm, the radius (thumb side) and the ulna. In the pronation (palm up) position these two bones are parallel but in the supination position these are crossed. At the base of these bones are the seven carpal bones of the wrist and then the five metacarpal bones of the hand. The phalanges are the bones of the fingers.

from the back toward the front opening. This angle is called the infrasternal angle.

The ilium has at its apex the iliac crest, which is easily identified on the live nude. The pubis forms the front of the pelvis and is connected to the ischia, the inverted arches at the base of the pelvis. The ilium and the ischium form the ball and socket joint that the femur sits in. The anterior superior iliac spine forms the top of the pelvis bone found at the top of your hips. Their proximity to the outer flesh make them clearly visible features to draw and help determine the angle of the pelvis in relationship to the torso (thorax). The posterior iliac crest forms the top two dimples at the base of the spine forming a triangle with the sacrum.

The femur is the longest bone of the body and often is the key bone that defines height. You will find that torso heights are pretty similar and when sitting most people are the same height, but it is the femur that can vary considerably. When standing with legs placed evenly apart, the hips will be parallel to the ground. With the weight of the body on one leg, the leg under tension will cause the hip to rise, so the angle between the iliac crests changes. To counteract this, the angle of the shoulder usually falls in the opposite direction to balance the figure.

The proportions of the pelvis vary according to the sexes, with the female pelvis being wider and somewhat more tilted backwards than the male counterpart.

Anatomical planes

Most books on anatomy will use some key phrases that refer to the plane of the figure the body part relates to. 'Anterior' means front and 'posterior' means rear. 'Superior' means upper and 'inferior' means lower. 'Medial' means towards the middle and 'lateral' means towards the outer edge. Imagine a soft pencil line running through the centre of the body, through the forehead, down the throat, past the manubrium (the top of the sternum in between clavicles), down through the sternum and past the xiphoid process, down through the middle of the *rectus abdominis* (stomach muscles) and ending at the middle of the groin. On the opposite, posterior side, the line would travel down through the neck, between the trapezia, down through the middle of the *latissimus dorsi* (the big triangular muscles which go around the figure upward into the under arm), in between the *erector spinae*

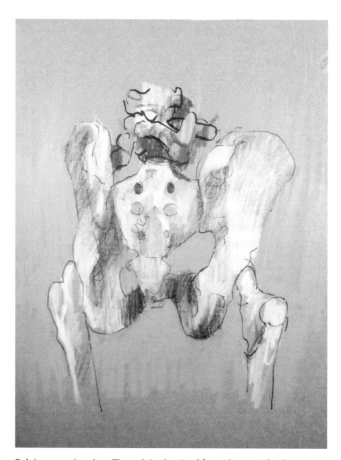

Pelvis, posterior view. The pelvis, derived from the Latin for 'basin', is actually seven separate bones which in babies are held together by ligaments but gradually become fused together in adulthood.

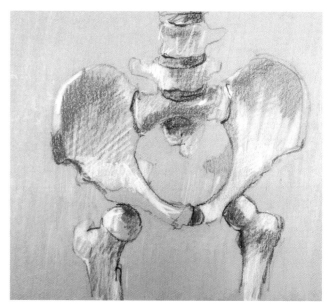

Pelvis, anterior view. There are the sacrum and the two hip bones called the innominate bones; each of these is made up of three bones.

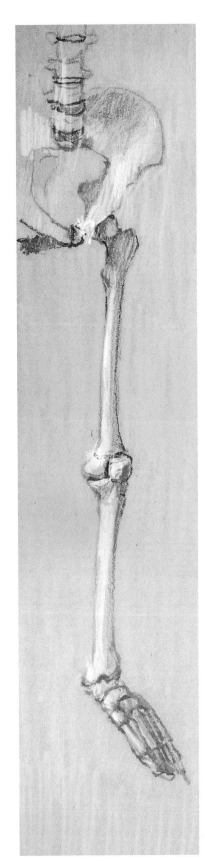

Bones of the leg.

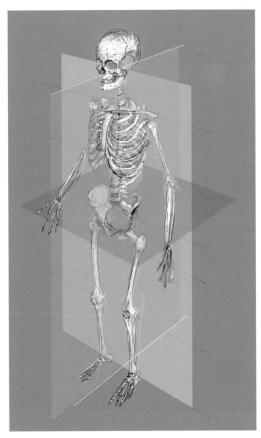

If we imagine a body split through the middle then we can think about three planes: x, y and z. A plane that bisects the figure so that the front and back are the two opposite sides is said to be bisected along the sagittal plane. If the same figure was bisected so that there was a division between the left and right halves of the figure then it is bisected along the coronal plane.

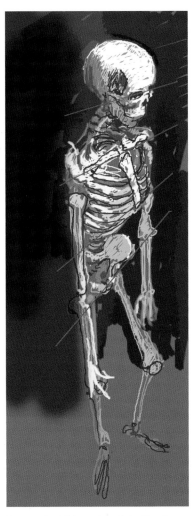

Perspective. This notion of dualism is really useful when we think about the figure in relationship to space. You can think about the figure conforming to rules of perspective, with those parts of the body that are based centrally about a central axis conforming to two-point perspective.

(the two rope-like muscles either side of the spine) and toward the sacrum. This would be the imaginary point where the coronal plane touched the surface of the skin on the front plane. Any measuring point is considered in relationship to this medial line.

Consider too the symmetry of the figure and if you feel your own body consider the points of the skeleton nearest the surface of the flesh. The sternum forms the central line between the breast and the pectorals. A common mistake is not to notice the difference in measurement either side of this medial line. Generally from our understanding of the figure we draw a figure straight on. If a figure is seen in three-quarters view it is very common for these differences to be rectified (the central line returning to the centre) so any measurements from one side of the medial line should be compared with the other. The clavicles reach from the sternum to the outermost edge of the scapula (shoulder blade) forming a raised bump. The top of the ulna is the elbow

and the top of the humerus is the raised bump (condyle) on the inside of the elbow (the lateral side). The radius is at the thumb side of the wrist and the ulna on the small finger side, and the ulna can be felt quite clearly near the surface of the flesh when you run your finger down your forearm.

The great anterior and posterior iliac crest can be seen close to the flesh, as can the great trochanter and the bony mass of the femur at the knee. The front of the tibia forms the shin that runs down the front of the leg and clearly the thinness of the flesh around the foot means that the majority of its architecture can be clearly seen.

In terms of perspective you can think about the idea that all parallel lines appear to converge to a single point in space. If you are looking straight onto the figure you see points of the skeleton will be parallel to each other: shoulders will be parallel to elbows which will be parallel to knees, elbows, ankles, etc. All parallel lines appear to converge to a common point so if you are standing looking at the three-quarters view of the figure then you can think about lines of sight parallel to the planes of the figure running towards your eye level. These double points on the figure converge toward the same point on the horizon.

Imagine sticking your arms out a bit like a policeman giving traffic signals. Consider your arms running parallel to the main coronal plane (front) and sagittal planes (side) of the figure. Raise your fingers to the point where they reach your eye level and this will locate the vanishing point. So anything above your eye level will converge down and anything below your eye level will converge up.

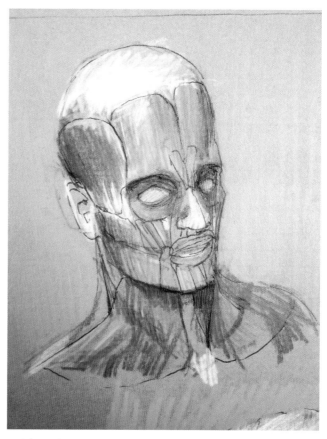

Facial muscles. There are a number of shallow muscles attached to the skull, which control various aspects of the features: the left and right *frontalis* raises and lowers the eyebrows; the *orbicularis oculi* controls the opening and closing of the eyelids. On either side of the skull are the large, plate-like *temporalis* muscles – these are partly responsible for operating the mandible (jaw bone), which is not attached to the skull but hangs from it. At the edge of the *temporalis* and *orbicularis oculi* is the prominent zygomatic bone, which is the cheek bone. Below the cheek is the masseter muscle, which also controls the jaw. The *orbicularis oris* is the circle of muscle surrounding the lips.

Muscles

A muscle is something which contracts or relaxes. A muscle will shorten, pulling the bones in the section below it towards itself (e.g. bending the arm). Usually on the opposite side of the limb will be another muscle, which will have the opposite job, contracting to straighten the body part that has been bent. Virtually all muscles will have their counterpart and will contract and thicken due to this opposing action. As we have identified already, the skeleton, which is near to the surface of the skin in places, affects the surface form, and the muscles (as well as subcutaneous fat) have a much greater influence on the surface form.

The sternocleidomastoid muscle is the rope-like neck muscle which connects from behind the ear and into the sternum. The muscles of the neck allow the head to rotate by approx. 180°, and to move side to side and up and down. So the muscles at the front of the head will pull the skull towards them (the head tilts forwards), and the muscles at the back towards them (head tilts backwards). This is covered by the platysma muscle which attaches itself over the clavicles.

At the back of the upper arm is the three-headed tricep muscle, primarily responsible for the extension of the forearm. On the forearm itself is a group of thin rope-like muscles, the extensors and flexors, which actually control the phalanges of finger bones. From the little finger side of the arm the

The deltoid is the triangular muscle at the top of the arm and the *pectoralis* is the chest muscle, causing the upper arm to move. Whilst the form of the deltoid is rounded when the arm is down, the head of the deltoid changes when the arm is elevated. The uppermost spine of the scapula becomes a depression in between two tubular forms, which then joins the base of the deltoid.

The bicep is a two-headed muscle that is connected to the shoulder blade and into the elbow and is mainly responsible for flexing the forearm as well as rotating the forearm into the supination position (palm up).

The stomach wall is made up of the *rectus abdominis* (the six pack) and causes the body to bend forward. Connected to either side of this is the external oblique, which causes the body to rotate. The *serratus anterior* group of muscles are actually connected to the shoulder blade and can be seen in muscled models as a series of saw-shaped muscles.

ulna can be seen on the surface of the forearm, which creates a depression between muscles and ends up becoming two rounded forms either side of it when the arm is brought right up to the shoulder. The radius can be seen at the edge of the first part of the forearm but disappears into the wider bulk of the forearm at the elbow. The fact that these bones are parallel in supination but twisted over each other in pronation means that the form of the arm changes in these two positions.

With the leg straight the back of the thigh is under tension and the front of the thigh relaxed. The contour of the thigh is like a large oval with the medial and lateral sides being longer. With the leg bent the front of the thigh becomes tense and the back of the thigh relaxes and the form of the thigh becomes more triangular towards the top. In this position it is possible to see the main direction of the femur running diagonally across the leg from the knee toward the outer hip (great trochanter) and the extensor muscles hanging softly behind this main form. On the lateral side of the tibia are the long thin muscles of the feet – the *tibialis anterior*, the *extensor digitorum longus*, and the *fibularis longus*. On the medial side is the *flexor digitorum longus*.

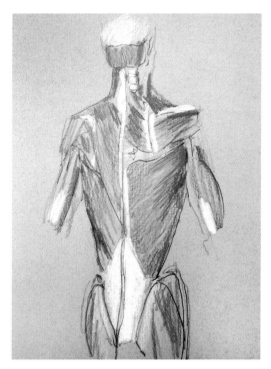

Emerging from the sacrum and running up the whole of the back and into the occipital bone of the skull are the two rope-like *erector spinae* muscles of the back. Their bulk means that the spine becomes a depression in between these two forms. In this illustration, the right trapezium has been removed the show the muscles of the shoulder blade.

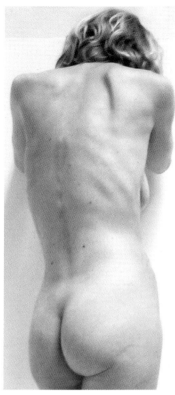

Across the front plane of the scapula are two muscles which are also seen on the live model, the *teres major* and the *infraspinatus*. These become more prominent when the arm is elevated. In this elevated position the *latissimus dorsi* becomes more visible, forming a hollowed out space around the armpit. The *latissimus dorsi* wraps around the thorax and tucks up into the armpit itself.

At the base of the spine and wrapped around the majority of the anterior side of the pelvis are the *gluteus maximus* and *gluteus medius* muscles (or 'glutes') which connect the hips to the upper leg, and are responsible for keeping us upright.

At the hips the long leg muscles are attached – the *tensor fasciae*, which is responsible in part for flexion, and the four quadriceps: *rectus femoris*, *vastus lateralis*, *vastus medialis*, and *vastus intermedius*, all of which are attached to the patella and are responsible for the knee extension and the hip flexion. The *adductor longus* and *pectineus* are the muscles that draw the thigh back to the body (adduct). The *iliacus* causes rotation within the thigh. The *sartorius* is the longest muscle in the body and runs diagonally across the thigh from the iliac crest to the inside of the knee and forms a recognizable contour edge in the upper leg.

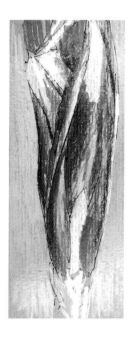

Toward the back of the leg is the *soleus*, which runs from the back part of the knee to the heel, and the two-headed *gastrocnemius* which runs from the bend of the knee and into the heel as well. The double bulge at the back of the leg is a clearly seen form on the body.

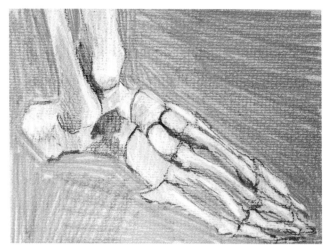

The bones of the foot create a gentle arch, and are covered by a series of tendons, which can be clearly seen at the top of the foot. The arch takes the main weight of the body and distributes it evenly throughout its length. The heel bone is a bony protuberance and is connected to the leg through the Achilles tendon, which joins the two *gastrocnemius* muscles at the back of the knee.

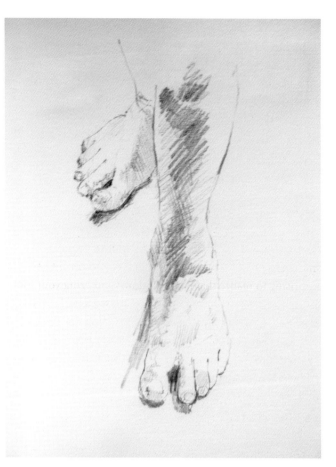

Feet: look very carefully at the negative space between them and the subtle change of size.

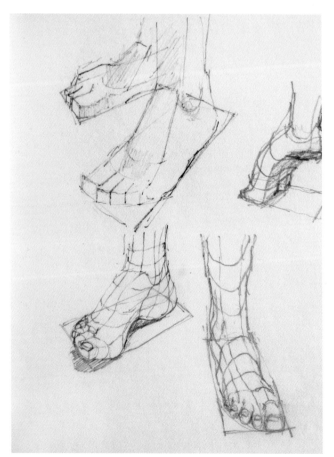

When you draw feet together pay particular attention to their relationship to the floor plane as well as their structure, thinking from the floor up, considering the floor plan of the foot and how the structure rises into space, almost as if you were drawing a building using architectural drawing.

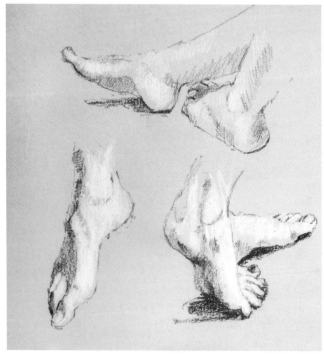

A series of studies of feet on coloured paper, describing the form and the changing planes of this beautiful structure. Don't forget that they are often perceived as too small.

Extremities

Many students find that feet, hands and head present the most challenging features of the body. This explains why many life drawings simply leave them out and when they are included they are often badly drawn.

The foot

The foot is a misunderstood form. You see your own foot as the most distant part of your body; from the vantage point of your eye a sight-size measurement of your foot would amount to just a few centimetres. So it can be somewhat surprising to realize that if you sit down and bring your foot up and place it next to your arm, it is as long as your forearm. Your foot is big and most people's feet are, so underestimating their size is common. From childhood schema we draw a kind of L-shaped leg and foot, but if you were to look at a dancer's foot or a footballer kicking a ball, the foot can almost be in line with the leg. So the angle of the foot can often be incorrectly seen.

When drawing the foot it is important to think back to basic shape. What is the horizontal length and how does that compare with the leg? What is the vertical height of the foot from the ankle to the lowest part? What angle is formed where the lateral edge of the foot comes into contact with the ground? On the medial side, what shape does the arch of the foot make with the space of the ground beneath it? If the foot is not in a standing position then it is important to cross reference it with the rest of the body, taking verticals and horizontals across, below and above to ascertain its size. Pay particular attention to the layered negative space of the toes and consider the scale of these shapes.

The hand

Consider a hand resting just above a form, a rigid flat hand, a fist, fingers curled around the side of a face and the implication of each. The Renaissance painters knew about the subtle language of the hand. Consider the hand gesture of the husband in the *Arnolfini Portrait* by Van Eyck or the complexity of the hand gestures in *The Supper at Emmaus* by Caravaggio.

Once you understand how to look at the hand, they can convey so much to your drawing but sometimes they can often end up looking like a bunch of bananas. Each finger is capable of individual movement and enables us to grip. The thumb has only two joints. The knuckle of the thumb is in a much lower position, about half-way up the hand and its flexibility and opposition enables us so much dexterity. Care should be taken when looking at the hand to note these planes and how they relate to each other. Focus on the overall shape of the hand and note the relationship between each finger and the spaces between them.

Like the foot, if you place your hand against your forearm with the heel of your palm into the crook of your arm, it reaches about two thirds of the arm's length. Open up your span and place that next to your arm and it is almost the same length. So a hand is big and can often be drawn far too small.

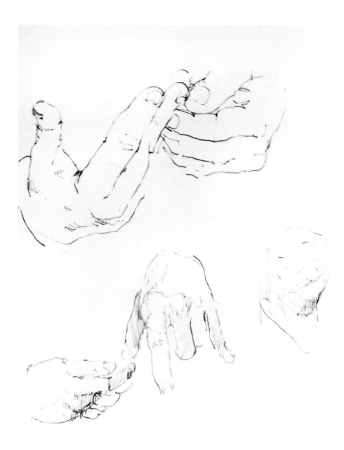

Hands can be beautiful things to draw and can express complex things, not just through sign language; their grace and power can create narrative potential.

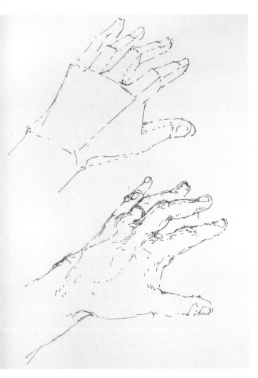

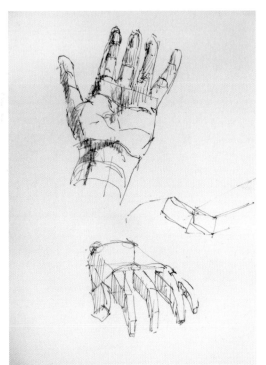

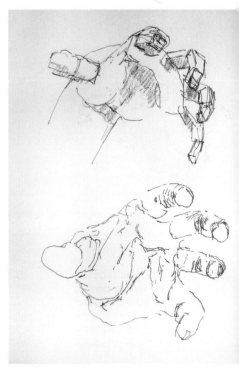

Feel your own hand and consider the way in which the back of the hand is connected to the wrist. Whatever the orientation of the arm, the flat trapezium shape is narrowest at the wrist and slightly widens at the knuckles. The hand can flex, so its plane can be ascending or descending in relation to the arm. Adjacent to this plane is a triangular-shaped plane, which extends from the radius to both the thumb and forefinger. This plane is much more flexible and flattens outward when the thumb is stretched out and compresses into a softer mound when the thumb is brought inwards.

On the palm side the movement of the thumb and little finger creates much more variation of form, from a cup-like space to a flat surface. From the top plane emerges the fingers and each can be considered to be rectangular in cross section, articulating at three knuckle joints.

Sometimes its is useful to understand the underlying structure of the hand and how this conforms to foreshortening before looking at the creases and the folds.

Features

Features cause some of the most pronounced problems in drawing. We spend so much time looking at features, it is often the case that these are exaggerated in their scale and it is the most likely place where we will revert back to drawing schema.

If you look at children's drawings of heads, the eyes are usually placed three quarters of the way up the head. In fact if you measure with your thumb and forefinger the distance between your chin and your nasal bone just under the brow and compare that to the space between your nasal bone and the top of your head it is the same. So your eyebrows are approximately half way up your head. If you measure the

space between your chin and the base of your nose it is about the same as your nose height.

Like the body, the relationship of the central line to the outer extremities is all-important. What is the measurement from the nasal bone to the outer edge of the temple and how does that compare with the other side? What is the angle of that central plane and how does foreshortening affect the relative dimensions of the head?

More so than before, measurement is vitally important in understanding these relationships as well as considering how the parallels will converge. It is much more important to focus on drawing the skull and its big forms, working out how much space the features take up, rather than getting lost in drawing an eye.

Head studies. Every day there are new models, new expressions and new viewpoints on the train that are endlessly fascinating to draw.

The head sits on top of the spine and the neck is also misunderstood. From childhood our notion of the neck is something like a cylinder protruding from the body. If you feel your own neck it is somewhat tubular in its construction at the front. The neck emerges out of the top of the thorax and the clavicles and manubrium form the base of the neck.

The sternocleidomastoid muscles run from the centre of the neck to the space under each ear, behind the mandible. The back of the neck is formed from the two erector spinae running up the back and inserting into the skull.

Attached to the skull as well is the seventh cervical vertebra and joining the scapulae is the kite-shaped trapezium. From the anterior side this is the triangular form behind the clavicle. If you place one finger on the seventh vertebra and one at the manubrium they are at two different heights. So the back of the neck is much shorter than the front of it.

Head proportions. The nose occupies about one quarter of the height of the head. If you measure your nose height and run that measurement around to the side of your head you will see that your ear is about the same size and at the same height. The inner edge of your ear is in line with the edge of your jaw and parallel to the front plane of your head.

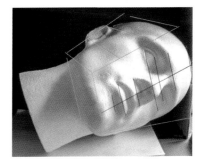

A line drawn through one eye and continued will go through the other eye too. This line is parallel with the eyebrow, the base of the nose, the mouth and chin, and it is at right angles to the central line running down the head. Bear this in mind as everything changes when the head tilts, bends or twists in space and so will therefore converge to a common vanishing point.

Form and structure

The human form is made up of curved planes and facets and these provide the key to describing it. If one wants to create a realistic nude then a good understanding of these structures is essential. Feel yourself, to get a sense of the cross section of your body.

In the supination (palm pointing upwards) position, the radius and the ulna are parallel, which means the contour of the forearm is more rectangular in cross section. In the pronation position (palm down) the radius radiates over the ulna forming a criss-cross of bones. This affects the contour making the part of the forearm nearest the elbow more triangular in cross section.

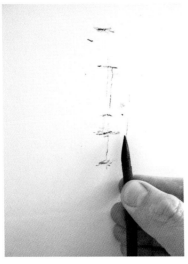

Drawing of Phoebe, stage 1. Begin the drawing by measuring the angle of the central line of the head. Imagine a line struck between the middle of the forehead, through the nose to the middle of the chin. Measure and mark off the key points: top of head, hairline, brow, base of nose, mouth and jaw.

Stage 2. Try to establish the height and width of head in relation to these. Use comparative measurement as these distances are often underseen.

Stage 3. Begin to lightly block in the main tonal shifts, working with the stump to create subtle tonal areas.

Stage 4. Be a bit bolder with the tone. Young faces are always challenging due to their subtlety.

Stage 5. More work has been done on the junctions between light and dark, noting the areas of greater contrast.

Stage 6. Further work has been added finding the trapezium and deltoids under the clothing, noting the angle between them. A brush has been used to manipulate the delicate tones across the clavicles.

Move up and feel the change in the oval forms of the bicep and the triceps at the back of the arm when the arm is straight or bent. Feel the rounded nature of it at the top of the arm and how the top edge of the shoulder blade joins it. Feel how the deltoid joins into the arm in an almost triangular way inserting itself on either side of these muscles. Do this to build up a mental note of the main forms you possess. Elevate your arm and feel the deltoid change in tension and form. When you draw the nude, try to think of these forms in your head and look at the figure from a number of different angles and directions so that you can see the form more clearly. When you return to draw it from your fixed position you will then have a much greater sense of what you are looking at and why the light is behaving in the way it is.

It is sometimes useful when you are making a life drawing to assume the pose yourself. That way you can use your eyes and your tactile experience to help you understand what forms are under tension, where the weight is being borne and which limbs are relaxed. Julian Vilarrubi talks about his time at the RA schools in the life room:

> One day a week we had an artist called Norman Blamey. With him we had longer set poses. He was very thorough. We would spend the whole day drawing from a single pose. In particular he would get us to look at structure and the transition of information from one part of the body to the next. The aim was to create a convincing transition. The question he wanted us to answer visually was, 'How does this form connect to this form and how do they describe this area of the figure convincingly?' Often he would sit with us individually and painstakingly draw exactly what he meant. I think this has enabled me to see well and be convincing in my drawings, whatever type or approach they are. It helps me think spatially into the space of the flat surface rather than across the flat surface hopefully making my drawings more convincing as forms, whether made of lines or tones.

Drawing of Phoebe: final stage. The drawing is brought to a conclusion, as the sitter was getting fidgety. Some models develop uncontrollable itches.

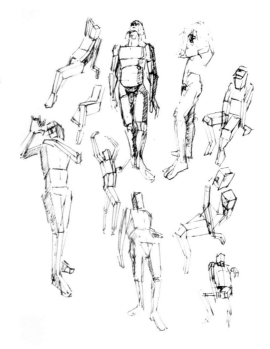

The figure can be simplified down to a series of box-like forms. How these articulate with each other can reveal a great deal about the form in space.

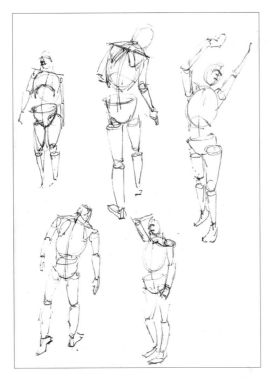

These drawings consider the figure in terms of tubular and ovoid forms. Attention has been given to the angle of these planes, identified through the prominence of the skeleton nearest the surface of the skin.

Touch drawings. These drawings were made partly from touching one's own body and partly from memory. With your eyes shut you are feeling your way across the form, trying to understand the flow of the body's landscape.

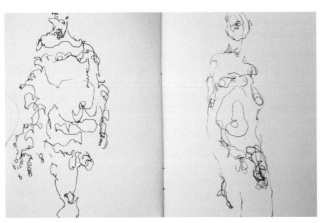

Touch drawing

Materials:

- Charcoal
- Pastel
- Soft pencil
- Graphite stick

Shut your eyes and pass your hand over your body. As you feel try to make a mark on the paper that communicates that information. Think about the weight of mark you make, the heavy hard surfaces, the soft forms. Make a series of journeys across yourself and try to make landscapes. The purpose of these drawings is to educate the mind to become more sensitive to the forms you are trying to communicate in your drawing.

Now look at sculptors' drawings. Consider the way that Michelangelo carves out form with red chalk, or the way that Giacometti's little ticks and curves mould the paper into space. (Compare his early drawings, which are much more concerned with plane, with his later paintings, which deal much more with contour.) Look at an etching by Rembrandt or Anders Zorn. Think about the way that their hatching lines change direction indicating the planes they are drawing. Dryden Goodwin has made drawings over photographs, scratching in the form of the head. Use the information from your touch drawing to do the same with your own photographs, carving out the form.

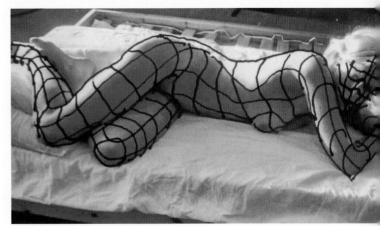

Contour. The information that you gained from the previous exercise can help a lot. You can also drape patterned fabric or use tape at regular intervals across the figure to help you understand the cross section.

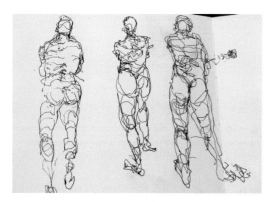

Thinking across the form, and building a lattice to describe how the forms come forward or recede.

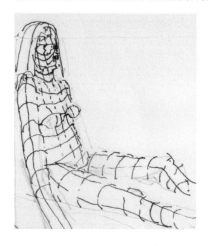

The pen is kept on the paper and meanders backwards and forwards across the figure describing the contour as a series of parallel planes.

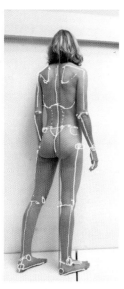

The sternum usually dictates the centre of gravity (red line), which must fall within the feet even though it is sometimes on the edge of the toes at tipping point.

These points act as markers and indicate the nature of the pose, the angle of the torso in relationship to the hips as well as describing the weight and balance of the figure.

Contour drawing

Materials:

- Biro or fine line pen
- Acetate
- Slide mount
- Projector

Take a line across the figure now. Work with a pen and try to draw the central median line running through the figure. Now imagine another line next to it and try to see how that line might move in and out of the figure. Then draw another and another until you have mapped a series of undulating verticals across the figure. Now try another drawing. Repeat the exercise as above, creating the undulating vertical but now add the bands of horizontal lines that would move across the figure. It is useful to rule a series of straight parallel lines about 2mm apart onto some acetate using an OHP pen. This can be put into a slide mount and placed into an old slide projector (these can be bought fairly cheaply nowadays as nobody uses them anymore). In a darkened room these lines can be projected over the figure, which will reveal the form much more clearly. Alternatively you could ask the model to wear a tight fitting striped top, or lay some striped fabric around them. Some models might be prepared to wrap masking tape around themselves or have a make-up pencil line drawn across their body to help you understand the form.

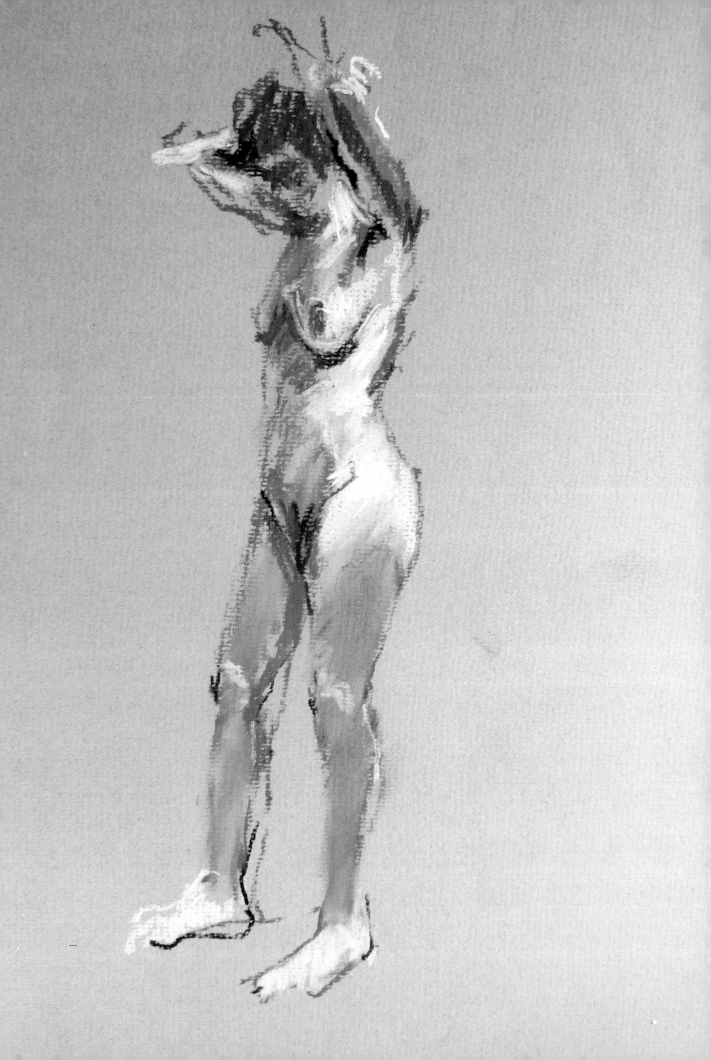

Tone

igures are not bounded by outlines; we perceive them because of changes in light. Our eye never sees anything in isolation, but compares object to background constantly. Tonality is a relative term: what governs how dark one object appears is determined by how light and dark all the objects are around it. We therefore have to approach tonal drawing in a way that is quite different from a linear way of thinking. We have to start by looking at the whole picture and determining within that space the parameters of tone.

Tonal drawing differs significantly from line drawing. With tonal drawing you're thinking about the light falling on the object, not the object itself. You are not *delineating*, but looking for the lost and found edges. Tonal drawings come in many types depending on the tonal scale, the media and technique used.

What are the darkest and lightest areas of the nude and where are the other values in relation to these two points? Of course what sets these parameters is the medium we exploit. Although the eye can easily see changes in tone, it finds it much more difficult to understand the whole scene. Tonal drawing has to be a much more organic way of working, where broad areas are established, gradually being refined to the point where the subtleties are achieved at the end.

As light falls onto a three-dimensional object, some of it will be illuminated and some of it will fall into shade and cast a shadow. If an object is one colour (its local colour), it will appear to vary in light and darkness across its surface. If the object were made of different planes, each plane would be a different tone unless it received the same amount of light as another. A change of plane makes us aware of an edge, which

High contrast. If you are using digital photography, you can play with the contrast settings to help you see this way of looking. Equally, you can squint your eyes to the point of almost closing them. This will help you simplify the tone.

appears in sharper contrast where these two tones meet. A spherical object graduates evenly in tonality across its surface, until it meets the areas of the object in shade. As an object receives light, it also reflects it. This will affect objects near to it. In the case of a sphere the background will reflect light into the shaded area and so usually one sees that the centre of the shadow is lighter than the edges of a shadow. In practice though, tonal drawing is much more complex. The real difficulty is to match your visual impression of the object's tone with your choice of media.

LESSON 16
Counterchange

Materials:
- Black and white acrylic
- Black ink
- Permanent marker (pro markers are optional)
- Brush

It is important to become familiar with the use of tonal draw-ing for this exercise. Think only about black. When you are looking at the figure, ask yourself, 'Why are you seeing what you are seeing? Is the figure seen as a light figure against a dark background, or a dark figure against the light? Is there a point of edge where this changes?' Black on white is a very austere approach, but by exploiting counterchange some quite sophisticated and inventive results can be obtained. Claude employed this approach in his landscape sketches and Frank Miller (*Sin City*) and Jason Shawn Alexander also use this

very graphic language in their drawing too. A pane of glass painted brown gave Claude a reflection of the landscape as a simplified form, removing the half tones and allowing him to see the darks and the lights.

To help you with this drawing, think about illuminating the model with a strong light source so that the figure has core shadows running across the form. You're really painting the shadows so record those as black and leave any other tones as white paper. Think about squinting your eyes, or if you are working from a digital image think about it more like a pho-tocopy. What areas are going to be left untouched and what painted? Do not draw the shapes first; instead think about what areas are going to become the mass of black and other highlights will be left as white.

Now that you have practised the use of black only, you begin to appreciate the use of shadow drawing to represent the figure as opposed to the use of outline to describe it. A useful

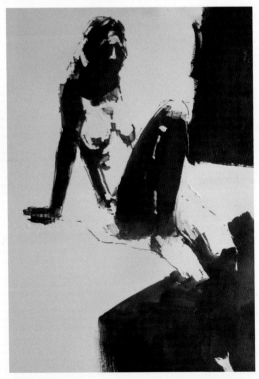

Counterchange drawing. Work with a brush and draw only the black. Think about drawing with the paint brush, using the full range of pressure to vary the line width. Start by blocking in the dark masses. Think carefully about how far the black should go. You may find the edge of the figure as a black mass, but equally the figure may be defined by a black background. Thinking about how you see the form: is it light against a dark background or dark against a light? Think about white acrylic as a corrective medium.

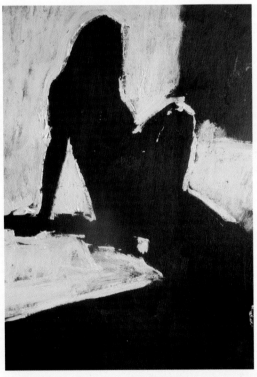

Negative painting, stage 1. Paint up a black background. This time use white paint and concentrate on the negative space and paint the space around the figure. Try not to fall into the trap of drawing it out in pencil first. Instead take your time and build the small shapes.

activity now would be to explore media further. What does black ink feel like? Is there a difference between Quink ink and Indian ink? What about using black acrylic or gouache? What about black oil paint? The viscosity of the medium might be worth contemplating here but also how you apply this: a small paintbrush (001), a medium sized brush (synthetic or bristle), a round, flat or filbert brush, or even a palette knife? Consider having a large sheet of paper in the studio that you can use for experimentation. How do you make marks with each? Explore mark-making with these tools and media. Try to understand the biggest mark you can achieve, the smallest and how the angle of attack and the movement of the arm can influence the mark too. Also, think about what paper surface you use, as this will affect the mark as well. Once you have developed a vocabulary of marks consider how these could be utilized within the figure itself. Also look at other artists' mark-making and how these marks have been used to describe the figure.

In linear drawing you have been defining a figure by describing its perimeter. With this you are only thinking about patches of black. Try not to fall into the trap of drawing an outline and filling in. Instead, think about addition and subtraction. If you have not quite got the edge, add more black: if you have gone too far, cut into black with white. Experiment with white acrylic, Tipp-Ex, masking tape, anything that enables you to organically develop the drawing. Remember that if you are working from life, your Claude glass will be helpful in simplifying the tones of the figures and losing the half tones. If you are working from digital images, consider manipulating the contrast. If you do not have photo manipulation software, then work from a black photocopy. This will naturally push the image in this direction. Of course, much can be gained by looking at woodcuts where the whole process is about subtraction of white. In particular look at the work of Kathe Kollwitz.

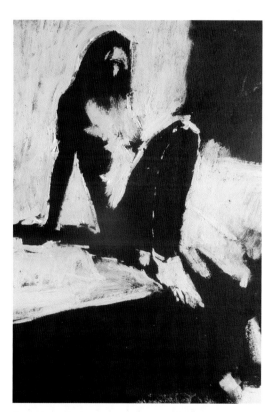

Stage 2. As the image progresses, make sure you cross-relate the various points on the figure above and below. Use black as a corrective medium to find the edge. Consider the light falling on the figure.

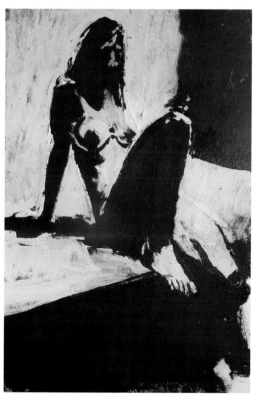

Stage 3. Now paint only the highlights, leaving the shaded areas of the figure as black. Finally, touch up any of the painting with black or white where it is needed. Remember the Schiele exercise in Chapter 2: a thin black line can be created by painting two thicker white lines over a black area and leaving a narrow gap.

LESSON 17
Duotone

Materials:

- Letraset pro markers in medium-grey and black

This exercise introduces a second tone, a mid-grey. Start the drawing in the same way. Think only about the extremes of black and white. Once you have established these parameters, then you can move on to consider the intermediate tone between these two extremes. More can be achieved with this way of working. You may also work on grey paper, establishing your shadow drawing and your highlight drawing. You can also explore Letraset pro markers. These can be bought in a vast array of hues and tones. Buy yourself a black and a mid-grey and explore drawing with these. Whilst these are crude tools and lack a subtlety of execution, they have a thick and thin end and can do a great deal if you explore touch. Some very beautiful drawing has been done with this limited means. Look at Alberto Mielgo's marker drawings and also David Downton's ink wash drawings.

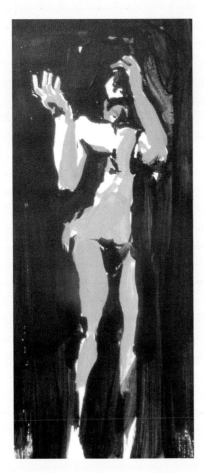

Duotone. In this instance the black is added first, really concentrating on the edges of the black background against the white paper. Next the second tone is added which begins to hint at the three-dimensionality of the figure.

LESSON 18
Charcoal

As the range of tones gets bigger so the possibilities grow, but there comes a point when too many greys cancel visual interest, so contrast is very important. Experiment with five tone studies (white paper, light grey, medium grey, dark and black) and then move to nine tones. Once you have understood the edges of a tonal range and feel comfortable with making these judgments not just from the 2D image but the 3D one as well, consider the potential of charcoal. Rather than working with the point, explore the edge of charcoal to create tonal masses. Again, establish your darks and reserve your whites. Consider your mid-points and work toward your intermediate tones. Think of blocks of tone rather than layered hatched areas filled in from outlines. This is the best way to tackle the main forms of the figure, blocking in the dark core shadows before moving on to the reflected lights in the darks and the half tones across the form.

A heavy quality paper with a good tooth makes a big difference. Don't use shiny paper as the charcoal skids off. Use a rubber too to add highlights but also to rework and correct. Charcoal is a fugitive medium and can be easily moved around the page. You can make marks and easily erase them, which is great when working from the figure: you can discover where the figure is rather than feeling that you have to pin it down right from the outset. You can start a drawing working really lightly, blocking in the main forms of the figure and establishing the masses before you start to refine the forms. You can smudge out what you have done and redraw quickly. You can blur the whole image and return it to a medium grey mass and rework the surface finding the drawing anew. Don't be frightened of it.

Buy a thick stub of charcoal from an art shop or use a bit from your barbecue (it's the same stuff). A big piece of charcoal can yield a delicate mark and a sensitive line when handled correctly and can be sharpened. A thin piece of charcoal can only produce a thin mark and (worse still) it breaks all the time. Charcoal can be moved around with the hand or a piece of kitchen roll. You can also use a paper stump to create delicate tones; it reduces the oily residue from your hand, which can cause it to stick to the paper.

Erasers are vital tools with charcoal. A plastic rubber can be cut with a scalpel and shaped. It can also be washed if it gets too dirty. A putty rubber is really useful as it can be kneaded and made into a fine point and will again remove the charcoal. You can still buy an old typewriter rubber in some stationers which comes in a pencil form. This is really useful for fine detail, but again experiment. Some rubbers can be awful and not rub out your drawing, but leave a greasy coloured residue on your paper. Stale bread also works but be careful of the crumbs.

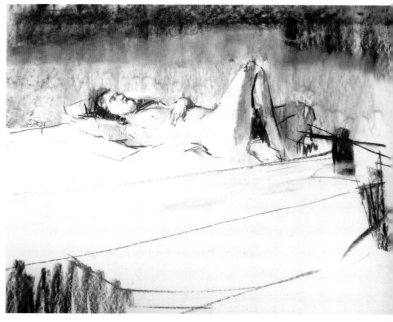

Charcoal studies. A twenty-minute charcoal drawing of Emma, trying to capture the drama of lights and darks on her figure, using a stick of scene painters' charcoal.

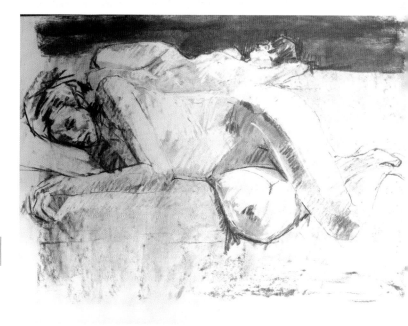

Erased drawing. A twenty-minute erased charcoal drawing of Emma and Lindsey. Here the paper was covered in charcoal first, establishing a light toned ground. Both figures were near each other but varied considerably in scale as Lindsey was a matter of inches from me. The highlights were drawn with a soft crumbly eraser and then the darks were added to establish edges. Note how Emma and Lindsey become one.

FIXING A CHARCOAL DRAWING

As it is fugitive, the charcoal will need to be fixed to the paper. You can buy fixative in an aerosol form to do this, but you must spray your drawing in the open air. Extra firm hold hairspray can also be used, and another alternative is to mix up PVA with water until it is the consistency of milk. This can be applied to your drawing with a spray diffuser. If you use this method try to ensure that you use a container so that the liquid goes a long way up the lower tube of the diffuser. This will minimize the distance the liquid has to travel up the tube before it atomizes in the air (otherwise you have to use a lot of puff). Also, ensure that whatever your fixing method, you do so about 40cm away from the surface; too close and you can get runs.

Compressed charcoal study, stage 1. As compressed charcoal is so difficult to erase the initial mapping in was done in line with some annotation of tone.

Stage 2. A very light application of compressed charcoal was hatched into the drawing. Like the counterchange drawing, the focus was on a simple demarcation of light and dark.

LESSON 19
Erased drawing

Materials:
- Charcoal
- Rubber
- Fixative

Very beautiful life drawings can be made using this technique, especially if your model is lit using Rembrandt lighting in a darkened space. Cover your paper with some charcoal dust and rub the tone into the paper with scrunched up kitchen roll or a cloth. Do not use your hand as the oil from it can combine with the charcoal making it more difficult to erase later on. (If you sharpen your charcoal on sandpaper, get into the habit of saving the dust in a container and using it for this purpose.) You can map out the main proportions of your drawing looking at the basic shapes and finding the structure. Once you have established the underlying drawing, pull out the lights with your rubber. Try to work as much as you can with masses rather than trying to draw an outline and filling it in. It is psychologically much easier to move a block of tone rather than a leg, so let the drawing grow organically. Once you have done as much as you can with the rubber, go back and establish the darks. Work as much as you can with willow charcoal, but if you need that extra depth of tone then work with compressed charcoal.

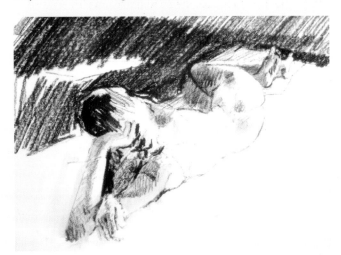

Stage 3. More charcoal was added with a clearer sense of the mid-tones and the darkest notes boldly established.

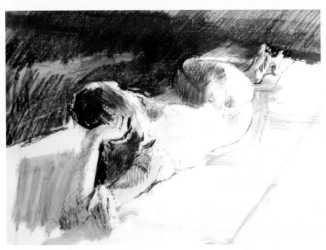

Final stage. Using a soft brush dipped in water, the compressed charcoal was damped to create subtle delicate greys. The hatched areas were unified into a more cohesive tone.

Compressed charcoal

Compressed charcoal is not the same as willow charcoal. Imagine crushing up charcoal in a pestle and mortar. This pigment can be mixed with a suitable binder like gum arabic or gum acacia. The resulting paste could be rolled up into a thin sausage form (in between bits of clingfilm) and left to dry out. The result would be compressed charcoal.

Compressed charcoal's properties of adhesion are much stronger than ordinary charcoal. It produces a much richer black but is much more difficult to erase. Compressed charcoal comes in uniform sticks, which transfers pigment to the hand easily. You may wish to hold them in a piece of tissue or wrap them in tin foil if you don't like getting your hands dirty. You need to handle the medium very delicately if you want to achieve very fine tones.

Because of the gum content, compressed charcoal can be mixed with water to produce subtle and delicate washes. This can yield some very exciting mark-making possibilities especially when used in conjunction with a brush. The medium also breaks down more readily into wet paper so stronger blacks can be achieved this way too. This can produce some very sensitive life paintings because you end up turning the compressed charcoal into gouache. But this is much more difficult to make changes to, so it is best to work lightly, building up to the darkest darks as the figure is mostly going to be made up of half tones.

You can buy compressed charcoal in a range of greys through to white. This will have a very different quality of tone to a charcoal drawing. In the former the tone is created through the pigmentation whereas in the latter it is through the opacity and transparency of the charcoal. This luminosity of charcoal is definitely something to be sought after. In cross section the surface of paper can be thought of as rather like a doormat: the roughness of the mat scrapes a shoe clean, so the roughness of the paper bites the charcoal and leaves a heavier deposit. Too much material will clog up the fibres, preventing a further deposit of material (think of really muddy boots). So the compressed charcoal can end up skidding across the surface of the paper. Fixing with PVA and the diffuser will add texture back, which does make it easier to rework. It is certainly advantageous to use coloured paper with this toned charcoal, and with pastels too.

LESSON 20
Limited palette

Materials:

* Pastels in white, yellow ochre, raw sienna, burnt sienna, raw umber, burnt umber and black

A palette of earth colours produces beautiful life drawings which have a warmth associated with flesh. It is useful to start the drawing with ochre and try to make the most of this colour before you start to introduce any of the others into the drawing. Again, experiment with your pastels to gain confidence in them. Consider the idea of limitation, maybe a series of two-colour and three-colour drawings.

The weight of the arm can be taken through the fingers resting on the paper to allow delicate mark-making. If the surface becomes too covered, think about using a mahl stick to raise your hand above the drawing so as not to transfer all the pastel onto the back of your hand. Pastel can be held in the hand on its side to draw broad areas.

A mahl stick is a length of bamboo with an old sock or a couple of dishcloths tied to the end. The soft end can rest on a canvas or against the edge. This will take the stress off your arm when painting.

Pastel study, stage 1. Using a limited range of soft pastels in earth colours, choose your ochre. You can skim over the surface lightly catching the surface to find the areas of tone that are slightly darker than the paper.

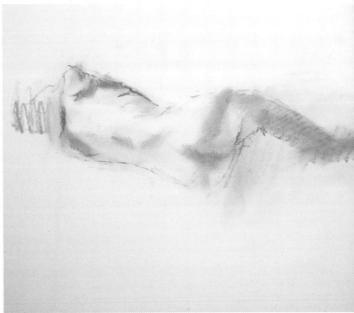

Stage 2. Change pastel to a sienna and add another tone and start to develop the tonal range. Keep the touch light so as not to clog up the surface too early on.

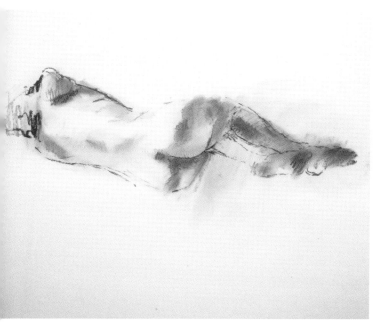

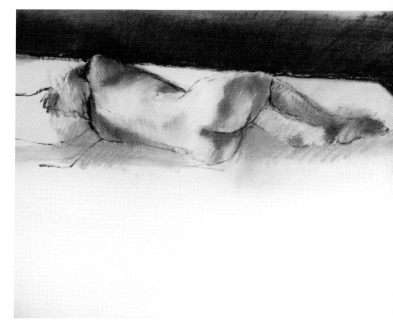

Stage 3. Use a stump to unify the surface and to find the half tones. The residue of pastel dust on the end of the stump can create delicate tone. Alternatively you can use your hand, some kitchen paper or even a cotton wool bud. Working with umber, push towards the darks, defining edges as you go.

Final stage. Rework the highlights and begin to find the darks by changing colour. Do not assume that highlights are white. Slowly edge your way up toward the highlight and down toward the shaded areas. Layer where necessary with other pastels. Here a light grey was used and the darkest umber, which can be mixed with compressed charcoal if needed.

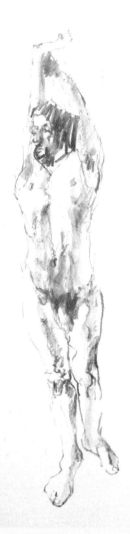

Pencil drawing. This study was made using water-soluble graphite. The medium allows you to work quickly and expressively, and is perfect for capturing the dynamism of this pose.

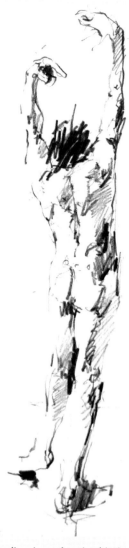

Pencil study. The same medium is used again, this time just shaded with the pencil, trying to create a tension in the use of line to articulate the forms as well as suggest some of the tensions within the body.

LESSON 21
Pencil drawing

Materials:
- 2B, 3B, 4B pencils
- Sketchbook
- Water soluble pencils

The pencil is perhaps the most widely used tool for life drawing. Shading produces tone by varying the grades of pencil as well as the pressure applied. Pencils are made by combining graphite and clay in varying amounts so 7H has a lot of clay and not much graphite; a 6B will have much less clay and much more graphite. The Hs are best avoided, but you might prefer a crisp line that doesn't need as much sharpening. Whilst you may own a pencil sharpener, these are only really suitable for HB pencils or harder. You may find that softer pencil leads break, so get into the habit of sharpening your pencils with a sharp craft knife. Use a shallow cut for a soft pencil, to minimize the pressure on the lead and cut away the wood, and a steeper angle for harder pencils. It is less wasteful of the pencil itself than a sharpener and you can control the kind of point you want. Note that there is no fixed scale for pencils: different manufacturers have different qualities for the same pencil grade.

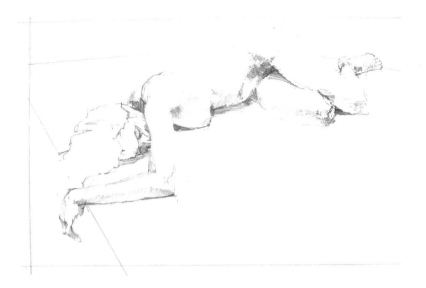

Pencil study. A somewhat more delicate drawing, trying to model the form and build up the tone in small hatching marks.

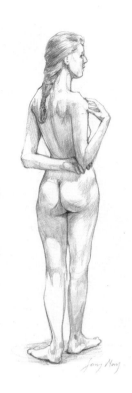

Jake Spicer runs the 'Brighton Draw' and the 'Drawing Circus' – both activities promote the exploration of drawing from life. Here is a beautiful pencil drawing of Mary, modelling the changing planes of her back.

Make a pencil drawing of the model, investigating the breadth of tone and visual contrast that can be seen in the figure, and experiment with toned paper too. Be careful that you do not produce too grey a drawing. Work loosely to find the tonal masses to slowly pin down the form, rather than working too tightly and focusing on line. Water-soluble graphite pencils, like compressed charcoal, can yield much more delicate light tones when mixed with water. A brush pen is a really useful tool to have in your armoury of equipment. A plastic squeezable handle carries a water reservoir, which feeds a supply of water to the synthetic fibres.

It is also good to try water-soluble graphite pencils. These can create really subtle areas of tone, great for modelling the half tones in the highlight areas of the figure. Water-soluble coloured pencils are also worth exploring, especially on coloured paper, and the following illustrations plot the development of one such drawing. Particularly useful are the cheap scrapbooks made out of sugar paper. The paper itself is fugitive and will bleach out under sunlight, but its texture really suits graphite and coloured pencils. If the sketchbook is kept shut then your drawings will last for years, but if you do want to feel assured that your drawing will survive the test of time, then treat yourself to an acid-free pastel paper sketchbook.

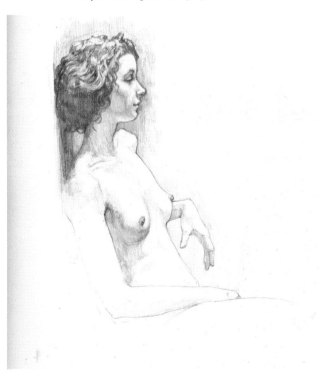

Another delicate Jake Spicer drawing, this time modelling the sternum, breasts, neck and hand.

Pen and ink study, stage 1. Using a very fine nib in a Lamy fountain pen, a very fine line can be produced by turning the pen nib the wrong way around to produce a more delicate touch.

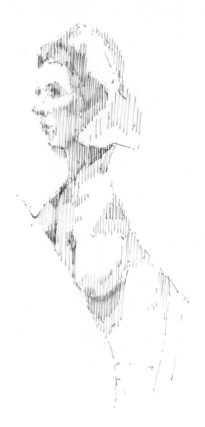

Stage 2. Keep the lines delicate and open to find the shadow shapes and really concentrate on the shape between the shadows.

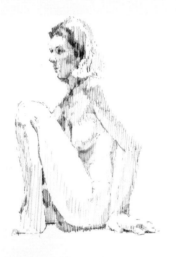

Final stage. The drawing is brought to a conclusion.

LESSON 22
Hatching and cross-hatching

Materials:
- Fine line pen

There are numerous pens and markers out there. You can use biro, fine liner, felt tip, fibre tip, brush pens, fountain pen and dip pen. In the majority of instances, tone is created through the application of hatching. Here you are creating areas of tone through the proximity of lines drawn and the thickness of the line being made. This technique of hatching is also used in hard ground etching to produce tone. Deeper tones are created by layering hatching marks, as well as biting the plate deeper. The great etchers Rembrandt, Whistler, Sickert, Hopper, Kollwitz and Anders Zorn produced beautifully sensitive life studies that are fine exemplars of hatching. They are well worth studying.

The movement from one tonal juncture to another creates a visual dynamic. Some etchers and photographers even have a tonal zoning system to organize images (look at a histogram). The same can be seen in nature. The tree trunk seen as light against a dark landscape becomes silhouetted against a bright sky. In portrait painting it is a much used cliché that the highlighted side of the head is seen against the dark portion of the canvas which undergoes a subtle tonal change across its surface (*sfumato*) when it gets to the shaded side

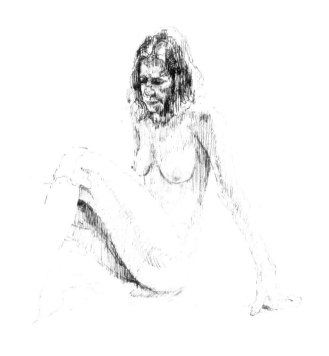

Correcting mistakes, method 1. The trick to using pen and ink is to do less, to leave out rather than to add. If you have overworked a drawing you can rectify it, however. Place your drawing over an identical piece of paper and using a sharp scalpel, cut out the piece that is wrong (cutting through both layers). You can then tape the clean fresh piece of paper, which is exactly the same size as the hole, to the back and redraw.

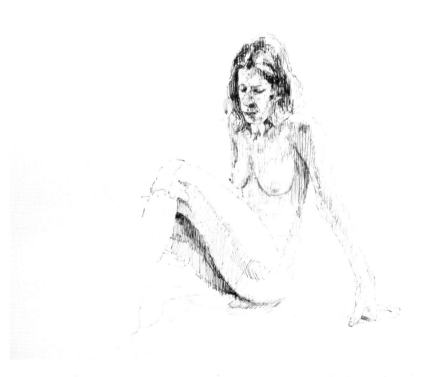

Correcting mistakes, method 2. Tippex over your mistakes and redraw. The disadvantage of this method is that the Tippex can give you a rough surface to draw on.

of the head. Some biro ink can be erased and some felt tips bleached. Some felt tips can be water-soluble and can create beautiful watercolour type effects. A plastic brush pen with a handle that doubles up as a water reservoir is a useful tool for on-the-move drawing.

Build up more of the drawing and try turning the nib the right way around, which is slightly thicker than the nib the other way. Some more lines can be built up over the first set to build up the right depth of tone.

Small scale

Materials:

- Lamy or fine fountain pen or dip pen
- Sketchbook

Draw a 5 × 5cm square in your sketchbook. Try to make a drawing of the figure and the room that contains them in this space, aiming to find the edges of tone rather than to draw outlines to fill in. Work the tones too lightly to begin with. It is easier to darken them later rather than trying to find a way to lighten them. Build up to the darks, but even in the black do not be tempted to fill this in.

We talked about the cone of vision earlier in the book; this is really where you can use this technique to calculate the scale of your drawing. If the average pencil goes into your vision five times, then if you look at your 5cm square, each 1cm will equate to your pencil width. So if you measure the figure as a fraction of a pencil (you could use your bamboo skewer here), the figure will therefore be the same fraction of 2cm. Whilst this presents a challenge it is worth remembering that many of Rembrandt's etchings are tiny. It also begins to lay the foundation of small thumbnail compositional drawings. It is also worth considering that if you want to work in a more labour intensive way, then working small is a much more economical way of working.

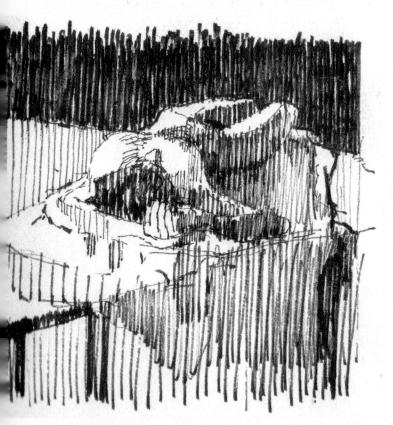

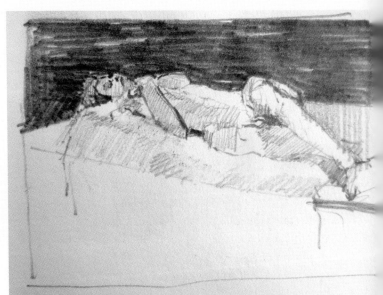

Drawing on a small scale in a sketchbook. This small drawing is only a matter of centimetres across but the scale suggests a much vaster space.

Small pen and ink study. This drawing is 7cm across and is a small compositional sketch for a painting. Here the hatching was used in a vertical direction and the weights of lines created by the pressure exerted on the pen.

LESSON 24
Opacity and translucency

Materials:
- Indian ink
- Dip pen
- Brush
- Distilled water

The classic technique here is ink wash. Indian ink is water-proof once dry so an initial line made in Indian ink will remain fixed when a wash goes over it. You can experiment with the use of a dip pen. A dip pen is a handle, which can hold different pen nibs. The nib is a steel tip, split down the middle usually with a small hole at the top of the spilt. Once dipped into ink, the ink rests in this hole, held in place due to surface tension. When the line is drawn, capillary action causes ink to flow down the split onto the paper. The nature of a dip pen is that it is touch sensitive so lines can be variable in thickness, yielding a greater variety of mark-making possibilities (see George Grosz, Otto Dix, Charles Keene or Phil May). Indian ink mixes best with distilled water (if you have a condenser tumble dryer use the water that you collect in the condenser), otherwise the soot particles can break up and leave a speckled result. Dip pen can produce expressive and gestural figure studies but can also yield incredible sensitivity. The unforgiving nature of the line does make it one of the most difficult media to draw with; one of the key things to remember with pen drawing is that it is often more about what you leave out than what you draw.

Pen and wash study. When one alters the opacity of a medium it is possible to alter its tone. These are very different in character to greys made by mixing black and white together. Because they reveal the paper surface rather than covering it up, these drawings have a tremendous luminosity.

Mark-making

Take a decent sized brush, preferably one that is capable of producing a wide variety of marks both thin and thick. Place this into a pot of black ink and make a stroke with it. Try to make one mark that starts thin, becomes thick and moves back to thin again. Do this a number of times until you feel confident that you can control the mark. You need to explore the variables: the pressure you exert, how you hold the brush, the tension in your arm, the speed you make the marks. Do this with a number of your brushes and move onto the next exercise. Do the same with your other tonal materials. Consider how the movement of the arm or wrist, the sound of the mark on the paper can give you clues as to the nature of a mark. Look at how other artists use mark-making. Keith Vaughan used brush and ink to create visually exciting textures, which created rhythmic patterns that eventually were translated into movements in his semi-abstract figure paintings. Henry Moore and Giacometti were both sculptors who sought to carve out form from the paper to create the illusion of form and mass. Looking at artists' visual shorthand will give you some new directions to think about and could be used in your own drawing to describe texture, surface form or movement. You need to consider why an artist uses a particular series of marks for this to be a meaningful activity.

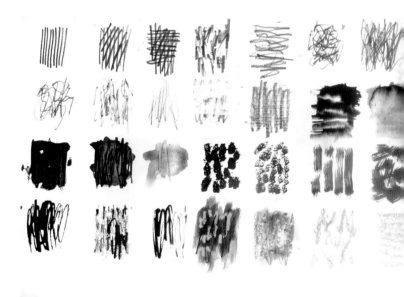

Mark-making exercise. Experiment with your media to find out what marks can be made. Consider too the configuration of the marks. Can a medium be altered with a solvent, or a wash be modified by adding salt to it?

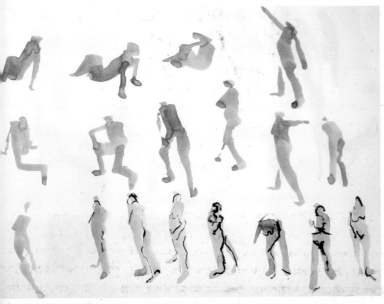

Fifteen-second gesture drawings of the figure, trying to capture the whole body with no more than five brush marks.

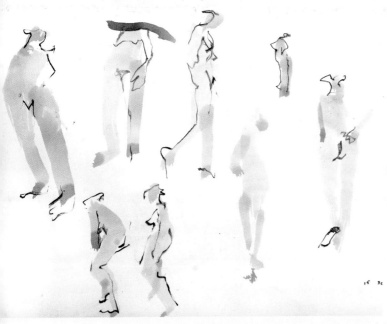

Thirty-second gesture drawings allow a little more time to add in some details, which contribute to the drawing as opposed to redrawing what has already been drawn.

Gesture drawing 1

Materials:

- Medium sized brush
- Thinned black acrylic
- Water pot
- Well palette

For this to work, it is useful to work with the model and ask them to form a shape a bit like a pencil. As the drawing progresses, get them to bend around their trunk before opening up their limbs away from the central core. Now with sketchbook and A1 paper at the ready, think about how you would draw the whole figure with a single brush mark. Do not try to draw the outline with one long windy mark. Instead, think about drawing through the figure, and how the width of the mark approximates to the width of the figure. Pay particular attention to the relative proportions of the figure. The widest mark you can make should be the widest part of the figure (the torso or hips); the narrowest a wrist. A common mistake is to draw too long a mark – you end up with a Giacometti-type distortion. The scale of these drawings relates wholly to the size of the brush. When the model assumes their position, do not draw. Ask them to hold their pose for one minute, studying them. Rehearse the mark in space. Rather like a conductor, your brush should move through the air, virtually tracing the figure. When the model moves after the minute then you make your drawing. After you have done a few of these and the model breaks out of the pencil shape, you can introduce other brush marks – two, three, but only up to five in total. Do not underestimate the value of the rehearsal time. Keep making the marks over and over until you retain the muscle memory of the figure. You are not drawing features, toes, ears, but you are really trying to express the *essence of the pose*. Pay particular attention to the negative space between the limbs. Look at the relationship they have with each other and note their relative scale and proportion. Now that you are able to capture the essence of the pose in five seconds, what would happen if you had the full minute?

Gesture drawing 2

Materials:

- Medium sized brush
- Thinned black acrylic
- Water pot
- Well palette
- Graphite stick
- Letraset pro markers

It is now useful to work with a more dilute wash so that you can produce a mid-grey. A graphite stick draws a beautiful line in a wet wash. You can now draw into your gesture drawing with marks that add extra detail. The mark clarifies areas rather than reiterating what you have already drawn. Practise this new skill, working between the sketchbook and the paper so that the drawings have time to dry. You are training your eye and hand to capture these fleeting moments; not only

will you focus on the essence of the pose and the clarification line, you can add more layers of wash to understand the tone. Work from a light wash and gradually either layer more of the same or by making denser washes increase the darkness. You can also explore this through opaque painting working from a light grey through to dark or starting with a mid-grey and working either side of this toward the lights and the darks. Try doing the same thing with charcoal. Use the side of a thick stick to make your gesture. Add further tones or erase towards the light.

Tone creates form, space, mass, weight and atmosphere and it is tone that carries with it the magical quality of light. The great Baroque artists knew only too well the drama that was possible with tone and it is to them that we should look if we want to find out more. For a long time artists built their studios so that they were north facing. This meant that the light would remain fairly constant during the day. By using skylights and blinds, artists could control the play of light over

Marker pen, stage 1. Letraset pro markers have an extensive range of colours available. They have both a broad nib and a fine point. Using your knowledge from the previous exercise, block in the basic gestures of the main forms. You will have to use more than five marks but the general sense of direction and width should be there.

Marker pen, stage 2. As the pens are transparent, a second layer of the marker will create a deeper tone.

a form and mimic its qualities. *Ateliers* would often start with tonal drawings from plaster casts of Greek statues. Without colour, the form is more clearly understood and students would spend days on the same drawing until they would then progress onto life drawing, which would have been approached in a similar way. Tonal drawing is the foundation for painting, and some painting techniques, in particular *grisaille*, exploit this. Tonal painting is a recognized approach and is the one with the longest heritage and for that we have to thank Giotto. Mastering tone will give your life drawings a sense of realism, drama, light and space.

Marker pen, stage 3. Changing colour allows you to pick out the core shadow. Care was taken to reserve the white paper to create highlights.

Marker pen, final stage. Finally the darkest tone was added and a light grey used to define the negative space and create both the room and the cast shadows of the figure.

Lighting

Light is crucial to our understanding of form and without it you will struggle with any tonal media. You need to consider the notion of directional light, either from above, below or from the side (or a combination of these) as well as reflected light and ambient light. Exciting results can be yielded from simple means, but a room with strips of fluorescent lights will create multiple light sources, which will simply flatten form. If you are sitting with the light source directly behind you then your model may well be flatly lit. Whilst they may have changes of colour on their flesh due to sun exposure, etc., there is very little to be seen and it makes the task of drawing them very difficult. If you were on the opposite side to the light source, then you would be looking at a silhouetted figure where the background will be very light and the figure shrouded in darkness and this is another difficult position. But if the light is to the side of the model, raking light will create highlights and shadows. The wall opposite the light source will reflect back into the shadow area and yield more subtle variations of tone, which will help clarify the form.

Sean Cheetham uses studio lighting angled high and to the left of the sitter to mimic the same kind of light found in a Singer Sargent portrait. Diarmuid Kelley creates a light chamber in his studio, effectively a series of screens and fabric overhang, which create a black space. On the side of this, he has an old window frame (found from his days at Newcastle) being the sole light entry point. This enables him to create the kind of darkness you might see in a Caravaggio or a Hammershøi.

A north-facing light source produces the most consistent direction of light throughout the day, but how do you cope if you do not have this kind of space? Even a candle, or a small lamp can yield exciting highlights, shadows and mystery. Bounced light will yield softer illumination and can be created with a single sheet of A1 paper. By holding the paper opposite the light source, a more diffuse bounced light can be thrown back into the shadows. Subtle difference of lighting in terms of height and angle to the figure will create different results. Remember that you can only draw a range of tones if you can see a range of tones. Playing with lighting so that the lights reveal the form is not just central to drawing the figure from life in tone, it is also one of the most vital things to get right in photography. Anybody that uses photography to draw or paint from must get lighting to work for them: many bad paintings are the result of bad lighting.

Lighting: so often problems are encountered before the drawing even commences. Flat lighting makes it difficult to see the forms and flash photography can leave harsh shadows and bleached highlights.

If only one side of the figure is lit it can lead to a very harsh split. It is better to ensure that both sides have some light.

A more sympathetic approach, which defines the lighting Van Dyck used in portraiture to define the nose. The light source is at the top right, raking across both sides of the head.

A theatrical piece of lighting from below. You see Lautrec experimenting with stage lighting in his work.

On photography

If you do not have an enormous studio, professional lighting rigs or simply do not have time to spend in someone else's studio, then in all likelihood you are going to have to resort to the use of photography. As much as possible, work directly from the figure – the physical and emotional intensity that this brings as well as the surfeit of information would be rich stuff to work with – but not everyone has the time nor the space to do this. What you can do, though, is take photographs and work collaboratively with a model to explore poses and spaces that are visually interesting starting points. Make sure that you have their permission to do so. Communicate with your model, discuss ideas and bring in images of other artists' work as an inspiration. In that way see the process of taking photographs as a collaborative act. Alex Kanevsky states:

> I don't know if I am a figure painter. I do paint lots of figures, but that's not all. When I do work with the figure, it is because of my deep and seemingly inexhaustible fascination with human form, human physical body. I find it endlessly interesting how they move, express emotional state, self awareness, age, change. I do a lot of work directly from a model: all my drawings and many paintings. The rest involve photography, usually my own. I have no reservations about using it, but it is somewhat limited and not as much fun as working directly. I have live models in my studio 2–3 days a week. That seems to be enough for me. I don't choose my models based on their outward appearance. Rather I like to paint people who are either completely at home in their bodies or at least don't know how to hide their disagreements with their own bodies.

There are online resources too. Most of these tend to be for comic book artists or illustrators to use for reference, and a number of books are copyright-free. There is even a series of online YouTube life drawing poses (Croquis Café) that you can work from on screen. However, you need to understand the limitation of the medium. What is missing from the photograph? Where a photograph might be dealing with a broad expanse of tone and may render large areas of the photograph black (think David Bailey or Bill Brandt), this emptiness is very difficult to have in your drawing. Be aware that the photograph is a distortion in terms of tonality, colour and space. Bracket your photographs by taking photographs correctly exposed and take others one stop over-exposed and one stop under, so that you can capture information from shadow and highlight detail. Do not try to make a slavish copy of the photograph but use all of your experience of drawing the figure and the memory of the moment to distil your intention. Photography and Photoshop can be powerful allies in helping you develop your understanding of the form, colour, composition, tonal range, visual contrast, and simplification, but don't be ruled by it. Again Kanevsky states:

> I can take thousands of digital photos and I do. Not so much as reference, but as an exploration tool. This does not involve cumbersome processing and storage issues and makes these photos expendable, impersonal and craft-less – neutral in other words. Exactly what I need from them. This had an unexpected freeing effect with colour.

You don't have to draw a naked model: you are surrounded everyday by people, be a voyeur and capture the moment. If a life class is not available and you want a nude, then do not underestimate the possibility of the double mirror. Remember that the more you have drawn from life the more you bring this knowledge with you when working from the photograph. Degas, Sickert, Vuillard and Eakins all used photography but they had a lifetime of knowledge to draw upon. Sometimes working from a black and white image can be useful in that it doesn't dictate the colour too much and allows you to interpret the tonal information into your own chromatic exploration.

The limitations of the camera are expressed in this image, when there is over-exposure. Whilst the shadow detail is good there is no information in the highlights. The human eye automatically changes its aperture (the iris) to suit the lighting conditions. The camera cannot, so while this photograph has good shadow detail, the highlights are bleached out, making it difficult to work from.

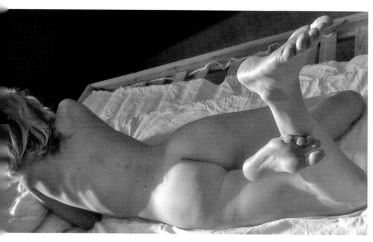

The lens can also distort the image. Consider the size of this foot in relation to the whole body.

The lens can distort, especially at the periphery of any image or if you are using a wide angle lens. You might want to exploit that distortion. If all else fails and you really do struggle with the drawing and want to get on with the painting, then as a last resort either trace or transfer the photographic image onto your support. You can use a projector for this (overhead, slide or data projector) or you can photocopy your image and prick out the outline. You can 'pounce' a drawing by pushing charcoal dust on a rag through these holes to transfer the image to paper or canvas. (Pouncing leaves a trail of charcoal dots on a new support, enabling you to redraw the image.) Alternatively you can rub a thin layer of charcoal/pastel onto the back of your drawing or photocopy and draw with a biro the other side to transfer your line to your support.

Collage

Materials:
- Acrylic paint in white, yellow ochre and black
- Newspaper
- Brush
- Scalpel
- Glue (Pritt Stick)

There are three main types of collage: mosaic, cut and torn. Mosaic collage uses lots of cut up tiny pieces of paper and the collage is built up rather like a mosaic. Cut collage utilizes scissors or scalpel to cut out individual shapes that match an area of tone or colour, whereas torn collage carefully teases the shape out of paper with the hand. It is useful to consider the grain of the paper. Tearing along the grain can produce thin strips, whereas tearing against the grain is not so easy. Consider creating a range of tones/colours when constructing a collage.

Using only the colours above, paint up old newspaper in a variety of flat tones. You should aim to make as many variations of tone as you can and aim to paint an area approx. A5 size. You can add white to black to make greys, you can add white to yellow ochre to make tints and you can add black to yellow ochre to make shades. You can also add black and white together to yellow ochre to make tones. Apply the colour without too much water, using a decorators' brush. Try not to leave too many gaps between the tones so that it doesn't waste paper.

Make a cut paper collage from a Euan Uglow painting. Uglow reduced the subject down into planes anyway, so it really helps you see the tones clearly and why they are there. A similar thing can be done using the cut out filter in Photoshop, but it doesn't always reveal the form. If you play with some of the other filters you might get better results (there is a lot of free software online that can offer similar effects too). Whilst you want to simplify the structure you don't want to lose so much detail that you produce a flat image. Print an image off to approx. A4 size and ensure that you have an image of good resolution but make sure it is black and white. Use only the range of greys that you have to draw the background. It is useful to start on one A4 piece of grey paper. Uglow would sometimes place his models against a background, which helped him find the proportions of the figure, a series of

Collage, stage 1. It is much easier to think of collage as a series of spatial layers. Start with the background and block in the large area with big tones. This paper was made with newspaper painted in acrylic. Paper that has got dirty or creased can equally be recycled for collage and old magazines can provide a ready supply of found colour.

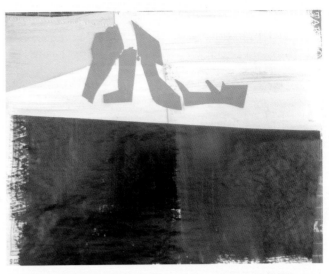

Stage 2. The collage paper was painted up in variations of white, yellow ochre and black. These mid-tones were cut with scissors and stuck down.

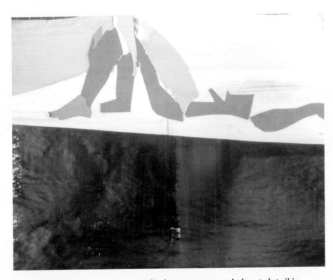

Stage 3. The next tone was applied, not concerned about detail in particular, but more concerned with mass and weight of tone.

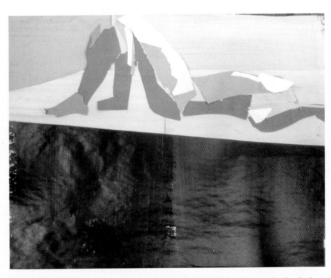

Stage 4. A further two tones were added, moving up towards the light. These were made with a combination of cut and torn collage.

wooden panels, a gridded map or a radiator. These guides will be useful for you too. Like the negative space exercise (Lesson 12), place the elements of the background in first. Use measuring callipers to place key elements and work out the space that the figure occupies. Now use only colours obtained with yellow ochre in (the tints, shades and tones) to render the figure. You should 'draw' with the scissors or scalpel. Do not draw out the image on paper and then cut these out; instead cut directly into the paper. Do not make a mosaic collage as you will spend far too much time making it. Instead, use the tonal areas of the painting to guide you.

Monochromatic collage can become flat, so by using two temperatures of tonal paper to separate foreground and background you create space and the warmer notes of the yellow ochre come forward out of the grey. You might become confused by the colour of a painting, but by working from the black and white image, it is easier to read the tone of the image and compare that to the tone of your paper.

Run off a length of masking tape and attach it to your table, sticky side up. Take small squares of your collage paper (about the same width as the tape) and stick them onto the tape in

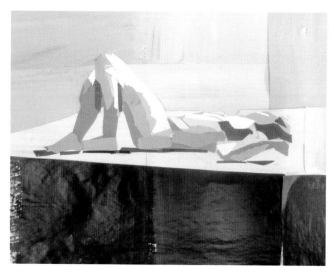

Stage 5. More tones were applied, trying to mesh together the main form of the body. At this stage it was realized that the background was not big enough so more tone was added.

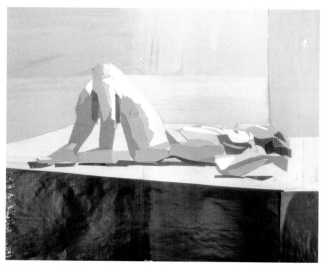

Final stage. Finally, small areas of collage were cut and applied. At this stage one might use the scalpel itself to transfer the collage to the paper as it is very easy for the collage fragments to become stuck.

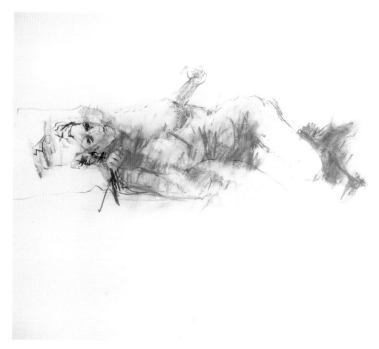

tonal order, creating a tonal range for your greys and a tonal range for your yellow ochre variations. Find your mid-grey tone and cut out another piece, about A6 size. From the middle of this paper use a hole punch to make a small circular hole in the middle of each colour. You can now use this to isolate any area on your image and lay the tonal strip near it. With your eyes half closed, run the strip near the hole until you see that there is very little difference between the tone in the hole and the tone of your collage paper. You can also refer back to your Claude glass. Whilst the whole image will be darker, it will get rid of the half tones and simplify the problem for you.

Traditional red chalk (sanguine) was used by artists such as Watteau and Rubens. Combined with black, it is possible to produce a wide range of subtle tones, which are sensitive to rendering skin. As it is harder than compressed charcoal, it can be sharpened quite easily to a point with a craft knife for more controlled details. It is slightly waxy in feel, and the medium is water-soluble enabling the production of delicate tones. In this nude, the medium is used quite physically and combined with graphite.

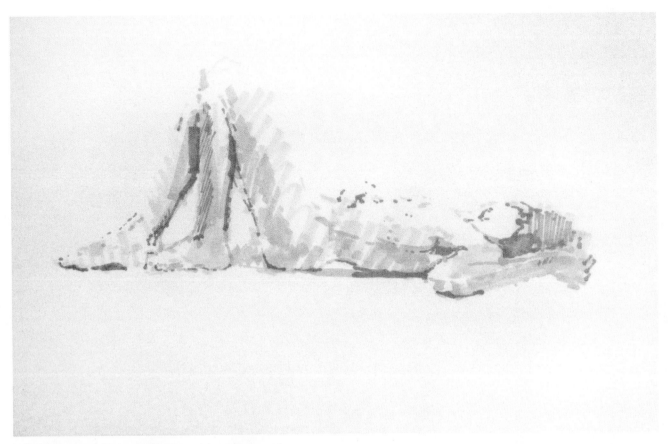

Using three different tones of marker this delicate figure study was rendered very quickly. An earlier version was drawn but one of the colours jarred, punching holes in the figure. So you might need to experiment to find the right combination of hues. Pro markers come in many hues and tones.

LESSON 28
Mixed media

Materials:

* The contents of your art bin

For the most part you have considered the idea of drawing in a single medium. Not only that, you have considered different approaches to drawing the figure in a compartmentalized way through the various lessons learned. What happens when you mix line and tone? What happens if you start a drawing with a partial peek drawing and then begin to measure it? What happens if you use basic shape to establish the key proportions and then execute a gesture drawing over the top of it? There really is no right or wrong way to draw but central to this investigation is to think about the notion of layers. What will go over the top of what? What media can be mixed together?

By now that sketchbook of yours is pretty full, or you may have already moved onto your next. Think about making experimental sheets of mixed media experiments. What happens when pencil goes over the top of biro? Would charcoal work with oil pastel? You need to make your own notes, and think about what you mixed with what, what worked and what was difficult to use. Here are some things to get you started but the list is endless:

* Fine line pen partial peek with charcoal blocking in tone
* Compressed charcoal, graphite and acrylic wash
* Wax resist – draw with a candle, wax crayon or oil pastel and apply a wash medium over the top of it (ink, watercolour, dilute acrylic)
* Quink ink, black and white acrylic with wax resist
* Very strong black coffee with graphite
* Marker pen, fountain pen
* Tippex, pencil and oil pastel
* Coloured ground collage with pencils and oil pastel

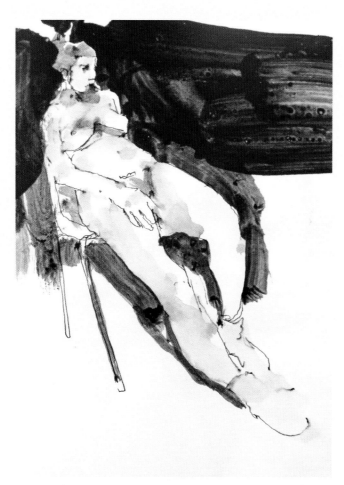

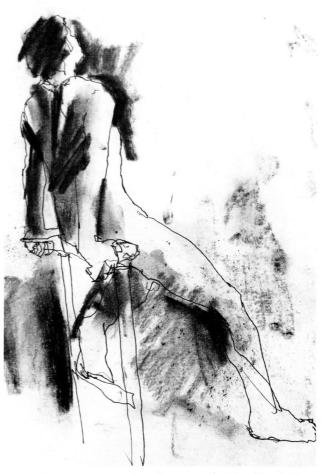

This drawing was made with a fountain pen, black acrylic and water. The emphasis of the drawing was to render the figure in ten minutes and capture some of the dynamism of the pose allowing for some exaggeration of scale. Note the way in which the wash has picked up the ink line and produced colours.

Here a five-minute partial peek drawing was made in a fine line pen. In the last minute a broad area of tone was applied with charcoal which considered the counterchange of light against dark.

A ten-minute mixed media drawing of Felix. This started with an initial sketch in pencil, which then had an acrylic wash applied to it, into which pastel was overlaid and finished with compressed charcoal.

Diver. This is a painting, in which the figure is almost assuming the same pose as a swimmer in the action of diving. The interest was in the dynamic movement and counterbalanced weight of the figure.

Chapter 6

Composition

y now you should have gained a much greater insight of how to draw the figure and of visual perception too. You have explored a variety of approaches to drawing as well as explored with an extensive range of media. You will have begun to reflect on what approach to drawing you prefer and perhaps considered how each approach might require a particular mindset when executing them. Whether it is the quiet, considered and tentative approach to measurement, the more zen-like poetic rehearsal of the mark in space for gesture drawing, or the hurried, intense concentration of fifteen-second drawings, you have produced not just drawings but reflections on yourself. At the start it was suggested that you should focus your attention not on the drawing, but rather on what you have learned from the drawing. Now that you are in a much stronger position, you can begin to turn your attention to the drawing itself, with a simple question, 'What will make it visually interesting?' Composition is one of the ingredients in creating visual interest as well as a device to create meaning in a work.

Study After Uglow. Pencil drawing based on *The Quarry Pignano* by Euan Uglow. Note how the composition is based on a kite-like structure creating diagonals, which lead your eye around the body.

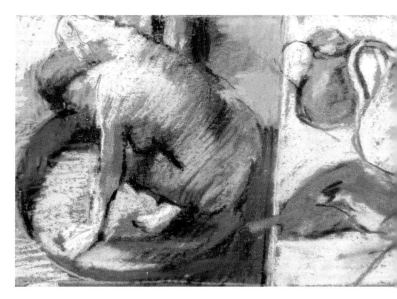

Study after Degas – a small pastel referencing the large pastel by Degas of the tub (*The Bather*) and the unusual angle of the view that is cut off by the sideboard. This suggests the influence of photography and Japanese woodcuts, which used similar visual cuts in compositions.

An A2 drawing exploring different formats of rectangle. If the diagonal of this rectangle is struck and a new lines cuts that at right angles through the bottom right corner (fourth rectangle), this dissects the horizontal into the Golden Mean, where the relationship between the small and the larger is the same as the larger to the whole. On the third and fourth rows other proportions are considered.

The same rectangles have now been used to create a series of spaces for the figure. Consideration is given to the placement of the figure within these rectangles, the negative space and how part of the image might line up with some of the underpinning geometry.

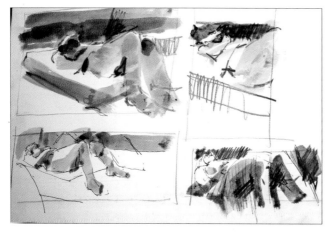

A series of quick compositional studies of the same figure exploring landscape and portrait format options.

When Uglow cut off the head of the figure in *The Quarry Pignano* behind a panel of colour leaving you with legs that act like mountain ranges, your eye is drawn into the space of her stomach and hand, which allude to the landscape and Italian light that the title refers to. When Degas cut off the edge of the composition with a table edge, dissecting the images into two trapeziums, he was not only creating movement for the eye; he was referencing the domestic space and the everyday activity of bathing rather than portraying the nude as an object for the male gaze. In one respect composition is a way of dividing a rectangle so that each part of the image, whether negative or positive, is as interesting as the other. It encourages the viewer's eyes to move around the image so that they discover more things but also control that navigation. Think of the blank surface you are working on as having a kind of unity. Everything you place on its surface creates a visual tension. Ultimately good composition balances these tensions through the use of opposition: negative against positive, emptiness against congestion, white against black. Not everything is equal. A shout seems all the louder in a quiet space than in a crowded hall. Think of a stage play where the canvas is the stage: the actors, costumes, props and set should each have a role to play in describing the narrative otherwise they are superfluous. Making a good figure drawing is not just putting the marks in the right place to describe the form – it is also about how you make the image of the figure visually exciting.

LESSON 29
The rectangle

Materials:

-
- Sketchbook
- Drawing implement
- Compass
- Ruler

Take a sketchbook and draw out a series of rectangles in the following formats using your compass to give you the proportions: 1:1, 1:2, 2:3, 3:5, and 5:8.

Can a figure be pared down to its essential parts? What is the shape that the figure makes in these different rectangles?

Working from the model or from your photographs, try to make five versions of the same figure study in each of these rectangles. Consider making the figure bigger or smaller, and try moving the figure up, down and to the left and right of the rectangle. What happens to the image and what creates the most visual interest? Should all of the figure be included? What happens if parts are cut off by the edge of the composition? Repetition is a useful thing here as you can make a number of drawings with the same idea but each time changing one variable: format, scale, colour, placement. Paul Klee talked about taking a line for a walk, so think about the various elements going for a walk around the format. This is the way that you discover the most visually exciting possibilities of your subject and is a really good way of making decisions before you embark on a larger painting.

You are used to drawing on A1 paper. So experiment with these other formats. On a smaller scale in your sketchbook experiment with a series of compositions using rectangles derived from the diagonals of the previous proportion. Start by exploring a square format, then use your compass to find the length of the diagonal. Now make a new composition using the diagonal length as the longer side. Repeat this exercise a few times, also considering whether your rectangle should be portrait or landscape. Use the same subject to work from, each time asking the question, 'What happens if I move the figure here?'

If you look at the ratios 1:1, 1:2, 2:3, 3:5, 5:8, these are all classic canvas rectangles that you find off the shelf from an art shop. They are derived from the Fibonacci sequence: 1, 1, 2, 3, 5, 8, 13, 21, etc. (1+1=2, 2+1=3, 3+2=5, etc.) which was first introduced to western mathematics in the thirteenth century by an Italian mathematician Leonardo of Pisa (known as Fibonacci). This sequence represents a proportion found in nature, which underpins the growth and proportions of bones.

If you fold the short side of some A4 paper over and line it up with the long side, you will have created a triangle of 45°. If you place the diagonal against another sheet of A4 you will see that it is the same length as the long side.

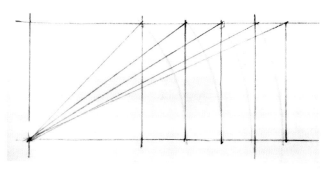

The ratio of the side of a square to its diagonal forms the basis of the A series. A4 is half the area of A3, and A3 half the area of A2, and so on. If you use Pythagoras' theorem ($a2 + b2 = c2$) to calculate the length of the diagonal of a square you will find that it is in the ratio 1: √2. The diagonal of an A format rectangle is in the proportion of 1:√3, and the next 1:√4 (which is 1:2).

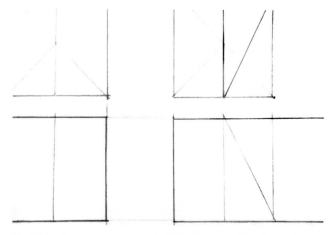

The Divine Proportion. A square is divided into two. The diagonal formed from the middle to the right corner is swung down to make a new golden mean rectangle.

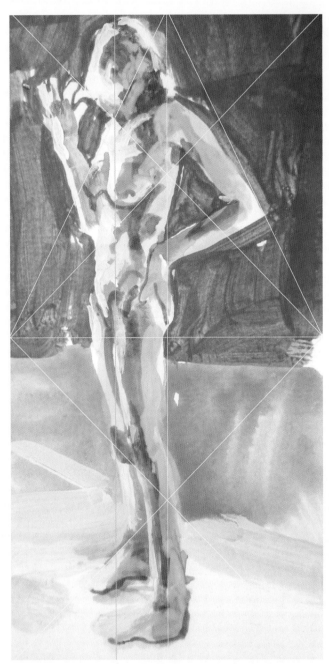

This small gouache was based on the stacking of two squares. The diagonals of both squares reveal the geometry and how the figure sits along a one-third vertical.

Four squares.

A landscape format image is looked at differently from a portrait one. The speed that you look across a long thin rectangle is different from a square format. You might want to look at the idea of a secret geometry, where the organization of key elements in the image align to an underpinning mathematical structure. This secret geometry is used to bring your attention to the narrative. In Caravaggio's *Supper at Emmaus*, Christ's finger lines up to a number of key intersections of the rectangle.

LESSON 30
The Divine Proportion

Going back to the Renaissance, the Golden Mean was used as way of creating order in a painting or a piece of architecture to create 'divine order', a perfect balance of two parts so that their proportional relationship was the same as the larger part against the whole. The Golden Mean underpins our own growth patterns, the relationship of one bone to another. This mathematical logic might yield an underpinning logic to your work and will certainly give you something to explore further in your figure studies.

Get some photocopies of some paintings from the Renaissance. Look at the work of Piero della Francesca, Rubens or Caravaggio. Draw over these images using your compass and ruler to calculate the golden rectangle. And see if key parts of the composition conform to this underpinning grid.

LESSON 31
The rule of thirds

You will notice on the back of your digital camera that the viewfinder is divided into nine boxes. Our eyes are pro-grammed to see order and to pick up on tiny changes of symmetry. Using these rules to ensure that you align some of the key elements of the image of the picture will make a more visually successful image. What if key parts of the figure, aligned to this underpinning grid and the intersection of the power lines, are the points you want to draw the viewer's attention to? What happens if you place a figure in an unusual rectangle or place the same figure in different rectangles and scale arrangements?

In your sketchbook produce a series of compositions that are divided into thirds. It might be easier to use your compass to create these by marking off the same distance three times. Now explore this compositional device in your own painting. Why not make a painting of a painting you have already done, making the key elements of the image conform to these intersections.

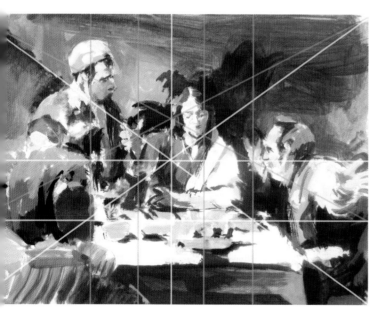

Study after Caravaggio.

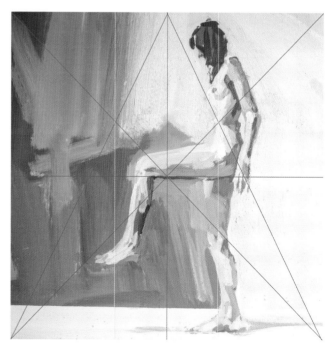

The rule of thirds. It can be interesting to divide up a photocopy of one of your own paintings. In this instance 'raising her leg' conforms to the rule of thirds and the underside of her calf divides the painting in two.

Principality. In this study after Degas your eye is led directly to the seated ballerina. This is achieved through the use of tone to create the greatest point of visual contrast.

Repetition. In this study of *Sunlight* by William Orpen, the artist places the nude in a space with repeated horizontals and verticals.

Ruskin's rules for composition

John Ruskin listed nine compositional devices in his *Elements of Drawing.* Although these might seem old fashioned they remain worthy of consideration.

Principality

When you begin with a sheet of white paper or canvas you have unity, a beautifully balanced surface. Any mark made creates a series of imbalances and the true art of composition is to balance out the opposing forces of the image. At the same time though, what is the point of visual interest? Where do you want the viewer to look?

Is this point of focus governed by the rule of thirds or does it lie on an intersection of Golden Mean divisions? Look at other artists' drawing and ask yourself the question, 'Where is my eye being drawn to?'

Repetition

The rectangle has two verticals and two horizontals. In this study, William Orpen used the repetition of vertical and horizontal divisions of the rectangle to create a static space that the figure played against as a series of diagonals. Seurat's compositions were riddles with repletion of shape; even the same figure might appear a number of times. The repletion of the diagonal creates a much more dynamic composition, which can be seen in Rubens.

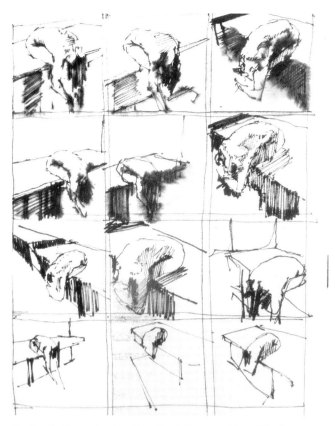

Continuity. These drawings investigate the same idea of the figure teetering on the edge of a table. Consideration was given to the scale of the figure, the positioning of the table and whether the corner of the room would become an element. Note that all of these use the square.

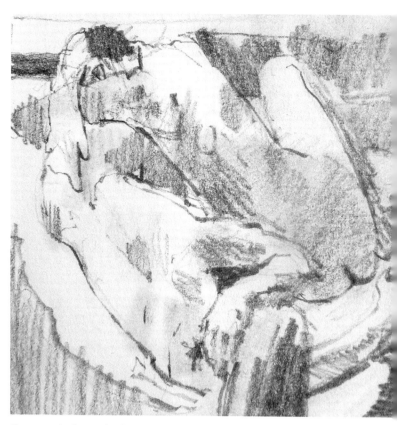

Curvature. In this study after Ernest Procter's *The Day's End* you can see the continuous use of curves throughout the whole composition.

Continuity

Here Ruskin refers to the repetition of forms, which might subtly change across the image, a series of columns receding into the distance conforming to perspective, for example. But it might be interesting to consider the idea of constants and variables. Why not make more than one version of an image? Why not make a series of repeated figure compositions with each image being subtly different? Maybe the figure moves a bit to the left and a bit to the right? Through continuity you begin to see how you can really understand the problem by running through the options.

Curvature

Ruskin states that curved lines are more beautiful than straight ones. Hogarth also pointed out that great image-making contained a line of beauty, which was sinusoidal in its nature.

Radiation. This small stipple drawing uses perspective to take the eye through the leg and bring it to the heads and the space behind. The vertical and horizontal background prevent the eye from going any further.

Radiation

When the rectangle is divided into verticals and horizontals the internal shapes become more rectangles. This can lead to a very static composition. If these play off the vertical and horizontals, creating diagonal divisions of the space, the result is a much more dynamic composition.

These not only create much more interesting negative spaces: they create movement for the eye, a sense of radiation that draws the eye into the image. Making the eye move around the image creates much more visual interest and also implies space.

Use what the figure sits on – a table, a mattress, a mat – and try to find a way of altering your angle of view so that this object becomes a dynamic trapezium. Think about how this shape might be placed into your picture. Attempt to create an image that leads the eye into the space and discovers a key point of the figure. Be careful that the diagonal does not cause the eye to fly out of the picture.

Contrast. This drawing is based on William Orpen's *Nude Study* from 1906. The painting uses a very strong tonal contrast between the background darks to the bright highlights of the figure and the dark pools of shadow across it. The drawing has had its tonal range shortened to flatten it.

Contrast. The same drawing has had its tonal range increased. The dark grey pencil now begins to look almost like compressed charcoal and creates the same kind of drama that is in the original.

Contrast

If the arrangement of shapes within the rectangle has a visual impact, then so too should the arrangement of tones within the picture.

In the days of wet based photography, a well composed image could be badly printed using the wrong grade of paper. Photographic papers had different paper grades, which corresponded with different tonal scales. The photographer was not just responsible for taking the photograph, they manipulated the image in the darkroom, altering the tonality and contrast, and might well have cropped the image too.

Now with the advent of digital photography, the image seems to arrive ready made. Photo manipulation software gives the same element of darkroom control and the language of that software relates to the same darkroom terminology ('dodging' and 'burning', for example). The artist has the same control: what media are chosen and how can they be manipulated to create contrast? This might be a set of tonal values, where the image has a breadth of tones from white to black, or the placement of values, so that eye meets juxtaposed areas of light and dark creating staccato rhythms. This could involve the figure and its relationship with the background. A brightly lit figure might be placed against a very dark background. A figure in shadow might be seen darker than they are to play against bright highlights.

Contrast may also come from activity. An area of the image may be left untouched to play against an area of intense drawing. This is where extreme foreshortening can make for a really exciting subject. The space between key features may be small but yield a real intensity to the image. There might also be exciting contrasts of scale – a foot might be visually bigger than the rest of the body.

Your hand may yield different weights of mark or the same line might have changing tensions within it. This may be used to differentiate between bone, flesh and muscle. Experiment with these ideas the next time you make a compositional sketch.

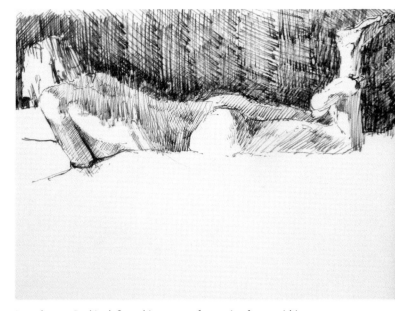

Interchange. Ruskin defines this as a set of opposing forces within a composition: light against dark; dark against light; busy against quiet; large against small. In this drawing the mid-tones are counterpointed against a dark background and a light foreground.

Interchange

Explores the notion of opposites. A busy area may be opposed to a quiet area, colours may be played against each other or tonal contrasts may be opposed. Johannes Itten refers to the notion of a contrast of extension. A large amount of green with a small part of red will look very different from a large part of red with a small part of green. In portraiture a highlighted area of the head may be opposed with a dark background, which subtly shifts to become a lighter background against the shaded area of the head against a lighter background.

Consistency

This concept appears to suggest the opposite of the previous two rules. The curves and rolling forms of the figure may not be counterpointed at all, but the whole composition may celebrate those swirls and lines. A whole painting may be built on a consistent use of colour, based on one hue or a limited palette (*see* Chapter 8). It might also be something to do with the facture, the way in which the artist uses a consistent approach to mark-making, for example.

Harmony

This has much more to do with the use of colour and will be covered in detail in the chapter on colour (*see* Chapter 8).

Consistency. This A1 charcoal and fine line pen study is constructed from a series of repeated diagonals, which create a rhythm that your eye picks up on.

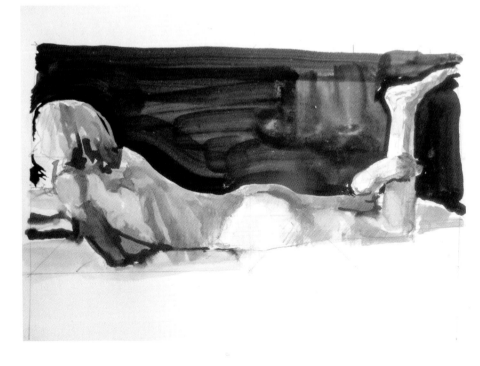

Harmony. An earth palette was chosen to create a harmonious range of hues.

A key note worth remembering is that a compositional drawing is one designed to solve problems. Your study might explore the way in which the figure is placed in the rectangle and how that figure could make interesting shapes within it. It might consider the tonal balances of the whole image as a series of light and dark masses and you might increase or decrease the intensity of the tone as a formal device. Your studies might involve colour, in which case consider the colour of the ground and the choice of palette, but in all these things you are attempting to solve these problems before you move onto a more resolved painting. It seems pointless to explore the format of the image and find that a $\sqrt{5}$ rectangle provides the best solution and to start painting on a square canvas, or to find a portrait format solution and then transcribe that to landscape. Neither is the point to produce a highly rendered study.

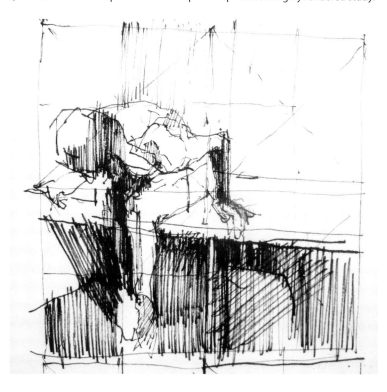

Study for a painting: a thinking drawing. Following the studies in 2010, the idea developed further into the same figure seen from the front. This drawing considers the division of the square and how these intersections might underpin the placement of the key compositional devices.

Study for a painting. A whole range of different photographic source material has been photocopied and collaged back together to create some new ideas. By photocopying, the differences in colour are ignored in favour of tonal and shape relationships.

LESSON 32
Looking at others

Materials:

- Sketchbook
- Drawing media

Choose your favourite paintings and make compositional drawings of them. These do not need to be small drawings but rather a diagram of the image. What works well? Could your own work be informed by some of these images? Can you identify the visual strategies being employed by each artist? What happens when you photocopy them and explore division? Do key parts of the images line up with the rule of thirds? Do the quarter or half-way points align to some part of the image? Is there an underpinning geometry? What about the tonal arrangement of the image? Are the tones closely aligned or do they span the whole range? Do diagonals take you in and around the space? How does the eye move around the composition?

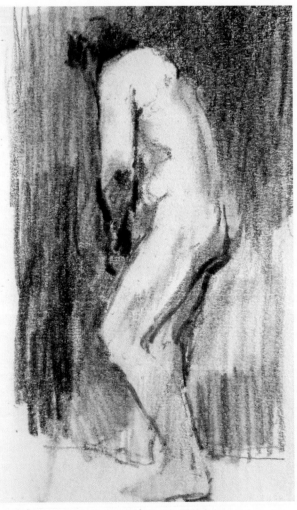

Study after Sickert. This was made in front of the Sickert at the Courtauld Institute. It is based on one of Sickert's Camden Town series, *Jack Ashore*, from 1912 and has a sinusoidal curve running through it.

Study after William Etty. This is a study of a male nude, probably originating from about 1835. The original is a loose oil sketch which really explores the visual contrast of the dark background and the luminous forms emerging out of it.

Probably the best way to begin answering these questions is to go back to the books and the Internet. What drawings are visually interesting? Visit Pinterest and look at the boards devoted to drawing. Create your own and pin any figure drawing or painting that you think is particularly compelling. Think about the formal elements: how is line used, what kind of shapes are in the image? How much space does the figure occupy? What is the background doing? Is the image flat or three-dimensional? How is lighting used in the image? What is the tonal range – is it limited or broad? How is mark-making used and are all the marks the same or are they varied? Make drawing studies of these images. Pay particular attention to their proportions.

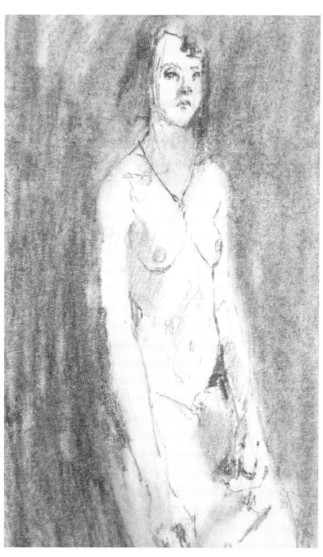

Study after Gwen John. Small pencil drawing trying to consider the subtle uses of muted tones running through Gwen John's painting *Nude Girl* (1909–10).

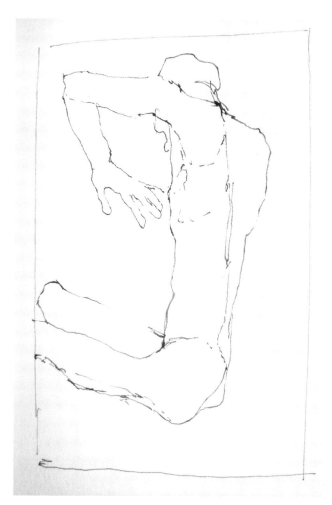

Study after Schiele. In Egon Schiele's *Seated Nude Study* (1910), the artist uses that device so often seen in his drawing of playing off the edges. There are a number of diagonals which form a tilted trapezium shape in the rectangle. This makes for really exciting negative empty spaces.

LESSON 33
Learning from others

By now you will have collected a lot of images of other people's work. Look closely at your top five artists' work and list as many words as you can which capture the essence of why you like it. Once you have completed this with all five, are there some common words or themes? This may well give you a signpost towards your particular interests and give you a possible insight into how you might develop your own work.

Throughout this text there are a number of artists mentioned in relationship to a particular technique. It would be a good idea to carry out some research on these and collect your findings in your sketchbook.

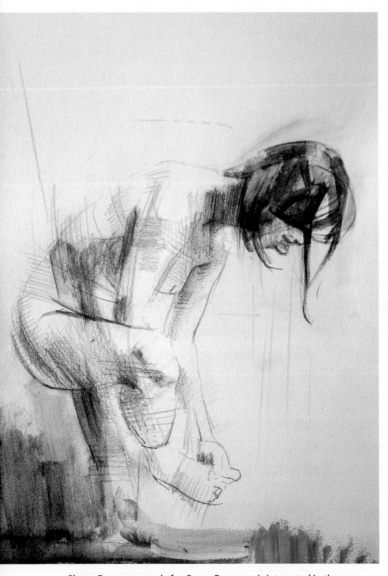

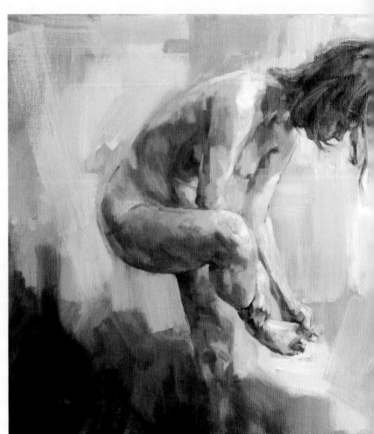

Shaun Ferguson, *Curve*. An important part of the developmental processes in drawing is to understand why you are making a drawing. For Shaun Ferguson, the many years of drawing from life has permeated his understanding of form. At the RA, one of his favoured media was pastel and the ability to layer colour to carve out form and space is central to his work as a painter.

Shaun Ferguson, study for *Curve*. Ferguson is interested in those fleeting moments, the inner dialogues the sitter has, caught in some silent act. The drawing acts as an intermediary between reality and the artifice of painting. Accidental marks suggest movements of paint and thinking marks are taken across the rectangle to consider the visual tensions that are created by the image. This architecture of the painting also harks back to his passion for Auerbach and the gestural articulation of space.

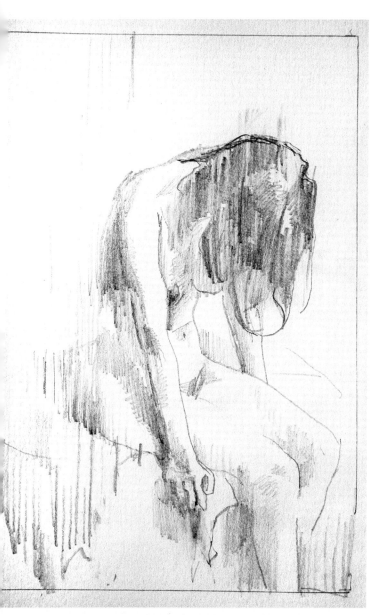

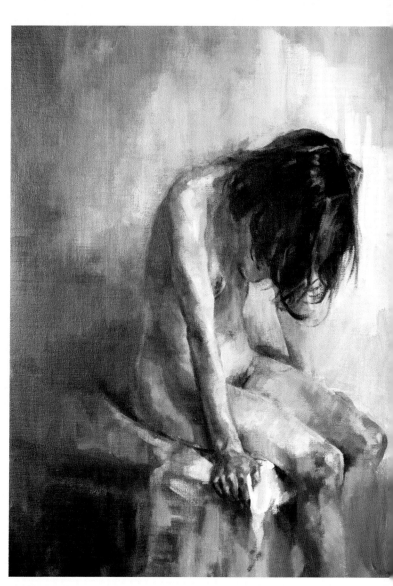

Shaun Ferguson, study for *Compton Avenue*. Ferguson will make drawings as part of the thinking process, to consider the viability of an image and to problem-solve some of the visual issues in the work. He will also make drawings from the paintings themselves for the same purpose – an opportunity to step back from a painting and see it afresh.

Shaun Ferguson, *Compton Avenue*. Compare the drawing and the painting and see how Ferguson has considered the lost and found edges, those areas of the painting that almost disappear into the background.

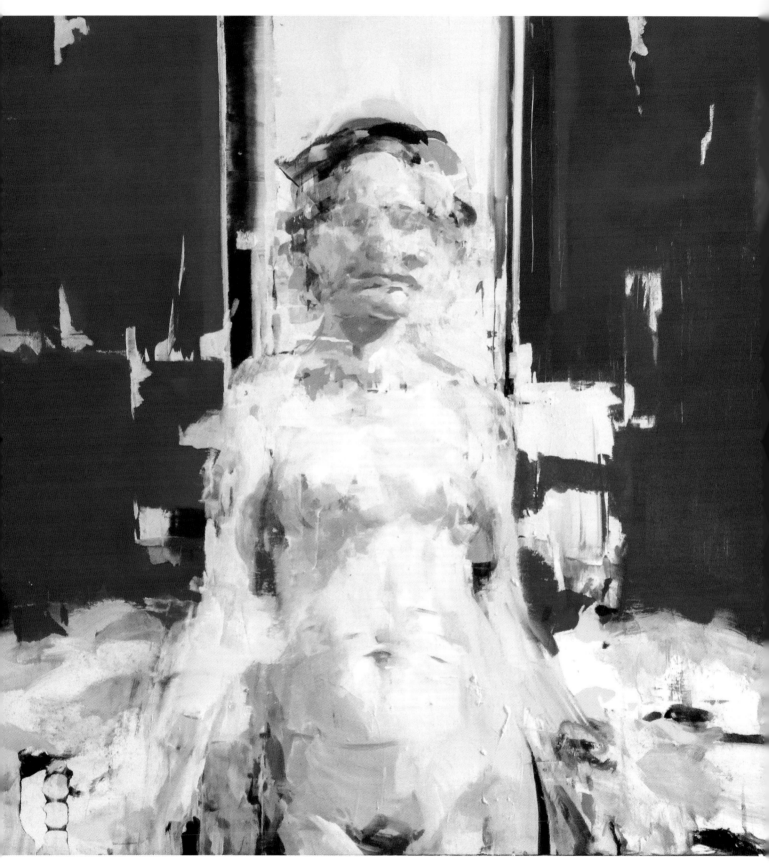

Alex Kanevsky, *J.W.I. Turning*, 36' × 36'. Oil on wood.

Chapter 7

Painting

o far we have concentrated on drawing, with a big focus on proportion and measurement as well as tone. In terms of painting the nude, these are still crucial concerns if you want to portray a figure with some degree of representational accuracy. You have come a long way down the path; you have understood the importance of shape drawing, negative space and tone, so why does painting seem to present so many problems? It has a lot to do with control: how you control the paint and how you control the brush.

Working wet-in-wet presents a more challenging painting problem (see *alla prima*, later in this chapter). You should explore the physical dimension of paint, its viscosity and how it can be thinned and made to flow off the brush or drag against a surface. What size and type of brush should you use? Which is the best way to hold the brush or knife? All of these variables should be explored until you find the right combination to ensure that you make the mark you want to make, where you want to make it without everything being a struggle.

Different media behave differently: what works for acrylic may not work for oil. Continue to experiment and make notes in your sketchbook. What have you discovered? What was easier to use and why? Even brands can vary – there is an enormous difference been Cryla and Liquitex, for example. The medium, the support and how it is primed have a big impact and all of these aspects are worth exploring.

Painting is not something that should be held in awe; if you can draw, you can paint. What you really need to do is experiment with enough different ways of painting, whether it is one or a number of mixed techniques, it's the empirical experience

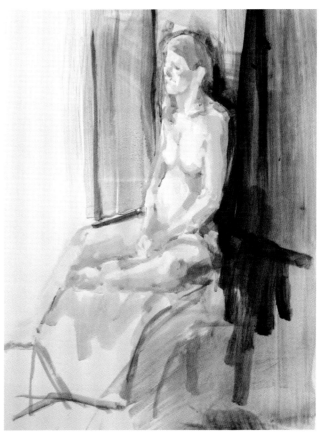

Verdaccio. Return to your gesture drawing exercise and experiment with acrylic or oil and the limited palette of white, black and yellow ochre. Keep the paint thin and you will have a painting that will dry quickly and so make it easier to control.

that will help you. Many artists who have helped in the writing of this book have all said the same thing: they were not taught to paint the figure, instead they learned their craft by thrashing about trying to work it out for themselves. Whilst it is true that there is increasing interest in a return to *atelier* teaching, for the most part, the contemporary figurative artist

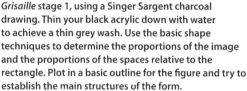

Grisaille stage 1, using a Singer Sargent charcoal drawing. Thin your black acrylic down with water to achieve a thin grey wash. Use the basic shape techniques to determine the proportions of the image and the proportions of the spaces relative to the rectangle. Plot in a basic outline for the figure and try to establish the main structures of the form.

Stage 2. By diluting the black acrylic you can achieve a tone that is light enough to be visible but not so dark that it dominates. Only when the relationships are correctly placed can you reaffirm the drawing.

has arrived at their language not by following a method, but by taking risks, experimenting and, through the process of doing, finding out how to control the medium and make the coloured dirt become flesh and form. You should make a similar quest. Use the guidance notes to give you a starting point, but do not be afraid to take risks. What is the worst thing that can happen? An acrylic painting that has gone badly wrong can be sanded down and painted over with a coloured ground and a new image can replace it. An oil painting can be scraped back and reworked. Things go wrong all the time and even the most accomplished artists have doubt and uncertainty. Most would argue that it wasn't their talent that made them a great artist, it was their sheer determination to solve this complex problem – one which continues to present them with new challenges. Enjoy the ride.

Where do we begin with painting?

Think about the act of painting as two connected but different approaches: *filling the drawing* and *finding the drawing*. In the former you begin by making a drawing on your support. This might be a very precise statement or something more like the basic shape exercise (*see* Chapter 3). This is usually executed in charcoal first and then the drawing is dusted off to leave a ghost-like image (otherwise the charcoal will mix with your paint). This is then fixed before painting commences. If you look at the photographs taken by Bruce Bernard in Freud's studio, you can see him doing this. You are establishing the drawing using paint applied thinly, establishing the main proportions and directions of the figure. Onto this framework you then build the tone and colour relationships.

In the latter approach you go in directly with the paintbrush, drawing with colour and like a charcoal you add and remove paint to discover the figure, to correct as you proceed.

Stage 3. Now that the drawing is established, work with broad areas of tone working from light to dark. It is better to work down to your darkest as it becomes much more difficult to make your tones lighter. You might want to use a larger watercolour type brush or turn your brush onto its side so you are using its depth to fill larger areas. Try to build up the density of tone gradually reserving white paper where you want to keep the highlights.

At the final stage, the drawing has been glazed with colour. This stage brings all the tones up to their full strength, using the visual contrast of the background to bring the figure out of the space.

Underpainting

Grisaille

Grisaille means grey. During the early renaissance, pigment was in short supply and was very costly. Paintings were priced according to the weight of pigment used. So one method of painting was to work only with black and white and complete the whole painting in monochrome. After this had dried, the painting would then be coloured with thin translucent glazes. By modifying the opacity of the colour a wide variety of tones can be produced whilst retaining a thin film of paint, which will dry quickly. This initial painting is called an underpainting. It was only much later in the twentieth century that artists started to explore a more direct method of painting directly onto the canvas itself with much more intense colours.

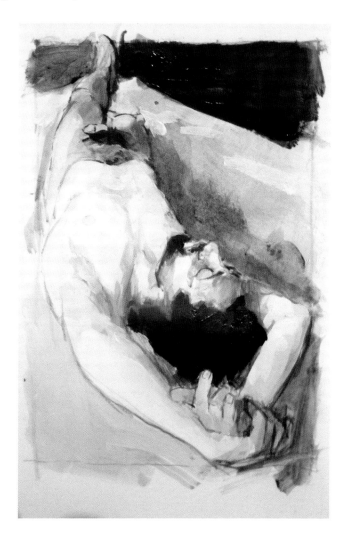

It is a technique that still has validity for artists today, especially for those who are seeking a more traditional grounding in painting. You will have a lot of problems to solve in a painting, and *grisaille* means that you have to solve the tonal drawing problem first before you move onto the colour problem.

LESSON 34A
Grisaille (filling the drawing)

Materials:
- 220gsm paper
- Watercolour type round brush (size 8)
- Black acrylic paint
- Waterpot
- Kitchen roll

Using white paper and black acrylic with a watercolour type round brush (size 8) you are going to draw in paint. Find an example of strong tonal images to work from, preferably something black and white.

When you have built up the drawing and established the key range of tones, you need to check your work with the Claude glass, looking at both the original and your interpretation.

Work with your tones lightly to begin with, gradually increasing the amount of black until you reach the darkest tones. Repeat the exercise with a grey ground, using black and white.

LESSON 34B
Grisaille (finding the drawing)

Materials:
- MDF board (primed with acrylic gesso)
- Decorators' brush
- Black and white oil paint
- Solvent
- Kitchen roll
- Surgical gloves (optional)

You can see this approach used in a study after Velázquez using black and white only.

Think about the negative space and how this figure becomes illuminated once it is framed by the darkness. As you get to the later stages of the image use the white to bring in the highlights and try to use a direct sense of touch. Harold Speed in his book *Oil Painting Techniques and Materials* talks about the 'deft touch'. This means that when you mix up a tone, whatever that is, you must place it with confidence on the painting. When you are hesitant and you are not sure about your mark you can soon sully your colour, so keep it direct and fresh.

Think about this like the way you draw in charcoal. Work broadly with your largest brush blocking in large masses, scrubbing in the oil to achieve a thin film (the lay in), wiping back to reveal the highlights. As the painting proceeds, the marks and the brushes get smaller.

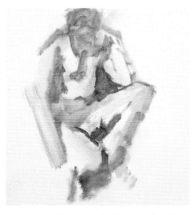

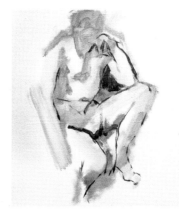

Grisaille study after Velázquez's *Mars*, stage 1. Mix up a light grey and work with a broader flat, placing areas of tone. Think about gesture drawing and block in the main directions of the limbs. Try to use the rag to create your light greys and do not be frightened to work back into the oil with a turpsy rag to bring back the lights. Like the acrylic study, keep everything light and work down to the darks.

Stage 2. Mixing up a darker grey begin to look at the core shadows and block these in, thinking about the junctions of tone.

Stage 3. Having established the broad areas of tone, now the focus is given to pinning down the drawing using the black sparingly to define the edges.

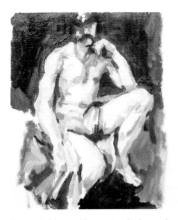

Stage 4. More affirmative darks and more work modelling the tones into the body, putting back the lights.

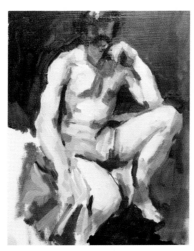

Grisaille study after Velázquez's *Mars*, Stage 5. Once the *grisaille* had dried, a small amount of oil was added to a much larger amount of Liquin to create a glaze. In this instance a blue glaze was applied to the background and an umber added to shadow areas to create warmth.

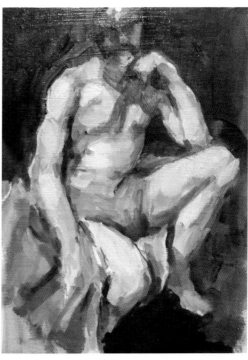

Stage 6. More glazes were added, mixing up colour and applying it transparently over the solid underpainting, creating a luminous coloured image.

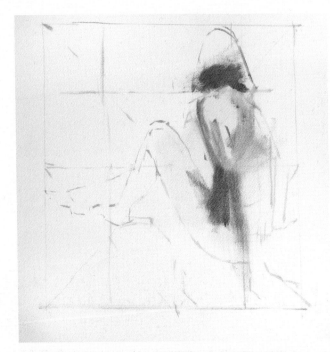

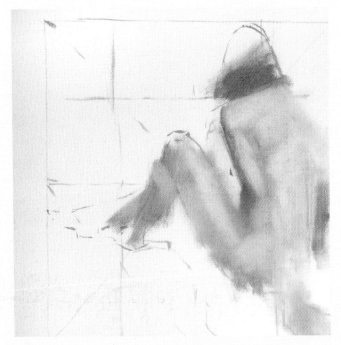

Bistre, stage 1. The figure is considered in relationship to the viewfinder. Care is given to how the figure fits into the underlying grid. The sienna is thinned with fine detail Liquin and drawn in with a fine rigger. Initial tones are blocked in with the side of a brush and rubbed in with a rag.

Stage 2. More wiping back is done with the rag dipped in Liquin. The residue of paint serves as the main tone of the figure.

LESSON 35
Bistre

Materials:
- MDF board or canvas
- Acrylic gesso
- Decorators' brush
- Oil paints in raw umber or a burnt umber, titanium white and black
- Solvent
- Kitchen roll
- Surgical gloves (optional)

Bistre is another underpainting technique. Where grisaille uses white and black, *bistre* uses brown on a white ground sometimes with the addition of black. The opacity of the colour is varied to create a luminous warm image.

Try to complete two *bistre* studies, one in acrylic using a broad-brush technique finding the drawing through the painting and one controlled exercise in oil where you establish the drawing first and then end up working into the drawing with a broader technique.

Use raw umber or a burnt umber and black. Begin more or less gesturally, making big sweeping marks trying to establish broad tonal relationships. As the paintings progress then the gestural quality of the mark-making decreases and you begin to find the form and the nuances of drawing. This is like the difference between line and tonal drawing.

Now paint with raw umber and black oil on an acrylic-gessoed board. One of the big differences is that the oil is not going to dry immediately, so if you make a mark in the wrong place you can remove your marks with rags or kitchen roll. Try to avoid too much solvent (white spirit, genuine turpentine or Zest-it). Solvents are sensitizers and can harm your body as they enter through the fatty tissue of your skin and enter your bloodstream, so wear surgical gloves to prevent your skin coming into contact with it. You can also use cotton wool buds to remove paint, dipping them into solvent to remove the paint residue from the ground. If you have primed your board well, you will be able to wipe back to the white ground.

Think about the drawing developing organically. Block in areas of black and wipe away to reveal mid-tones and highlights. The paint is fluid so if you wipe too much put some more back on but use the same kind of brushes, something

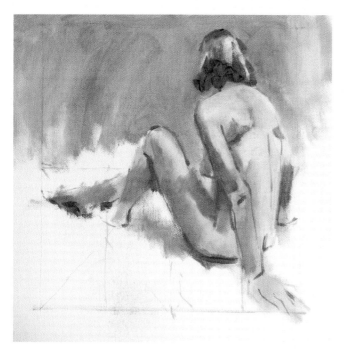

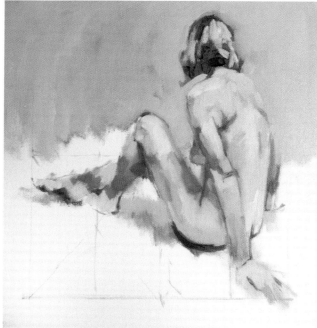

Stage 3. Greater density of sienna is created by adding the darks and redefining the edges.

Stage 4. Now blues, umbers and ochres are added to the general colouration of the figure. The underlying tonal structure gives an armature for the colour to sit on. The cooler colours on top of the warm add a visual excitement.

which is soft but resistant. Try turning the brush on its side, using the wrist to create a thin lay in. Try to keep the paint thin, so that it is easier to manipulate and will dry quicker too. When using oil it is useful to keep in mind 'lean to fat'. Think thin darks and thicker whites; later you can add more oil to your painting to create fatter glazes.

Try the same thing again, this time adding white into the equation.

The aim of this exercise is to consider the way that you can use a controlled technique with a broad brush.

A NOTE ABOUT WHITE

Titanium white is the whitest and most opaque white you can use. This means that if you use a technique where you paint out what is underneath it is invaluable. However, when titanium white is mixed with colour, it can soon bleach the colour out and make it seem chalky. Flake white and zinc white are both used for mixing with colour. Flake tends to produce a warmer tone and zinc a cooler tone; both of these are somewhat more transparent and will give you more luminous colour.

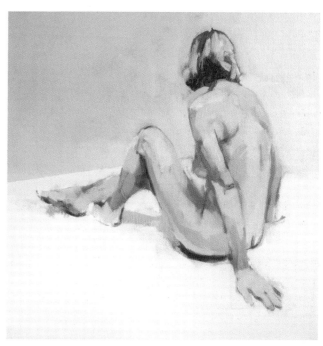

Final stage. More blues are added to the back of the figure articulating the cooler shadow areas making the body recede away from the arm. The foreground was painted to create the solid plane for the figure to sit on using cool off-whites.

Tonal painting on neutral grounds

Any trip to the National Gallery is worthwhile as it is full of fantastic examples of figure painting. Survey the paintings up close, look at their surface and you will mostly be looking at thin paint. They say that you can pick up a Rembrandt by its nose, and it is certainly true that his crusty nose is painted with thick paint. Thin paint enables you to have a degree of control with a fine brush and it will move fluidly over larger surfaces when applied with a stiff flat. It also means when you are using oil that your paint layer dries quicker. As you have now begun to work in both acrylic and oil, you have realized that they behave quite differently. Acrylic dries very fast, in as little as a minute, so your painting technique has to be either meticulously planned or you have the freedom to splash it around with the sure knowledge that you can find the drawing of the figure through the painting. As your first layer will be dry, it will be easier to build up the layers on top of each other and using titanium white you can paint out the mistakes. You will have also appreciated from the mountain of acrylic building up on your palette that you lose a lot of your paint because it dries so quickly and that the surface of your painting can become quite crusty too. If this does happen and the surface does become difficult to manage then you have to sand it down with either sandpaper or wet and dry. You must do this in the open air, especially if you are working on MDF. The surface can become beautifully smooth and allow you to model very fine forms in the figure. You will have also noticed that the tonality of the colour you have mixed changes dramatically, usually darkening as it dries, and this can be used to your advantage once you are used to the degree of tonal shift in the paint. Acrylic changes colour and tone because acrylic medium is white in its wet state, drying to a clear film, so any acrylic colour will appear to be lighter when wet.

Oil obviously takes much longer to dry. They say that oil paint was invented to paint flesh and this slow drying allows you to blend subtle changes of tone across the form of the body. Drying time varies according to the oil content, the atmospheric conditions, the thickness of its application and whether driers have been added to the paint. Oil dries through a process of oxidization: an outer layer of skin forms and then a layer below that and a layer below that. Think about a tin of gloss paint left in the shed; when you break through the top layer of skin the underneath can still be wet. Working in oil, you paint a layer with the least oil content and end up layering with paint with increasingly more oil. This drying process means that the colour does not change when dry.

The National Gallery is full of brown paintings as northern Europe was held to ransom over pigment by the Italians. Look at a Piero della Francesca or a Titian with its light and airy palette and compare it with a Velázquez or a Rubens. Northern Europe had to use the cheaper earth colours and attempted to yield the biggest range out of limited means. Robert Gamblin makes a very insightful comment on his video about colour space, when he talks about the fact that the early Renaissance artists had to develop a painting technique based on value (the relative lightness and darkness of colour) as they had very few pigments available. The nineteenth century saw an expansion in the amount of colour available to artists largely due to the Industrial Revolution and the painting that developed toward the end of the century would start to favour the exploration of hue as opposed to tone (think of Impressionism, for example).

The price of paint varies considerably and the cheaper colours tend to be the earths. You can pay many more times their amount to buy the really intense hues. Getting to grips with value painting will help your figure painting achieve subtle colouration and three-dimensionality.

By using these underpainting techniques it also means that if you do wish to use rich pigments, they can be used sparingly, glazing over a monochrome image staining it with colour, whilst retaining the tonal balance of the image.

Glazing

Acrylic can be thinned down with water to achieve a glaze, but you risk the colour becoming unbound and losing its adhesive quality. Mix your colour with acrylic medium and this will help you to achieve glazes that adhere. The same is true of oil: mixing medium into the paint will extend the range of possibilities with your figure painting. Liquin is a very versatile medium and is favoured by Alex Kanevsky. It comes out of the bottle ready to use and will halve the drying time of your paint. However, there are many different mediums that you can experiment with in both oil and acrylic.

VERDACCIO

Verdaccio is another underpainting technique similar to *grisaille*. You use just yellow ochre, black and white and this produces a greenish-grey result. This can be an excellent colour to play off the warmer notes of the highlights and richer colours of flesh, when you glaze these on top.

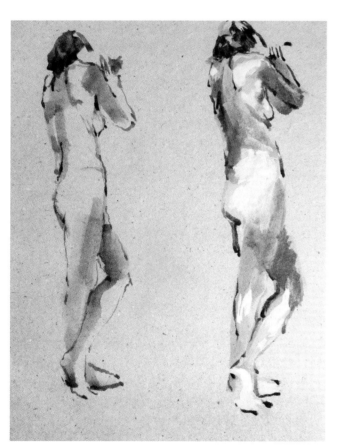

Acrylic *bistre* study. Left: umber acrylic has been used more or less like watercolour on grey board using thin washes to create the darker tones. Right: with the addition of white to create tones brighter than the mid-grey ground.

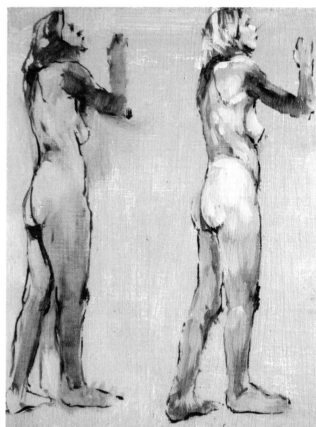

The same again; this time a mid-grey acrylic ground was painted onto the board and a red oxide was used. Note that the change of colour has a massive impact on the temperature of the figure. Note also how the white oil mixes in with the red oxide rather than sitting on top of it.

LESSON 36
Earth palette studies

Materials:

- MDF boards
- Black and white acrylic
- Decorators' brush
- Black and white oil paint
- Earth colours (acrylic or oil) – choose from yellow ochre, raw sienna, burnt sienna, raw umber, burnt umber, red oxide
- Kitchen roll
- Solvent and surgical gloves (optional if using oil)

You are going to experiment on grey grounds producing a series of tonal figure studies. Paint up one of your gessoed boards with a layer of acrylic grey. Aim to produce a light grey ground and onto this you are going to paint using one of your browns in oil and one of your browns in acrylic on greyboard. In this example a red oxide and raw umber were used. Consider the handling of these two materials and their behaviour on a porous and non-porous surface. Think about the nature of the brown that you have chosen: its warmth or coolness, and the depth of tone achievable on the grey ground where grey becomes your lightest tone. Do the same thing again, this time adding black and white to your brown and see how many variations of brown and green you can produce. Once these studies are dry, experiment with glazing these paintings with some of your primary colours thinned down with medium.

The physical characteristics of paint

Painting has to do with viscosity, opacity, transparency, value (tonality as well as contrast and tonal range) and temperature (i.e. warm and cool). How paint feels is vitally important, its density, the drag of the brush, the resistance of the bristles. Put simply, one can think about two fundamentally different painting techniques:

1. glazed layering, the process by which a transparent wash is placed over the top of another transparent wash (where the overlap of two colours produces a third colour)
2. opaque painting, where a solid colour is placed next to another solid colour or placed on top of a solid colour.

How these paints behave will also be affected by the drying rate of the resulting layers and the thickness of the paint. Finding out about different ways of painting, exploring the viscosity of paint, the tension and scale of a brush and the technique employed make for an interesting discovery. Compare *Portrait of Lady Elizabeth Cavendish* by Lucian Freud (1950), with its luminous delicate layering of thin transparent oils on a copper support, to the portrait of *Eli and David* (2005–06). You see later visceral clogged surface of Cremnitz white painted with a stiff hog hair. And you see these two different techniques used by the same artist, fifty-five years apart. Painters learn to paint by painting. It takes time but the discoveries you make will pay dividends in your figure work.

Watercolour

Watercolour is the combination of pure pigment and gum acacia, which is water-soluble. Place too many layers on top of each other and the colours can intermingle and become muddy, so the purist watercolour artists tend to keep to a maximum of three layers. Whilst it is interesting to note that many people decide to take up the medium later in life, it is one of the most challenging techniques in that you have to get everything right – the drawing, the colour, the tone and its placement – in one go. *Grisaille* is a great introduction to watercolour in that it introduces you to the notion of opacity and transparency.

Start with a crisp linear drawing in pencil. Establish the positioning of your figure on the page. Try to keep the surface of the page free from erasure marks as this will scuff the paper and affect the watercolour wash.

David Longo (www.greyisthecolor.com) has just started his own game design company. His Pinterest site is full of visual resources, to inspire him and his team, into these fictive worlds they are about to create. Yet it also contains his own drawings and paintings from the model. How else can you create a believable fiction if your vision isn't steeped in reality?

David writes:

> I started working with watercolour because I like the look and immediacy of the medium, the expressiveness and random qualities. Plus watercolour lends itself to the poetry of saying a lot with little.

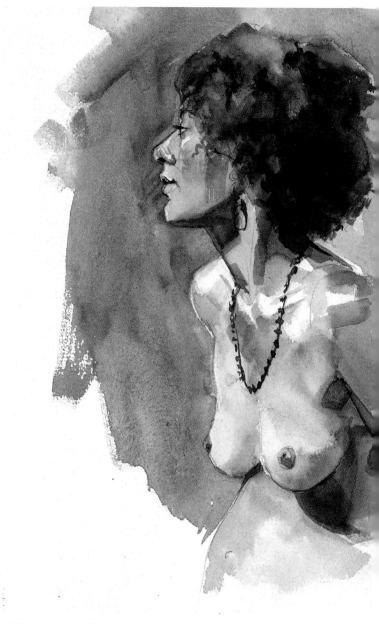

Alternatively make your drawing on a separate piece of paper with as many corrections as you need. Once you are satisfied with it, photocopy the result and rub a thin layer of charcoal or pastel onto the back of the photocopy. Now place this over a new sheet of paper and trace the drawing with a biro. You will be left with a crisp transfer drawing to paint on top of.

Traditional watercolour relies on working from light to dark, starting with the lightest colours and gradually darkening down until you reach the darkest notes. You cannot lighten the colours after application, so like the *grisaille*, it is better to start too light than too dark.

Acrylic can be used this way and so too oil paint (given enough time for the layers to dry). Whereas watercolour is water soluble and too many layers produces a muddy effect, acrylic is waterproof and separate layers do not mix unless one works wet-in-wet, so many more layers can be built up on top of each other without the risk of mixing.

Watercolour comes in two main types: pan and tube. Pan is a combination of pure pigment and gum acacia and the colour can be at its most intense. Spend time with it applying water and mixing up your colour to see how rich it can be. It is useful to have spare bits of paper to colour test on when you are painting. Keep these as a record of your experiments in colour mixing and store in your sketchbook to refer back to. Some cheaper pans can have whiting added and have inferior pigment, so it is far more economical to buy a more expensive watercolour set of about twelve colours than a bigger, cheaper one. Sets with fewer colours will force you to mix much more.

David Longo, *Pigeon*. Watercolour on paper. Longo's watercolours have the same sense of economy that you see in the late Andrew Wyeth's paintings of Helga. White paper is left untouched to describe the light falling on the model's cheek, nose, clavicles and shoulders. Ochre and sienna washes broadly articulate the changing planes of the chest wall, breasts and upper arm. Like a Diarmuid Kelley or an Egon Schiele, the model is left incomplete. She floats, tightly cropped, in the corner of the paper but the eye is not distracted by this absence. Instead you are drawn to her gaze and you also become lost in the beauty of her profile and the beauty of the painting.

Tubes can contain other things to reduce the drying rate of the colour (honey, fillers, etc.) and are really useful if you want to make up a very large wash and work on a much larger scale, but you can end up throwing a lot of your unused colour away. The small watercolour sets usually come with a portable brush. Sometimes these are designed so the brush can be put together to make it long enough to use, where the bristles can be contained inside the handle. Most of these brushes are far too small for watercolour. The best results will be obtained by buying the largest brush that you can afford, which will also hold a point and have a good tension in the hairs. Use soft brushes (nylon, squirrel or sable hair) but do not use hog. Watercolour paper is best used for your watercolour painting and you can think about two main techniques for this medium. The first requires you to make a crisp linear drawing in a hard pencil, which will enable you to identify where to put the paint. Ensure that you keep the paper surface fresh for this to keep any corrections to a minimum. The second requires you to draw with the paint directly and build up the painting rather like the gesture drawing (Chapter 5, Lesson 25).

Watercolour is deceptively difficult. Often overworked and applied with far too small a brush, the medium requires decisiveness of mind, dexterity of hand and lightness of touch.

Indirect watercolour

Materials:

- Large round sable type brush
- Watercolour pans
- Water jar
- Kitchen roll
- Watercolour paper
- Pencil

In this example the feet are very close to the viewer, merely a matter of inches, so their relative size is large with the two thighs shooting upward establishing the maximum height of the figure. The distance between lower toe and uppermost knee equates to half of the total width of the figure measured on the horizontal. The right foot of the model is a third of the distance across. On the other side, the torso takes up half of the remaining space with the model's left arm taking up the last half. Striking horizontals, the armpit is level with the sole of the model's left foot and the breast is level with the ankle of this same leg. So logic would throw your eye and tell you that the body would be bigger and show you more of both the torso and the head. Logic would place the head at the top of the page, not half-way up the leg. The drawing of this image was a much more considered journey across the body.

Establish your pencil drawing first, taking care with the measurements, the negative spaces and the overall proportions.

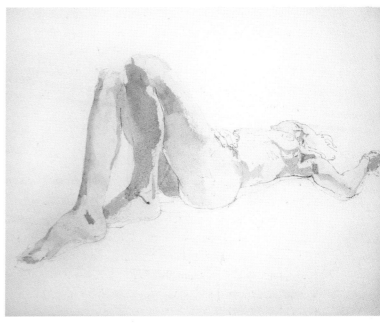

Watercolour study, stage 1. The painting was a more delicate affair. The whole drawing was covered with water and then given a light wash of yellow ochre. Care was taken not to overdo the depth of colour (better to go too light than to try to reclaim an area that is too dark).

Stage 2. The legs, being the darkest values on the figure, came next, working with washes of umber and sienna and building towards the darks, and finding the depth of dark around the bottom and the shadow fast into the model's right leg.

Final stage. As the painting progressed these darker notes were taken across the figure, modelling the thigh and the ankle before moving onto the body and modelling the thorax. Only when the form was modelled were the shadows placed, thinking carefully about the direction of the plane. The blue was mixed with the umber and applied not just to the table but also to the figure as well. Finally the large wash was applied with a much bigger flat brush to establish the background space and the tabletop plane.

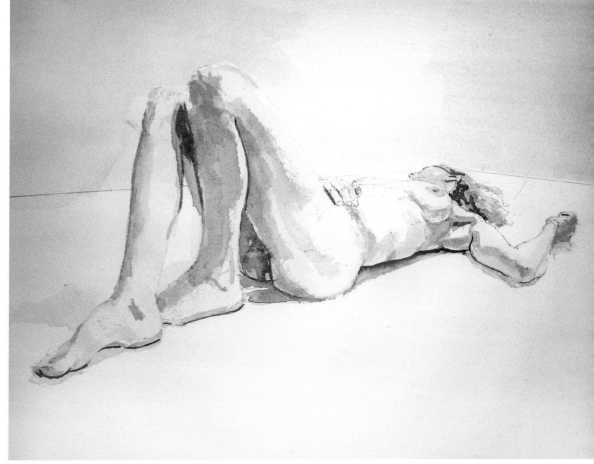

Direct watercolour. In this ten-minute study, no initial drawing was made; instead broad areas of light wash were added, reserving white paper for the highlights. Negative painting was done with the background to find the edges of the figure before a final linear brush mark was added to pick out key forms.

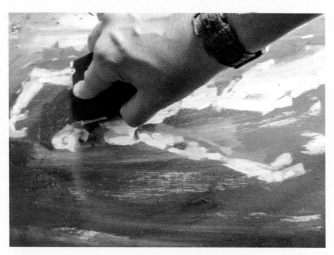

Reclaiming a painting. Whilst a watercolour can be washed under a tap, and an oil painting stripped back with solvent, if you are using acrylic your only recourse is to start again. Here the painting is sanded down to flatten the surface and remove the brush marks. Remember that if you are working with MDF this should be done outside and with a dust mask.

LESSON 37B
Direct watercolour

Materials: as before

You may find that you need to increase the water content of your brush on watercolour paper to enable the brush to move fluidly over the paper. Use what you have learned from gesture and summarize the essence of the pose with a pale wash. You can use just water on its own and then drop colour into the puddle that has formed as this will cause the wash to bleed out into the pool. It is useful to have more than one watercolour on the go at any one time, allowing the initial wash to dry on one painting, whilst you are starting another. Into this gesture drawing you can now add another layer, this time darkening the tone to start thinking about the shadow areas. If the paper is somewhat damp then these will be soft transitions, and like the contour exercises, you can think about the direction of your brush mark. When the paper is almost completely dry, you can return to the painting and work with a finer point to pick out detail and the darkest notes. Remember your tonal exercises, thinking about the limitation of only three tones to work with. With this approach you are aiming for something that has an eloquence of expression, which captures the sense of form and movement. Technically the challenge will be a colour and tonal one, so it is a good idea to test out your discoveries. If you have over-done it then you can remove watercolour by pressing kitchen roll into the damp paint or taking a clean brush dipped in

water wetting the area and doing the same. Be careful not to scrub the paper surface as this will roughen it. As for colour, it would be a good idea to keep it simple and use as few as you can, perhaps two browns and a dark blue. The task is to become familiar with the medium to see how it behaves.

If you want to create a large even wash, you would be better off using a larger flat. Tilt your paper so that it has a slight inclined plane and strike a wide line of watercolour at your topmost point. Repeat this so that your next band of colour touches the bottom edge of the former. That way the first wash bleeds downward and into the next line creating an even tone. If you have highlights you wish to preserve, then you might want to experiment with masking fluid or wax resist.

Reclaiming a painting

Of all painting media, watercolour is by far the most difficult to use. To produce a watercolour without preliminary drawing and to achieve freshness, colour and tonal sensitivity as well as capture the pose takes a lot of skill and practice. Don't despair if your first attempts go wrong. You have to keep drawing with the paint. If all goes wrong and you really do have something that has potential, but has become muddy or the drawing has gone wrong, wash it under the tap.

If you are working on good quality watercolour paper, the weight of the paper should hold up fairly well; ordinary

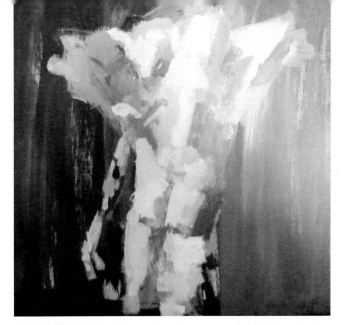

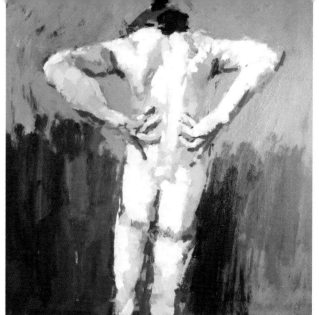

Over the top of the old painting a new one starts. Here titanium white is vitally important as it is opaque and allows you to paint out your mistakes. The underlying image was badly drawn and as it progressed it seemed like a bad idea.

The new painting was much more successful at capturing the dynamic tension in the figure.

cartridge paper may become fragile. You will be able to take off a fair amount of the paint. You can use a clean sponge (a clean kitchen scourer is fine). Wipe the paint off in one or two goes if you can but do not try to keep wiping as this could damage the paper surface. You can also lay kitchen paper over the top of your damp painting and blot off excess paint.

If you are working in oil, depending on how well you have primed the support, you can virtually remove all of your initial lay-in with solvent and a rag. If it is acrylic then you have to resort to sanding down your painting and overpainting in an opaque technique to place a new image over the old.

Watercolour paper is costly, which can be intimidating, so use whatever paper you want. Even envelopes can be used to create a fine painting.

Practise making the same painting over and over again, especially if you are using a photograph to work from. Think about replication and variation, working from the same image but changing one thing. Traditionally watercolour is about transparency but a derivation of watercolour is body colour. This is the combination of watercolour and white gouache. Gouache gives you the chance to paint with opaque colour and to overpaint what you have done. Designers' gouache is a rich pigmented version of poster paint and powder paint. It can be a beautiful medium and is as broad in its scope as oil or acrylic. It is watersoluble so can be affected by layering, but can be very exciting to use with watercolour on coloured paper as well.

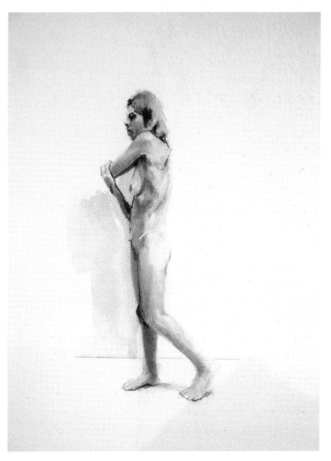

Body colour. This study incorporates both traditional watercolour and the use of white gouache to pick out the lights and to create more muted hues.

Alla prima in oil

To some extent you have been working with a reactive medium. You paint a colour onto another colour and that causes a reaction. What you paint first will be affected by what goes on top. You need to consider your approach to the painting; should you find the drawing or fill the drawing? You could start by drawing out the main forms, structures

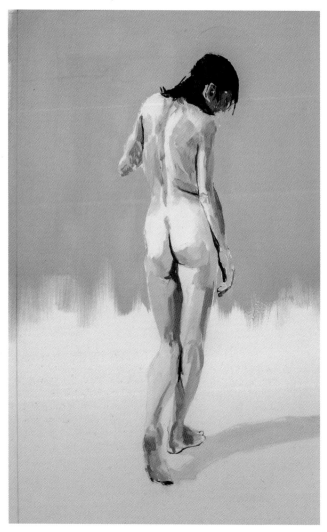

Shaun Ferguson once said to me that you had to be much more *strategic* in oil painting, as you had less opportunity to 'find' the figure than with acrylic. In this painting of Johanna, which is oil on paper, I experimented with drawing the whole figure in pencil first, mapping the structure of the body in much the same way I would approach a watercolour. I then premixed all of my colours on a very large palette using a palette knife and then tried to place each colour very decisively, using a soft flat. Only when this was dry did I return and glaze back into the painting, using much more liquin to create transparent tonal and colour changes.

or movements and like watercolour apply the paint thinly, building up thin darks. You could build toward the lights, gradually increasing the confidence and assuredness of your mark-making. The aspiration is to achieve the totality of the painting 'all-in-one wet' as Ken Howard states in his book *Inspired by Light*, in that everything on the surface of the painting is drying at the same time and at the same rate. Howard goes on to suggest that if he doesn't achieve this, the following day he returns to the painting and scrapes it down removing the thicker areas of paint but leaving traces of the previous day's work as a starting point for the following day's all-in-one wet application. If one is working on canvas the scraping back with the palette knife leaves a ghost image because the paint sits in the weave of the cloth and the knife removes the top layer. But if you were working on board then the whole image might come off. Other areas of paint can be tonked by applying a layer of newspaper over a wet area to remove some of the surplus. This reduces the amount of paint on the surface without wholly taking the image away and will also leave you with a monoprint on the paper.

If you look at the YouTube clips of Sean Cheetham painting a head, then you can see that he initially covers his canvas with an *imprimatura* layer of raw umber. Into this he draws with the paint in a linear way establishing the main measurements for the form, the brow, eye sockets, placement of the nose and mouth, etc. He also establishes the shadow shapes using a thinned turpsy umber. He then proceeds to identify the darkest tones on the head. Working with opaque colour, he blocks in the darkest parts first, so that all the darks that are the same tone are painted at the same time. He then modifies this pool of colour, lightening it before then moving onto the next darkest tone, gradually moving the tones toward the light. Cheetham paints with a fairly traditional set of earth colours, and it is interesting to note how the coloured ground (which initially seems dark) is actually the tone of the lightest notes on the head. It is only when he blocks in the big darks surrounding the head that you see this. He finally works on establishing the key lights before also going back into the darks to readjust the depth of tone.

Generally Cheetham works with opaque colour applied fairly directly, like a jigsaw, placing a patch of colour next to another patch of colour without much overworking where the colour could become muddied. The placement of each patch of colour is assured and that goes back to the underlying drawing being sound. He uses filbert hogs, which are not too large and he keeps the overall paint film relatively thin.

LESSON 38
Alla prima

Materials:

- Canvas or MDF boards
- Black and white paint in earth colours (acrylic or oil) – choose from yellow ochre, raw sienna, burnt sienna, raw umber, burnt umber, red oxide
- Kitchen roll
- Liquin (if using oil)
- Solvent and surgical gloves (optional if using oil)

Place your model against a large sheet of black fabric. Use a light source to the left and above the figure so that you get raking light and modelled shadows (Rembrandt lighting). Try your own all-in-one wet painting using the techniques outlined above. Remember to get the drawing right at the start and use an approach to sight size where you get the figure to be the proportions you want. Use a technique mentioned in Nicholas Beer's book *Sight-size Portraiture* of holding a hand-held mirror so that during the process of the painting you can look at your painting and the model upside down or inverted left-to-right to help you see the work afresh.

LESSON 39
Demonstration of an acrylic alla prima study

Materials:

- MDF board
- Acrylics in titanium white, yellow ochre, crimson, raw umber and phthalo blue
- Hog brushes
- Kitchen roll

Painting of Felix, stage 1. For this figure painting, the palette consisted of white, yellow ochre, crimson, raw umber and phthalo blue. The colour was arranged on a piece of MDF the same size as the painting into mounds at the top edge. Working with a large hog, the kind that is used by professional decorators, a colour is mixed up on the pallet, which is similar in tonality to the unprimed MDF board. The figure is considered for some time, trying to visualize the five key brush marks (or less). What is the essence of the pose? What are the main directions of the torso and limbs; what are the angles between the pairs – shoulders, knees and ankles?

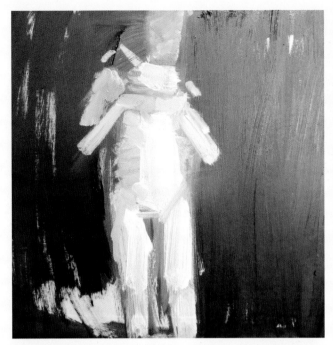

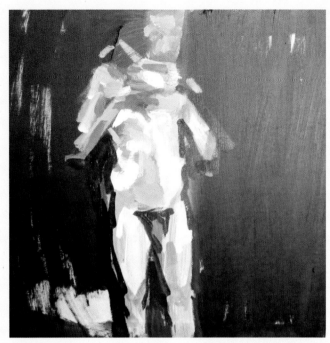

Stage 2. The initial marks were made within a few seconds, like the gesture drawing trying to capture that spirit of the pose. Into this wet puddle of colour, some yellow ochre and crimson were added and then this colour was used to establish the tonal shift of the big planes. Try not to mix up too much colour and do not overload the brush. You want to have enough for a few marks and then mix up a new colour. That way your painting will have a colour richness rather than everything becoming a muddied monochrome. Block in the large masses of the background to help you judge the tonality of the whole image.

Stage 3. Changing to a smaller brush, start to make some bold statements about the planes into the wet areas of paint. See what happens to the colour when it mixes on the surface and also when it dries. Acrylic dries very quickly: even your paint mounds are drying out, becoming more viscous. Too much paint too early will create a difficult impasto surface to work with.

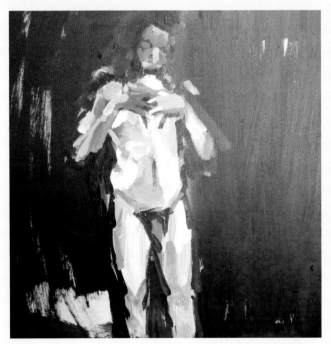

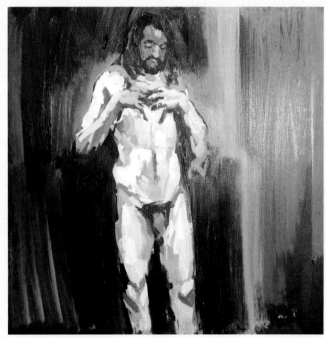

Stage 4. Mixing raw umber and blue together gave a dark that was then used to tighten up some of the drawing. Working with yellow ochre and crimson some warmth is added to the image, which began to suggest that the large expanse of shadow area might be left cooler.

Final stage. More colour was added in smaller and smaller dabs, trying to retain the freshness of mark-making but equally serving to describe the changing planes.

Painting of Lyndsey, stage 1. A much bigger painting this time, executed with a much bigger brush. The same approach was used at the start, trying to capture the whole figure in five brush marks.

Stage 2. Into the sienna some white and yellow ochre were added and more dynamic mark-making was painted into the wet colour underneath.

Stage 3. Raw umber was added to the mix, trying to make sense of the shadow detail.

Stage 4. More dabs and dashes of paint were added, trying to develop the form. As a rule of thumb, mix a little colour and try to use it wherever you see its presence. As you will run out of colour, you are forced to mix up a new colour which keeps the image alive.

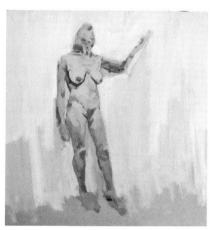

Stage 5. Negative painting starts to block in the space, but it also starts to re-address some of the drawing that is wrong. Whilst it would be lovely to get everything right in five marks, it so often goes wrong and you end up with distortions. These can be corrected or retained depending on whether or not they add to the emotional intention of the work.

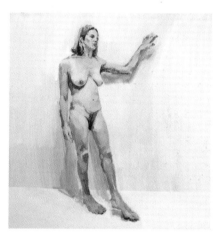

Final stage. A lot of subtle scumbling, dry brush and glazed layering was worked into the body to bring it to a conclusion.

LEAN TO FAT

Lean to fat is a general principle applied to the ordering of layers in oil painting; thin, heavily diluted glazes forming the underpainting are built onto with subsequent layers of fatter, more oily paint. Oil painting cracks if there is uneven drying rate across the work. It cracks if the layer of paint on top of another layer dries more quickly than the layer below it.

LESSON 40
Oil alla prima *study*

Materials:
- Oils in lemon yellow, cadmium red, burnt sienna, ultramarine
- Liquin

Time: approx. 1 hour

In this short *alla prima* oil study be bold and do not be frightened to mix colour that is wrong. It is perhaps better to be affirmative and attack the painting, being really direct with your mark-making. As the painting progresses you can always modify the underpainting. Start with the biggest brush you can and make each mark describe the direction of a limb. Consider the light and darks and try to work toward the tonal relationships. Once you start to work more on the form, gradually change to smaller brushes finally finishing with a small round to pick out edges and linearity.

A study like this benefits from the tensions set up between you, the model and the length of the pose. You are not after a photographic likeness; instead you want to make a painting that contains beautiful marks and beautiful colours.

Scumbling and drybrush

One of the fantastic things about acrylic is that it dries really fast and it enables you to build up layers really quickly. You are not limited by the lean to fat rule, so thin paint can be painted over thick troughs, watery glazes can create exciting marks on the surface of the painting. You can paint with a knife and soon afterwards modify the surface with a glaze and rest assured that the paint will not crack. You can redefine your edges within a matter of minutes and a whole gamut of painting techniques can be deployed in a single session. What would take months in oil, takes hours in acrylic.

The disadvantage of working with acrylic is that it dries quickly – as discussed before, you do not have much scope for moving the paint around and it is difficult to remove the paint once it has been placed. The surface of the painting can build up very quickly and leave a crusty texture that can be difficult to work over unless you sand it back, and it is very difficult to blend colour and produce soft transitions of tone. One solution is to employ the technique of scumbling and drybrush. In this example you can see the progression of a painting using this technique on a black ground. When Courbet said, 'I have discovered light' he was working on a black ground rather than a white one. Every colour, relative to the black ground, is lighter than it, so one is painting the illuminated form out of the dark.

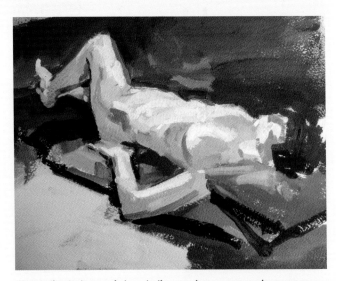

Direct oil painting made in a similar way, but on watercolour paper. The absorbency of the ground was making it difficult to move the paint around so the whole image was covered in Liquin first. Study made with lemon yellow, cadmium red, burnt sienna and ultramarine.

Scumbling study, stage 1. Crimson was scrubbed on to the surface of an MDF primed with black acrylic. This red almost disappears into the black ground but allows you to establish the drawing without absolutely committing to it. A little yellow ochre was added to this and as another layer is scrubbed on, this red becomes somewhat more visible. Further layers start to build up to the lights.

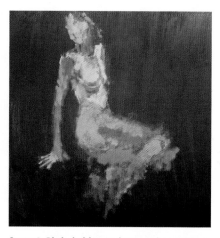

Stage 2. Phthalo blue and raw umber were mixed into this pool of colour and further areas scrubbed into, this time concentrating on the shadow and some of the tonal shifts within them.

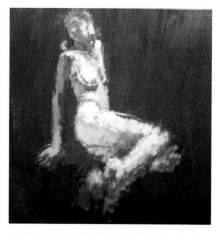

Stage 3. White is used much more now to scrub highlights over the darker areas of the image. At this point the action of the brush, although still loosely skating over the surface, has a more dragged, controlled feel, modelling the contours.

LESSON 41
Scumbling and drybrush

Materials:

- Canvas or MDF boards
- Acrylic in black and white, yellow ochre, crimson, raw umber, phthalo blue
- Kitchen roll
- Solvent and surgical gloves (optional if using oil)
- Liquin

Sickert used a lot of scumbling in his work, often utilizing very coarse canvases so that the texture of the canvas itself would create this broken colour. He would scumble a layer and leave it to dry before returning to the next layer the following week. It was said that he started one painting on a Monday, another on a Tuesday, another on Wednesday, and so on, so by the time he was back to the beginning of the week his first layer was bone dry. So what looks like a spontaneous study was actually the product of many months' work. The contemporary French figure painter Jean Rustin also uses scumbling with acrylic. His colouration, like Sickert's, uses muted de-saturated hues which optically fizz on the surface of his paintings creating a rich but darkly compelling image. In the following demonstration, a study after Sickert has been made which may throw some light onto how Sickert would have gone about his painting. This study is based on *Le Lit de*

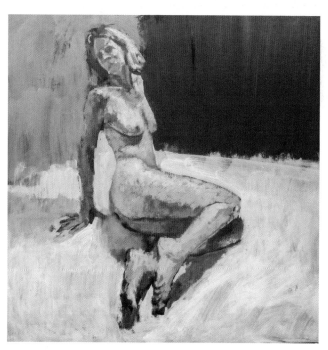

Final stage. More controlled drybrush is added (dragged), pulling out much more delicate transition of colour. Negative painting helped establish the edges of the figure as well as hinting at the space behind.

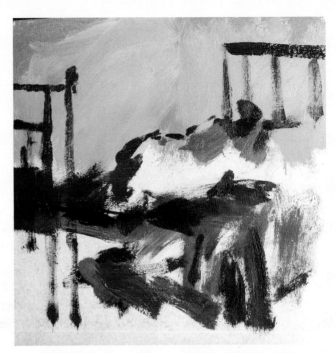

Sickert study, stage 1. Using acrylic on unprimed MDF, some broad sweeping marks of crimson and green were scrubbed very quickly over the surface to help establish the cast shadow of the figure and the background wall.

Stage 2. The next set of marks began to define loosely some of the drawing, establishing both the front and the back of the four-poster bed and beginning to indicate the figure with a series of short sharp strokes of crimson. Ultramarine was mixed with umber to create the near-black darks. This was drawn back into the figure using stabbing motions to create the abrupt bits of drawing.

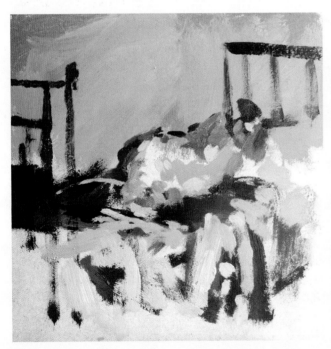

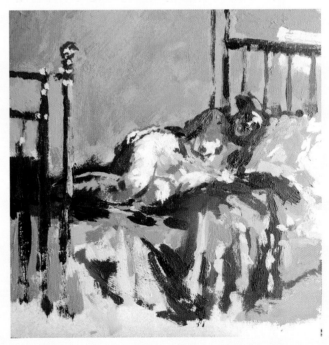

Stage 3. As the painting developed, more scumbling was used to build the mattress, the pillow, and the mid-tones of the figure, once again mixing small amounts of a colour and skimming this over the surface of the painting, questioning where that tonally equivalent colour could go.

Final stage. More colour mixing and smaller marks add to the tonal dimension of the study. Sickert would wait weeks between the application of each of these layers ensuring that the oil was bone dry before the painting progressed. In acrylic this study was completed in one hour.

Cuivre (1906), which is supported with a pastel study *Le Lit de Fer* (*The Iron Bed*), made in 1905. It was Sickert's early practice to make drawings from life and then make paintings from the drawings. Much later on in his career, Sickert was one of the first artists to make paintings from newspaper photographs. This process of making the painting from the drawing meant that it gave the artist a distance between the life model and the painting which meant that he could begin to consider the painting as a thing in its own right and be much more abstract in his approach. It is also interesting to note that Sickert made two versions of the same painting with two different rectangles and different compositional and colour arrangements. This study was done in acrylic on an unprimed MDF board. Acrylic is not detrimental to the support so does not need priming. The colour of the board provided a mid-toned ground and the absorbency of the board suited the technique. This meant that the whole painting was completed in one hour.

The paint is applied to the support in a dry state where very little moisture is used. This means that the deposit of colour is not too great but it can be built up quickly in acrylic. The same effect in oil will take considerably longer when one allows for drying time in between layers. Scumbling can also be done with watery or thinned colour. The action of the arm will thin the colour and modify the under layer. With acrylic this can be done with water or medium and in oil painting Liquin light gel is a thixotropic medium for scumbling.

Whilst the action of the brush is a physical one in scumbling (it is more the action of the arm that brings about the beautiful smoke), drybrush produces a similar effect but with a different kind of physicality. Ruskin describes an approach to watercolour in *Elements of Drawing* where on top of a wash a tiny amount of moist colour is applied to the end of a small brush and this colour is carefully stroked over the surface, catching the tooth of the paper and leaving a deposit. This can be done with a larger brush too, but the effect is the same, building up layer by layer, tiny strokes of colour. In the watercolours of the Pre-Raphaelites, this produced incredibly rendered and luminous watercolours that almost look like oil painting. In the twentieth century Andrew Wyeth used this technique in both his watercolours and his egg temperas. At the height of his fame, Wyeth undertook a series of secret paintings of Helga Testof, caretaker to one of his neighbours in Chadds Ford, Pennsylvania. Hidden from everyone, including his wife, Wyeth produced over 240 paintings and

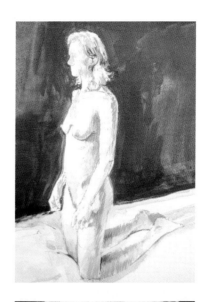

The light poured in through the studio window creating this amazing intensity of light. For the briefest moment one was reminded of Wyeth's *Helga* series. So, like Wyeth, this acrylic study started with a pencil drawing, then had large washes applied to it before finally working on small, delicate hatching and cross-hatching marks of opaque colour applied over the top.

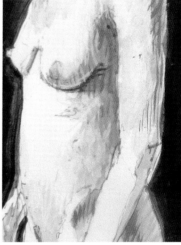

Detail of the hatching and cross-hatching which serve to create visual flickers of bounced light across the figure.

these were supported by numerous pencil drawings and watercolour studies. The watercolours hover between high realism to abbreviated annotations. At their best they have a tremendous vitality and visionary quality. Wyeth mostly worked in egg tempera, a medium of pure pigment mixed with egg white. Painted onto a gesso ground, this paint dries almost instantaneously. A contemporary practitioner of the medium is Antony Williams who like Wyeth builds up a painting through tiny flecks of colour. An interesting connection here is that the technique works in a similar way to coloured pencil, layer upon layer of little marks, which mix together optically to produce an overall colour. Williams uses this idea to play off underpainting layers of differing hues to produce shimmering but quiet distillations.

This acrylic study pays homage to the composition and lighting of one of Wyeth's *Helga* series.

Dabs and dashes study, stage 1. The painting started with a broad series of slab-like marks. The notion of these marks was to find the atmosphere of the space and go some way to considering the negative space surrounding the figure.

Stage 2. More marks were added, trying to create an exciting space that would hint at some of the objects contained within without giving them focus.

Dabs and dashes

David Dawson was Lucian Freud's assistant and had unlimited access to Freud's working process before his death in 2011. In a very telling series of photographs of a painting in progress, it is clear to see that Freud started a painting with a charcoal drawing on canvas. This was then dusted back with a cloth to reveal a ghost like framework as well as ensure that the loose charcoal would not mix with his oils. Freud began by painting a series of slab like dashes of paint establishing a set of colour and tonal relationships that gradually built outward to form the image of a head. As the painting progresses, more slabs of colour find the form and the overall composition starts with the centre pieces and works outward. One of the inherent problems of oil painting is caused by layering wet paint on top of wet paint so instead each colour is placed next to each other (like we saw with Cheetham). Without layering, the problem of wet-in-wet painting is minimized and each area of colour is left to dry by itself. This broad brush technique was developed by the Impressionists as a way of

solving the problem of *plein air* painting. James Guthrie's *A Hind's Daughter* shows a beautiful set of slab-like marks which help define the cabbage growth in the foreground and her skirt. You can certainly see it employed by other coastal painters at the turn of the century. Van Gogh employed the use of short dashes of colour in his oils because it gave him the colour intensity he was seeking and the direction of the strokes could help him define the form or the movement of the subject.

In the following example, the photographic source material was put into photoshop and the DPI (dots per inch) were deliberately altered to produce a highly pixelated image. This helped create the impression of a dabs and dashes painting so it was much easier to translate it that way. It also meant that one was much less likely to concentrate on detail, but instead capture the overall feel of the figure. A similar thing can be done by reducing the image size on the computer screen and then taking a screen snapshot of the small image; alternatively, just squint at the figure.

Stage 3. The figure has been located within the space and summarized into a series of broad dashes establishing the direction of the limbs and torso.

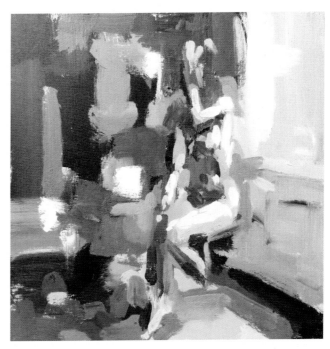

Stage 4. The lights are now being found and with it a description of the figure through smaller marks. The scale of the brush has changed at this stage.

Bernard Dunstan's painting often uses this approach to dabs and dashes, as well and scumbling, to create his richly-encrusted intimate interiors. Dunstan uses distemper, a medium that was also favoured by one of his heroes Vuillard. Rabbit-skin glue size is prepared in a double boiler like a bain-marie. The hot glue is mixed with dry pigment rather like egg tempera and this is applied to the support. The colour dries very fast and can be layered almost immediately, a bit like acrylic.

A more contemporary example of this technique is demonstrated by the American painter Ann Gale. In her painting *Empty Kingdom*, a male figure lies on a couch in a shallow space. The background is constructed out of a number of larger decorators' brush marks. Whilst the figure is constructed from a similar set of hues, their scale and changing direction begin to indicate changes on the form. In more recent work the scale of the dashes has diminished and the surface is constructed out of multi-layered dabs and dash marks. If areas of paint are in the wrong place then the painting is scraped and subsequent reworking can take place.

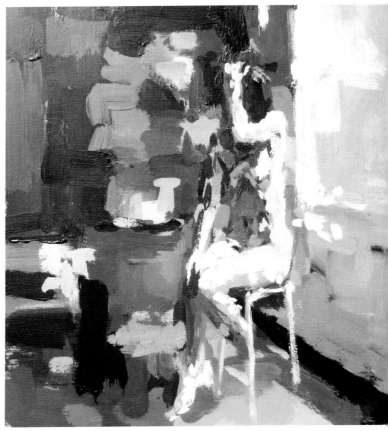

Final stage. The figure is finally resolved with small inflections of colour trying to keep the image still quite open for the viewer to do the work.

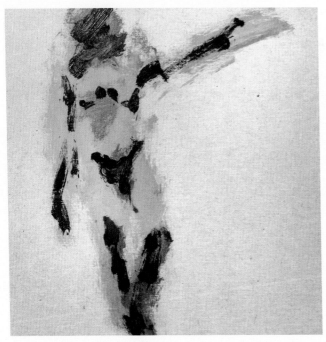

Dabs and dashes, second study, stage 1. In this example the painting starts with the figure rendered in smaller more closely toned dabs rather than on the space around the figure.

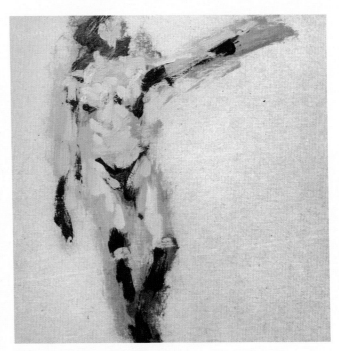

Stage 2. At this point the edges of the figure are undefined by the darker stabs of crimson mixed with umber begin to establish more of the drawing, as well as pick out the darker tones.

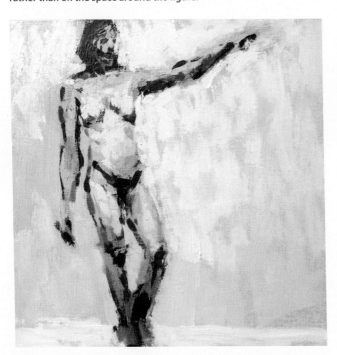

Stage 3. Negative painting is being used to define the edges of the figure and create some space for it to stand in. At this stage the drawing is not quite right.

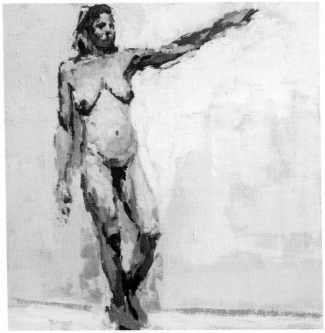

Final stage. Smaller dabs are now finding the range of tones and colours across the figure and have helped correct some of the drawing problems of the earlier stages of the painting.

Complementary colours, stage 1. The pencil drawing has been used to pin down the figure. Consideration at the outset was given to the format of the rectangle, the basic shapes of the triangle and rectangle of the legs, and the horizontals that the figure fell within.

Stage 2. Working with cadmium yellow mixed with cadmium red, washes and hatching marks of purer colour are applied to this drawing trying to retain the whiteness of paper to get real luminosity.

Stage 3. Mixing phthalo blue into the orange produced muted hues. These were also glazed over areas and more hatching marks were added to model form and define the half tones.

Pointillism

Pointillism is another technique developed at the start of the twentieth century by the French painters Seurat and Signac. The painting is built entirely out of a series of dots of pure colour. In close proximity, the colours mix together optically in much the same way that a magazine looks to be in full colour but is only printed with the yellow, magenta, cyan and black. This technique produces luminous colour but is incredibly labour intensive. Chuck Close uses a similar dot technique for his large scale portraits. Here layers of colour are placed on top of each other in a concentric set of circled dabs and dashes. Each individual colour optically mixes to create an overall colour effect, and like a pixelated image coalesces into the recognizable image when viewed at a distance.

If instead of dots we used lines, then we would apply the paint in much the same way as an image is constructed from hatching and cross-hatching; Toulouse Lautrec is a good example of this. Lautrec did a number of intimate oils on cardboard in the brothel that he often frequented. These were made with hatching marks using the paint in the same way as one might use a coloured pencil. The quick drying nature of the medium meant that these layers of broken colour would create optical colour transitions.

Stage 4. A large wash of blue was added to the background as well as placed into the shadows cast by the figure.

Final stage. A chromatic grey was mixed and this was placed under the figure to act as a strong visual contrast.

LESSON 43
Knife painting

Materials:

- Flat palette – a piece of hardboard or MDF, acrylic sheet or an old tea tray (alternatively you can tape cellophane to your painting table to give you enough room)
- Acrylic paint in titanium white, yellow ochre, phthalo blue, raw umber and crimson

You will find it easier to mix up colour freshly with a palette knife. Of course one of the great things about the knife is that it is easy to clean (simply place the knife in some kitchen paper and wipe off the paint) so you are not left with the problem of paint residue on the end of the brush sullying other colours. If you are using oil, you can quickly mix up a large quantity of one colour or lots of variations of colour. It is a lot easier if you are mixing on a flat palette rather than a well palette.

Knives can be used to paint with and they can yield some wonderful mark-making opportunities. Work larger and with conviction, think about thin layers built up toward thicker ones and consider the figure simplified down to form flat planes. That is why it is a good idea to make a palette knife from the collage you made in Chapter 5. If you are working from digital images, it might be useful to use some kind of filter to simplify the planes. Otherwise return to the squinting techniques used in tonal drawing. Kyffin Williams provides a good example of how to use the tool; so too does Paul Wright.

Knife painting is a physical act: you are moving the material around the support and trying to capture the figure in a highly simplified way. The larger the painting the more scope there is, so concentrate on the main masses and directional forces of the figure.

Nicolas de Staël did not describe the tonal transition across a buttock. He wanted to strip the figure down to its core and summarize the notion of a footballer in motion. Do not be frightened by simplicity and strive for directness.

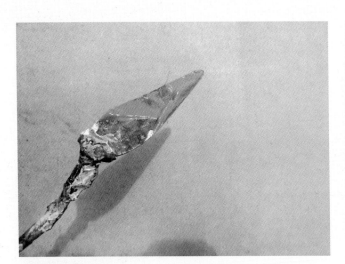

Painting with a knife. Gather up a small amount of colour onto the edge of your knife. A little will go a long way if the physical energy that is used is direct and assured. You can literally scrape the colour over a board or canvas. Thinner colour will dry more quickly, regardless of medium, but in acrylic the less paint build-up there is, the better, especially if you have to modify the painting later.

Mixing with a knife. Alternatively you may wish to leave the colour somewhat unmixed so that the knife mark has striations running through it.

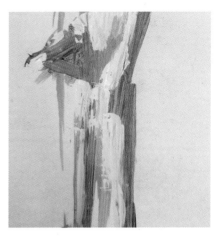

Like so many of our techniques, there is a difference between oil and acrylic. The drying time of acrylic affords you the luxury of intent. Be forceful. Do not be frightened to be bold in your statements. A five gesture drawing is a good place to start. Try to establish with eloquence the five main directions of the figure.

It is much better to work with a palette that is flat rather than something textured, so for this painting a new board was selected and puddles of colour applied tonally at the top to maximize the space to mix. Use the knife to scrape off a section of each puddle to gather into the middle to mix. Experience of mixing colour will tell you how much to use. Colour mixing practice is valuable so try mixing colours on your palette and recording their results. This will build a colour memory in your head. Pull the colours through each other until they blend together into an even hue. Now some umber is mixed and applied to establish some darks.

Now white and phthalo blue is mixed together to make a light tone and these are added in broad swathes.

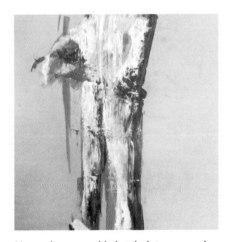

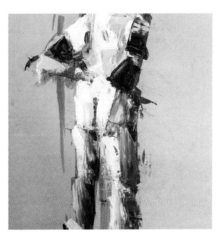

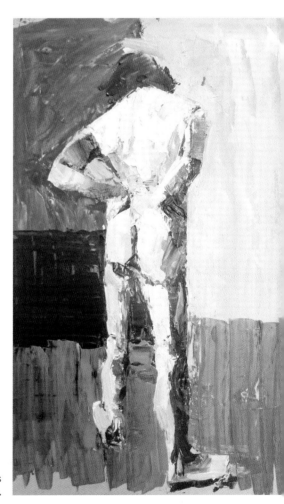

More colour was added and a lot more work went into developing the form, but the drawing and sensitivity of mass was lost so the image was scraped back.

Once you have established the directions of the pose, begin to build up the masses. In this instance the colour begins to find uppermost parts of the form that are catching the light. The decision was made to simplify the planes into box like constructions and to use just a three tone approach to understand the figure.

More work went into the figure using the intermediary tones as well as establishing the negative space surrounding the figure.

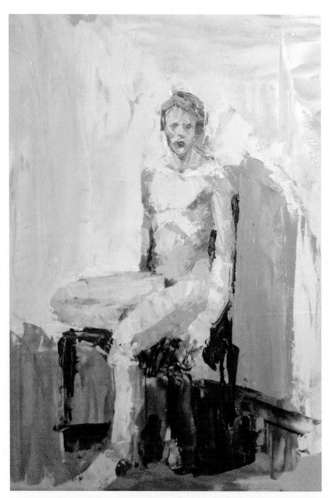

Direct acrylic palette study from the figure. The painting was made with cheap plastic painting knives and a small metal one. There was a real tension to get the study completed in forty-five minutes.

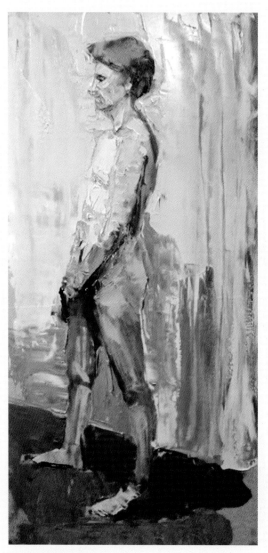

A similar timescale, this one executed in oil mixed with Liquin. There was a sense that the paint could move around the board a lot more easily than the acrylic, and colours could intermingle, but there was also a sense that it could all become a cacophonous mess if the drawing lost focus.

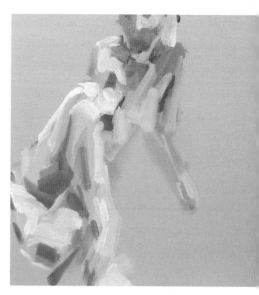

In the example given here the first marks were made thinly on a grey ground using a little Alizarin rose madder and yellow ochre to start.

Then raw umber was introduced into the mix and some of the darker tones blocked on, trying to use the grey ground and the highlight tone.

Now the wiping starts, cutting back into the paint to allow space for the lighter paints. Use kitchen roll to remove excess paint and to redraw.

Now white is added and the highlights are starting to be blocked in (keeping to the same brush at the moment).

After cleaning the brushes and palette, fresh colour was mixed up and the big brush replaced with smaller synthetic flats. All of the brush marks are executed with a determined chop, keeping the motion short and in the direction of the plane, so that the paint is kept fresh and purposeful. The painting continues trying to model the form, to reach up to the highlights as well as introduce some linear elements to define the drawing.

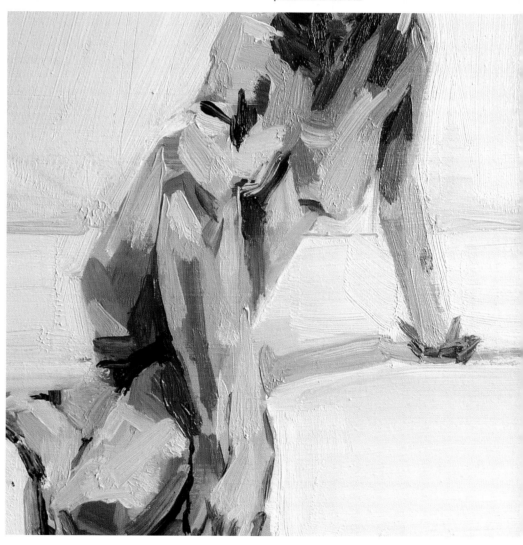

Impasto

Thick impasto offers more challenges especially if one is working in oil. Impasto can be applied with a brush or knife and in many instances both. When working in this way, you are almost sculpting with wet clay, building up form and scraping it away to rebuild again. The material is alive and responds to every touch so in order to avoid a quagmire of brown, you need to return your thoughts to those gesture drawings and make positive decisions. Kitchen roll is essential and invaluable for wiping brushes clear of paint.

Working with a lot of brushes is a good idea. You can premix a lot of puddles of colour in advance and each brush might correspond with a different colour, That way you will have more chance of producing a fresh result. Regular palette cleaning is essential too, especially if you are using a big brush. You will run out of room once those puddles of colour have mixed in with each other. One of the joyful things about using water-soluble oil paint is the ability to clean brushes with just washing up liquid and water. Seconds at the sink and you are ready to return back to painting.

If you are going to use solvent for cleaning traditional oil then do not pour this down the sink as this is harmful to the environment. Try to clean your brushes as much as possible onto newspaper and kitchen roll to remove as much excess paint as you can. Leaving your brushes in a jar with solvent is not a good idea either: the solvent will cause the sludge of oil paint to come off the brush but the tips of your brushes will be sitting at the bottom too. If you have something at the bottom of the jar to allow the tips to rest above the sludge then the overnight clean is a good idea. You can also buy a paint can that has a wired handle where brush handles can rest. Dirty solvent can be poured through coffee filters and decanted to another container, leaving the sludge behind.

The impasto technique can easily go wrong. The palette knife is a handy tool to scrape back the paint and leave a space to rework the image. It can be soul destroying when you lose control of the image, so you have to be prepared for the frustration. Persistence is vitally important.

TIM BENSON

Tim Benson (http://timbenson.co.uk) studied at Glasgow School of Art and then went on to Byam Shaw. By his own accounts Glasgow gave him a good grounding but his journey to becoming a painter was largely one of self discovery; only through thousands of hours of deliberate practice, and many disasters along the way, can an artist make an image look simple.

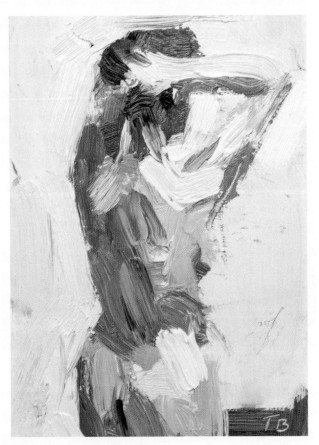

Tim Benson, *Standing Female Nude* (oil on board). This small oil sketch, executed quickly and masterfully, captures the essence of this pose: the hands held behind the head, the internal curve of the back sweeping into the external curve of the bottom. The plane of the right shoulder blade is elevated upwards and described with two brush marks.

An impasto approach in acrylic is a lot easier as you have less of a problem with wet-in-wet muddying, but it can dry too quickly if you want to achieve a particular effect. Of course you are using a lot of paint and this can be off-putting especially if you are using expensive colour. You can make your own impasto medium quite inexpensively by mixing talc and PVA until it achieves a thick paste. This can be applied to the support to create texture that you can then paint on or it can be mixed into your colour.

Chaïm Soutine provides an early precedent and so too do Matthew Smith, David Bomberg and of course Frank Auerbach. If you ever get a chance to see the inside of Auerbach's studio then it is worth noting the splattered paint residues of failed attempts. Perhaps more so than ever, the underpinning armature of brush marks is vitally important. Get the proportions, angles and masses established right at the start with a big brush.

General points

A good strategy when working on a white ground is that you should start light and work down to dark. With a mid-toned ground, you work either side of it finding the darks and reaching up for the lights. It is all too easy to see the lights too light especially if you are using photography as a reference point. Coloured grounds are an excellent way of making your painting more economical in that they unify the pictorial surface and create a colour theme to work against, as well as reducing the absorbency of the ground so that the paint goes further on the support. A black ground can make muddy colour beautiful and helps you focus on painting light rather than dark. Some people prefer to sketch out the design in charcoal first and then work in with paint, dusting off the excess, whereas some want a meticulous drawing to work into. Some draw with paint and some get stuck straight in, finding the drawing as they go.

Use whatever works for you and do not feel that there is a right way to do anything. These demonstration paintings have been done with the intention of getting you started. All water-based paint can be mixed together (gouache, watercolour and acrylic) in the same piece of work. Oil paint can be painted on top of acrylic, which means that you can do the underpainting in acrylic which is fast drying and the more refined blended top layers in oil. However, do not put acrylic on top of oil as it will not adhere and will eventually peel off. Egg tempera was traditionally used as an underpainting layer in many Renaissance paintings for the same reasons as acrylic.

Techniques can be mixed together in the same painting; do not feel bound by the categories. If money is short, then work cheaply with paint samples from the DIY store, bits of cardboard as supports, or off-cuts of wood and lining paper. Enjoy the process and do not be put off by the challenges. If a painting goes wrong, sand it down, scrape it back or wash it under the tap. If it is a complete disaster, paint a new colour over the top of it and start again. Take time away from the painting and analyse the work in your sketchbook. What needs changing? Sometimes the answer comes when you get rid of the best bits. Photograph everything you do and keep a record of the various stages of a work. This is really useful to look back over after a few months or years. Ask yourself the questions, 'Have I learned something? Am I getting better?'

The question of technique is not a search for style but a recognition that different kinds of paint behave in different ways. Only through your own experimentation will you find what works for you. In terms of drawing we discussed the idea of mindset: how you are will influence how you paint. You might want to sit down and be very intimate with the subject. The figure may suggest a quiet and tentative approach. Another day and the dynamism of the pose or the movement of the figure may require something more passionate and gestural. Experiment with everything – scale, media, support, ground, viscosity, implement, and the different ways that you can put the paint on. Do not be frightened to get it wrong, as this is how you learn. When you get complacent with the way you work, change something.

Keep your attitude to the discipline: aim to learn something new each time you make a painting.

Study after Muybridge. Part of a series of small-scale male nudes painted from the black-and-white photographs Muybridge made at the end of the nineteenth century.

Colour

hat is the colour of flesh? Pink, brown, white, purple, green, or perhaps all of them?

In much the same way as you needed to learn to see differently to help you with your visual perception and improve your drawing, you need to tune your eye into colour. Many people look at a post office box and see a red cylinder, but what kind of red is it? More to the point, is that red the same in different conditions: in the light of an overcast day, in the late evening rays of sunset or under a sodium light at night? So flesh colour is affected by many variables: the colour of the flesh itself (which varies from individual to individual according to ethnicity), exposure to the sun, body temperature and even the skin's condition (dermatitis, freckles, dead skin cells, etc.) as well as what colour light source shines on it (fluorescent, tungsten, daylight). Then there is the matter of the colour temperature of the eye itself; some people have a warmer colour eye than others and that can even vary in each eye.

One in seven men 'colour confuse' (the term colour-blind is a misnomer) and can find it difficult to differentiate between certain hues. All men see less of the red end of the spectrum than women. How do you know if you see any colour the same way as everyone else? With all of these problems how do you solve the problem of painting the figure in colour?

A good operational plan is to not worry about trying to make flesh colour. There isn't one. Instead mix a small amount of colour playing around with it on your palette and try to produce some beautiful mud. Offer this up to the model and think about areas of the figure that are the same tone as this mud and place it on your painting. Mix another mud and

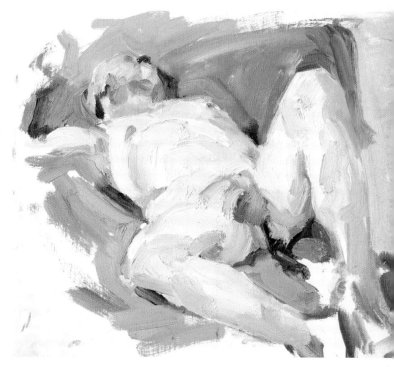

Tim Benson, *Reclining Nude* (oil on board). David Bomberg talked about capturing the 'spirit of the mass' – the essence of the figure in that particular moment, the visceral use of paint as a metaphor for that physicality of flesh. Here Benson performs the same alchemy turning mud into flesh and light with a dynamic economy of means.

repeat the process thinking about where that could go. If your painting is constructed with these beautiful patches of mud then you might be onto something (look at Sickert or Gilman) and consider the idea of equivalents as opposed to actualities. Trying to mix up flesh colour is a bad idea; buying a tube of paint described as 'flesh-coloured' is even worse, because flesh is multi-coloured.

If you try to make one overall colour for flesh, it is likely that you will use it all over the painting and the result would be lifeless, just as if you were to paint a postbox with a single red, making it lighter and darker with white and black.

It is much better to consider how that red might become warmer or cooler and mix many variables of red, making it more orange or purple or maybe even adding green into it. Similarly, consider flesh as something warm or cool, light or dark, and be bold.

Colour palettes

When you go to an art shop you are surrounded by a myriad possibilities. What colours do you choose to buy? Colour varies in price according to the pigment used and whether the paint is student quality or artists' quality. So budget may also be a constraint, but it is perhaps wiser to use less colour and discover the full range and potential of that palette, than to fall into the trap of buying everything on the shelf.

Yellow ochre, raw sienna, burnt sienna, raw umber and burnt umber are all earth colours and to a lesser or greater extent they are brown with a colour cast (reddish, yellowish. etc.). These colours form the core of a traditional value-based painting approach. Terre verte was used as an underpainting colour and ultramarine was a prized colour too. This forms perhaps one of the most widely used palettes for the painting of the body and if you are using a predominantly earth-based palette it will provide you with a cheaper set of hues.

Ken Howard said that into his earth palette he would introduce one guest colour. This might be a fully saturated red, or ultramarine blue. It is worth introducing one colour at a time to see what results you can achieve with that addition.

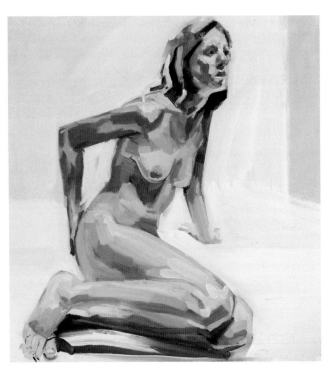

Impasto. This painting uses large brushes in a direct *alla prima* approach where the physicality of paint is clearly left in evidence. The whole painting was made in a single session of approximately two hours.

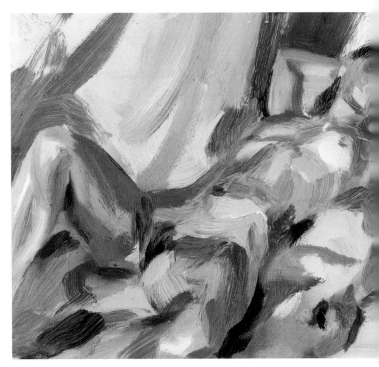

Tim Benson, *Reclining Female Nude* (oil on aluminium). Wet-in-wet painting can be knife edge stuff, as the image can hover between eloquence and a cacophonous mess. A brush dipped into a mound of viscous oil paint can leave furrows and ridges of matter. This material, made of the earth itself, describes the sculptural planes and masses of the body. Here the touch has to be direct and purposeful, and the brush cleaned continually lest the residue of previous hues should sully the freshness of the mark.

Tim Benson, when asked about his choice of colours, had this to say:

> Apparently I have a very limited palette, everyone keeps telling me that. It is limited in the core colours I have on my palette at any one time, but I wouldn't say that the palette I use within my work, within the paintings, is limited. What I mean by that is that the colours I have which are consistent for any painting I do – whether it's a landscape, still life portrait, whatever – I only have six core colours and I've found that over the years of practising, learning the craft, if you like, that it's a distillation of all the colours; I can mix just about anything I'm looking for from those colours. The process of being forced to find colours, to mix colours is, I think, very important. It gives you more of an innate appreciation of colour, craft with the brush. It's like a puzzle: you are finding the answers, you are finding the piece of the puzzle that you need rather than thinking, 'Oh, there's a tube of something I think that is right – bang and there you go'. Now, the more colours you have on your palette the more confusing it is as well. You get very quick at mixing your own colours, and intuitive too; you are forced to solve problems for yourself and this makes you a better painter.

What about the other colours that you put onto the palette? It is easy to be seduced by the hundreds of colours available to you, so it is much better to see what can be done with limitation.

Here are some palettes you might want to experiment with:

Palette A

Titanium white, yellow ochre, cadmium red, burnt umber, ultramarine, black.

Palette B

Titanium white, yellow ochre, raw umber, phthalo blue.

Palette C

Titanium white, yellow ochre, Naples yellow, crimson, raw umber, ultramarine blue.

GOYA'S PALETTE
- Venetian red
- Italian yellow earth
- Italian brown ochre
- Italian burnt sienna
- Vermilion
- Bone black
- Lamp black
- Ivory black
- Peach black
- Flake white

WHISTLER'S PALETTE
- Lemon yellow
- Cadmium yellow
- Yellow ochre
- Raw sienna
- Raw umber
- Burnt sienna
- Vermilion
- Venetian red or Indian red
- Rose madder
- Cobalt blue
- Antwerp blue (a weak pigment inferior to Prussian blue)
- Flake white
- Ivory black

WINSLOW HOMER'S PALETTE
- Flake white
- Burnt sienna
- Prussian blue
- Light red
- Yellow ochre
- Black

ANDERS ZORN'S PALETTE
- Flake white
- Yellow ochre
- Vermilion
- Cool black (ivory + cobalt blue)
- Warm black (ivory + burnt sienna)

SINGER SARGENT'S PALETTE

- Blanc d'argent (sub. permalba white)
- Chrome (pale) (sub. cadmium yellow light)
- Transparent golden ochre (sub. transparent gold ochre)
- Chinese vermilion (sub. cadmium red light)
- Venetian red
- Chrome orange (sub. cadmium orange)
- Burnt sienna
- Raw umber

REMBRANDT'S PALETTE

- Lead white
- Ochres
- Bone black
- Vermilion
- Siennas
- Raw umber
- Burnt umber
- Lead-tin yellow
- Cassel earth

ALEX KANEVSKY'S PALETTE

- Titanium white
- Unbleached titanium
- Van Dyck brown
- Raw umber
- Transparent red oxide
- Permanent madder brown
- Alizarin crimson
- Cadmium red
- Naples yellow red
- Ultramarine
- Prussian blue
- French cerulean
- Horizon blue
- Sap green
- Cinnabar green
- Viridian
- Light yellow ochre
- Naples yellow french
- and many others used only occasionally

SHAUN FERGUSON'S STANDARD PALETTE

- Titanium white
- Transparent/mixing white/zinc
- Cadmium red deep
- Yellow ochre
- Phthalo blue
- Ultramarine
- Raw umber

With occasional additions of:
- Alizarin crimson
- Lemon yellow
- Hooker's green
- Cadmium red light

TIM BENSON'S PALETTE

- Titanium white
- Lemon yellow
- Cadmium red
- French ultramarine blue
- Burnt umber
- Alizarin crimson

PIERS OTTEY'S PALETTE

- Two yellows
- Two reds
- Two blues
- Cremnitz white
- And two or three specials

Colour mixtures. Find out what your colours can do by mixing them together. Here this A1 sheet makes a note of the different colour mixtures obtained from a simple palette of cobalt blue mixed with white, raw umber, yellow ochre, and cadmium red.

Playing with colour

Experiment with mixing the earth colours before you introduce other hues. What can you produce and how do these approximate with the colour of the figure? Put samples into your sketchbook as a reference, with notes on how you mixed them. Paint up small bits of paper and proffer these up to other artists' interpretations of the figure to see if you can find a colour match. These should be fairly quick to do, but try to keep your palette and brushes clean at the end of every colour mixing session, otherwise your results will be flawed. The purpose of this exercise is to give you a sense of what is achievable with limited means.

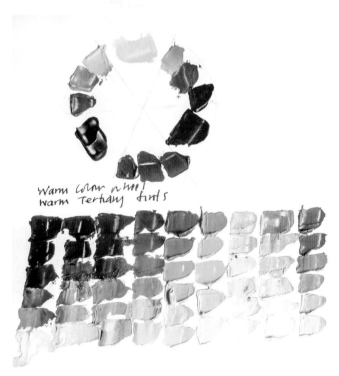

Tints. A simple colour wheel based on the warm primaries: cadmium yellow, cadmium red and ultramarine. These are then mixed with titanium white to produce a tint chart. A different chart would be created using zinc white or the cool primaries, lemon yellow, crimson, and phthalo blue.

Tints, shades and tones

Try adding a tiny amount of white to these hues and see if you can detect subtle changes of temperature as well as tone. A small amount may bring out their full intensity. Explore the difference between titanium, zinc and flake. Write down what you have done with each option and try to think about the range of tones as well as colours you have produced. Do the same thing with black and also grey. Each time you make a colour mixture, you are beginning to log that in your head. Every subtle change is tuning your eye up to notice these in the figure itself.

It can be valuable to do these exercises with colour that is left over at the end of a day's painting. Norwich School of Art had something that they called Norwich grey, which was all the leftover colour from all the students' palettes mixed together. Tom Phillips has for many years produced a series of paintings called *Terminal Greys* using these leftover mixtures.

Once you have gained an understanding of the potential of this earth palette use any of the painting techniques described to make a series of quick thirty-minute painting studies of the figure. Explore the use of these hues on coloured grounds too.

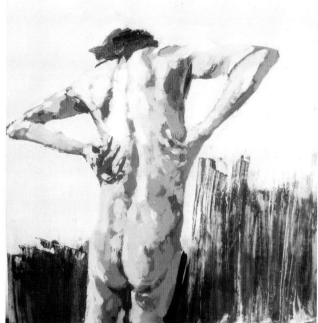

A study of Felix using mostly tints in his back. A few tonal darks were needed to balance out the image.

Colour theory

Isaac Newton discovered that white light could be split into a spectrum, which was made from three separate primary colours. These could be reformed again to make white light. These additive primaries are red, green and blue.

Colour is experienced in the brain from the light receptors in the eye. There are two kinds of light receptor, the rods and the cones. The rods are sensitive to light and dark and the cones come in three types, which are each sensitive to these three primary colours.

Before digital television became widely available, the old cathode ray colour TVs produced an image that was made up of only these three colours. Like a pointillist painting, an image of a figure would be made up of just these, but it was the amount of red, green and blue that created the illusion. When two of these primary colours are mixed together they produce a secondary colour: red and green light makes yellow light, green and blue cyan light, and blue and red, magenta light.

But if you were to mix red, green and blue together on your palette you would not get white, because pigment is not light and you are not mixing together their wavelengths.

A digital printer will produce a perfectly realistic image of a figure with yellow, magenta and cyan inks (the addition of black to increase shadow depth). If these three colours are mixed together, the result will be mud rather than white. It is the absence of colour that produces white in printing (think white paper) so these are called the subtractive primaries.

Painting is neither light, nor digital printing, although if you were to paint using yellow, magenta and cyan exploring optical colour mixing, then you could achieve a wide range of hues. In the 1970s, Chuck Close made his large-scale head paintings with an air brush using this colour separation approach, but it did take him eighteen months to produce a painting.

Pigment is material, which has the property of absorbing and reflecting certain parts of the visible spectrum. This can range from all sorts of sources: mud, minerals, blood, dyes, etc. The Industrial Revolution brought new pigments to the Impressionist artists, which transformed the amount of colour that was available to them, which in turn influenced how they painted. Now in the twenty-first century we have even more pigment available to us.

Putting the theory into practice

In 1993 the artist and filmmaker Derek Jarman wrote in his book *Chroma* that at art school he 'learned colour but did not understand it'. The point of this chapter is to take some of the theory and make it practical for you to learn about colour, by using it. That empirical knowledge will help you enormously when it comes to painting the figure and the world around it.

Some people are frightened of colour, but you need to dive in and become excited by its potential. So as this chapter develops, you might want to consider what you want from colour: do you want to produce more realistic figure painting that resembles your subject? Do you want to have a clearer understanding of how to mix the colours you see in front of you? Do you want to have a more cohesive understanding of how to design your image so that the colours work well with each other, creating a more visually pleasing result, or do you want to be bolder and more expressive in your painting without using colour straight from the tube?

Defining colour

Any colour can be defined by three things:
1. Value (the relative lightness and darkness of the the colour)
2. Hue (the family of colour that it belongs to)
3. Intensity (saturation or chroma)

Any discussion about colour requires us to define the language explicit to it. 'Hue' is another name for colour. When you see student quality paint referred to as cadmium red hue, then the colour you are using is not a cadmium red at all, but a colour that looks like cadmium red.

Colours can be warm or cool in terms of their blue content, so a crimson may be cool in comparison to a cadmium.

Whilst the theory states that there are only three primaries, in practice yellows, reds and blues have different relational temperatures. To achieve the maximum scope for mixing the best range of colour without buying every tube of paint in the shop, then it is certainly useful to have a warm and cool of each. A good standard palette would be lemon yellow (greenish), cadmium yellow (orange-ish), cadmium red (orange-ish), crimson (violet-ish), ultramarine (purplish),

and phthalo blue (greenish) or cobalt blue. Of course a white is vitally important and occasionally black can be useful too.

Simultaneous contrast

The same red can appear colder if it is placed on a white background than if it is placed on a black background and its tonality will appear to be different too. This is called simultaneous contrast, so a figure surrounded by black fabric will look very different from the same one surrounded by white.

Change the background colour and this will affect the apparent colour of the figure. Not only will the background be reflected into the figure itself (so a red background will make the figure more reddish), the colour of the ground you are painting on will affect the colour you have mixed up on the palette.

Light

The light on the figure, as well as the light the artist uses to paint by, will affect the colour too. A painting made under artificial light will look different from a sunlit one. As Shaun Ferguson states:

> In the mornings I organize my studio, tidy from the previous day, research, ponder, draw, photograph – all useful activities which also act as a kind of ritual, creating a clear focus to paint. I only paint with natural light. I may have some 'almost tonal' pieces which I save for the evening but I've learnt over the years not to trust tungsten or so called 'daylight bulbs'. Therefore light largely dictates my schedule.

Pick up a magazine like *International Artist* and you may find a distinct difference between the saturation of colours used by artists from different countries. British painting tends to be muted in favour of subtle variations of grey. That is because the light in the UK is muted. Move closer to the equator and the light is very different. The light in an Andrew Wyeth is sharply defined by a crystalline clarity and sharpness of shadow. Compare a Wyeth with an Antony Williams and whilst the subject matter and technique may be the same, the light in their nudes is so very different.

Simultaneous contrast. This is a little colour exercise based on subtle colour mixing. A series of bands are produced by simply mixing two colours together. The trick is to add a little at a time. Once this is dry a dab of colour is applied across each of the bands. This hue will look different as each background is different (simultaneous contrast). Then this dab is subtly changed and the process repeated. Finally a new dab is applied to this spot of colour. Again subtle mixing ensues and each dab of the same hue falls onto a different coloured background.

In 1924 Harold Speed wrote that a figure painting could be achieved with one red and two blacks, which were mixed from a couple of colours on his palette (look at Anders Zorn's palette, earlier). A lot can be done with very little, as you have already seen, with *bistre*, *grisaille* and *verdaccio*. A completely resolved tonal work can now be glazed with warmer pinks and creams retaining the cooler shaded areas of the underpainting.

You may be very happy to stay with value painting, which places tonality at the forefront. Why not try a warm red, yellow ochre and black and white study? A *bistre* study can be made with just sienna so try a blue, black and raw umber combination. When choosing a range of colours think about something to make your mid-tone lighter and darker, warmer and cooler. If you want to gain a clearer understanding of colour, however, then it is useful to have a map.

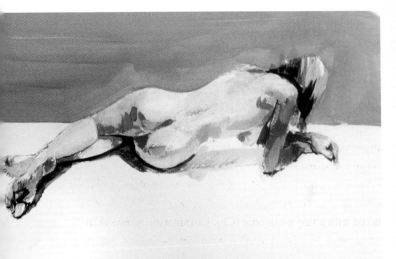

LESSON 46
Colour wheel

Materials:

- Compass
- Ruler
- HB pencil
- Colours: lemon yellow, cadmium yellow, cadmium red crimson or Alizarin rose madder, ultramarine, phthalo blue or cobalt blue
- Kitchen roll
- White dinner plate or white palette
- Painting knife
- Water pot (for acrylic) or dipper (for oil)

Johann Wolfgang von Goethe wrote his colour theory in 1810 and Johannes Itten taught colour theory in the 1920s; both discussed the idea of a colour wheel and a colour sphere. You can make your own, and you can buy one from a good art shop, but making your own will give you a much clearer understanding of how the coloured muds on your palette behave and why sometimes red and blue do not make purple.

In practice the background colour behind the figure will have a profound effect on its appearance, as well as the colour of the ground that it is painted on.

A balanced colour wheel using both warm and cool primaries. In between each pair an unbiased primary is mixed. The colours nearest to each other on the wheel produce the most saturated secondaries. The order of the colours is: lemon yellow, cadmium yellow, cadmium red, crimson, ultramarine and phthalo blue.

Take your compass and draw a circle in your sketchbook of a convenient size. Using the compass, mark off the radius around the circumference; this will give you six equal divisions. Lightly draw a pencil line through the centre of your circle joining the marks opposite each other and you will have created a circle with six wedge-like shapes. Place a small dollop of each colour around the edges of your dinner plate or palette, in the order that they appear above. Into the left corner of one wedge place a small palette knife mark of lemon yellow and the right corner cadmium yellow, then mix both of these together and place this yellow in the middle of the wedge. Leave a wedge space and move onto the next: place the cadmium red (so that it is close to cadmium yellow) and in the other corner your crimson. Mix these together and place in between both reds. Leave another wedge and repeat again, placing ultramarine near to crimson and phthalo blue near your lemon yellow. Ensure that every time you come to collect up some colour, you clean the palette knife with your kitchen roll. You now have a circle with three edges filled and three gaps between each wedge.

Look at the empty wedges. Each one is bordered by two primary colours. Take the colours in the corners nearest each other and mix them together and place those at the centre of your colour wheel: cadmium yellow and cadmium red, crimson and ultramarine, lemon yellow and phthalo blue. You have now produced three secondary colours: orange, violet and green. Now take each secondary colour and mix in some more of the primary colour and place a sample of these into the corners of the wedge so that you produce a yellow-orange, a red-orange, a red-violet and blue-violet, etc. You have now created the tertiary colours.

If you now draw a smaller circle on a separate piece of paper and, as before, mark off the radius around the circumference, you can draw an equilateral triangle. Mark this clearly with a fine line pen and then draw through each apex a line that bisects the angle and the opposite side. Use coloured lines if you wish. If you cut out this smaller circle you can use a paper fastener to join it to your colour wheel. This rotates around the colour wheel to help you identify triads and complementaries.

Saturated colours

Acrylic straight from the tube is usually fully saturated. Oil can sometimes be at its base level and may need bringing up to full saturation with a small addition of white (or if viewed in a more transparent state). When you mix two primaries together the result can either be saturated or de-saturated depending on the pair of colours that you choose. If you think about lemon yellow it is a yellow with a tiny bit of blue (Yb). Cadmium yellow is a yellow with a tiny bit of red (Yr). Cadmium red is red with a tiny bit of yellow (Ry). Crimson is red with a tiny bit of blue (Cb). Ultramarine is blue with a tiny bit of red (Br). Phthalo blue is blue with a tiny bit of yellow (By).

So when you look at the different combinations of two primaries to make a secondary, only two pairs from each potential secondary colour are actually just the combination of two colours and these are the ones that have been used in the colour wheel.

A good colour wheel should reveal a gradual transition from each primary through its tertiary and secondary colours. You can produce as many versions of colour wheels as you want. There is something very satisfying about mixing up colour and understanding how you achieved it.

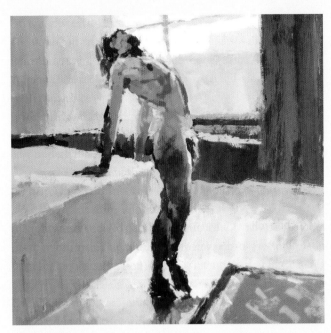

Coloured greys. This acrylic on board painting uses coloured greys (sometimes referred to as tones). Each colour has been added to a black-and-white achromatic grey. This muted palette is characteristically English.

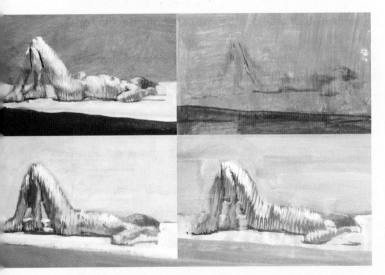

1. Working with blue only, produce a tonal study using the opacity and transparency of the blue as well as the method of application to execute your study.
2. Use only blue and white to make the next study. You can control the transparency of the blue as well as the amount of white you add. The white too can be made more or less transparent and hatching was used as a painting technique.
3. The next study will be made by mixing your blue with both white and orange. You can also glaze over the top of your painting (blues, oranges or transparent whites) to achieve your result.
4. Your next study will require you to mix together your orange and blue to produce a chromatic grey (or you might get a brown) and use that colour with white to produce your study.

LESSON 47
Tertiaries

Materials:
- Paints in titanium white, zinc white, lemon yellow, cadmium yellow, cadmium red, crimson or Alizarin rose madder, ultramarine and phthalo blue or cobalt blue, black
- Kitchen roll
- Palette knife
- Water pot (for acrylic)
- Dipper (for oil)

So much colour is de-saturated, so it is important to see the range of different secondary colours and tertiary colours we can produce from our set of six. The colours in flesh are not going to be fully saturated, so by experimenting with these different colour mixtures above you will begin to see the possibilities of what colours you can achieve. The amount of each primary will also affect the colour, not only in terms of value, but temperature too. Mix up as many of these colours as you can, recording as you go what colours you are mixing together.

When you mix white with your colour you create a tint and when you mix black you create a shade. Methodically take a pair of colours and mix up three versions of each secondary; then proceed to add white to each puddle, adding small amounts at a time so that you can see a change in the colour but one that is not too drastic. Experiment with both titanium and zinc and reflect on how these colours might be matched with some of the colour you see in artists' paintings. Look at the colouration in a Euan Uglow or a Lucian Freud. Then do the same with black, producing a series of shade charts. Add a very small amount of black, a bit like spice in food, to enhance and develop the colour rather than to dominate it.

Every time you buy a new colour, carry out these exercises in your sketchbook. It is a good idea to do these on a separate sheet of paper so that the paint can dry before you put them into your sketchbook. That way you will get a very comprehensive understanding of not only what you can do with your paint, but also when confronted with the nude you can refer back to your colour notes to see if you can match the colours that you are now looking at.

Complementary colour

If you refer to your colour wheel and look at the line that bisects the apex of each triangle, these point toward the opposite or complementary colour of each hue on that wheel: yellow and violet, red and green, blue and orange. When placed side by side, complementary colours have the effect of enhancing each other, as the eye naturally generates a complementary version of a colour it sees. This is called the 'after image'. The next time you are in traffic, look at the brake light of the car opposite you and see what happens when it switches off. For a brief second you will see a blue light. Every colour generates its own opposite in the eye, which explains why simultaneous contrast works. Side by side, complementaries increase the apparent saturation of its neighbour and optically vibrate, but mixing them together has the opposite effect and cancels out the hue producing a chromatic grey. If the complementaries are not exact then browns are produced.

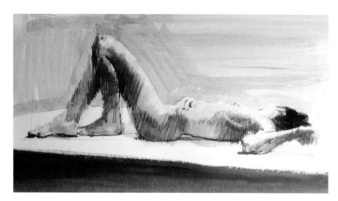

Red and green – 1.

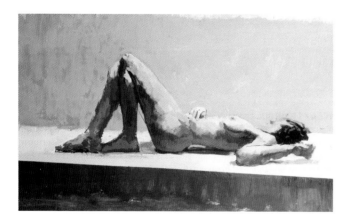

Red and green – 2.

LESSON 48
Complementary studies

Materials:

- Compass
- Ruler
- HB pencil
- 220gsm cartridge paper
- Paints in titanium white or zinc white, lemon yellow, cadmium yellow, cadmium red, crimson or Alizarin crimson, rose madder, ultramarine and phthalo blue or cobalt blue
- Kitchen roll
- White dinner plate
- Brush
- Paint pot
- Dipper

You can now begin to really use your knowledge of colour mixing and apply it to the problem of painting the figure. Mix up a large quantity of a fully saturated orange and paint four coloured grounds. These can be any size you want and in the illustration given each painting is approx. 8 × 12cm. You are going to make four different versions of the same painting using different strategies so onto each of these oranges draw the same figure. You can trace off if you wish or you might want to draw freehand. You just want to make sure that the main elements of the figure are established.

Opaque complementary, stage 1. The images on page 149 demonstrated the use of two complementary colours when used like watercolour. Orange and blue were combined using washes, glazing and hatching in acrylic. In this instance the same image is painted using opaque painting, mixing the colours with white to produce neutrals. In the first stage the dark undertones of the shadow areas are blocked in.

Stage 2. More white is added, finding the lighter tones of the figure and mixing between orange and blue to create warm and cool tones.

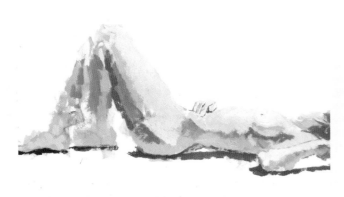

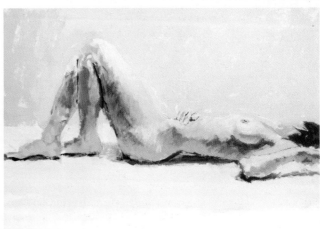

Stage 3. More opaque painting, using dabs, dashes and scumbled areas of colour, finding the lights and starting to draw the darks back in with a fine rigger.

Stage 4. Finally balancing the whole painting, blocking the negative painting and modifying the darks with transparent glazes over the opaque underpainting.

Split complementaries

Another harmonious way of using colour is to look at the colour wheel and instead of choosing two opposite colours, choose one of the two colours either side of one of the complementary pairs. So you might use a yellow with a red-violet and a blue-violet, or a red with a yellow-green and a blue-green.

The 'zing' effect

If you use one of the complementary pairs de-saturated, and then use a very small amount of a highly saturated complementary you create the 'zing' effect. This can be used to great effect to create a visually exciting result.

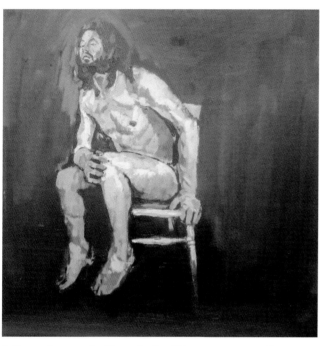

Split complementaries. The main visual idea was to create a figure out of two greens – a blue-based green and a yellow-based one – with a small amount of red base used on the head.

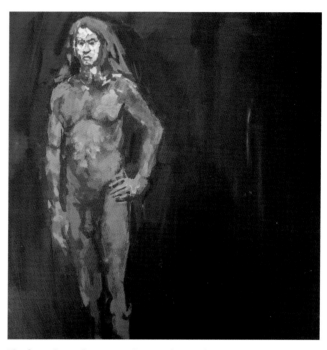

The figure has a de-saturated orange basis, playing around with lighter and darker versions of red, orange and brown, with a small amount of highly saturated blue alongside tints of blue to describe the form of the head.

Warm and cool primaries

Materials:

- Acrylics in titanium white, zinc white, lemon yellow, cadmium yellow, cadmium red, crimson or Alizarin, ultra-marine, phthalo blue or cobalt blue
- Water pot
- Brushes
- Kitchen roll

Now that you have fully pushed the idea of a very pared down palette of just two colours, what happens when you open that up to three? You have warm and cool variations of each of the primary colours so experiment with the potential of focusing on just warm primaries and seeing what difference is made between a watercolour-type approach and an opaque painting technique.

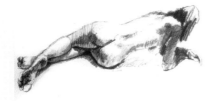

Cool primaries. The drawing was made from life and then the original photocopied onto 220gsm cartridge paper six times. The idea was to keep the drawing the same so that you would notice the differences between each image. Transparent lemon yellow, magenta and phthalo blue were used.

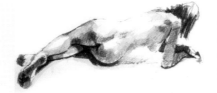

Warm primaries: cadmium yellow, cadmium red and ultramarine.

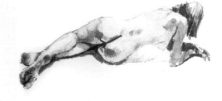

The same cool palette but with zinc white. Note the transparency of the colour: you can see the drawing coming through it.

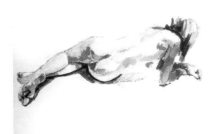

The same warm palette with zinc white added.

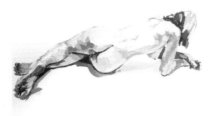

Cool primaries and titanium. Note the opacity of the colours allowing the solid overpainting of one colour on top of another, but a more chalky appearance.

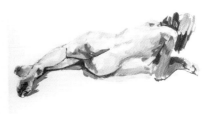

Warm primaries and titanium. Note the temperature differences between each image.

Triads

The use of three primaries is a classic triad: each colour is placed equidistantly around the colour wheel (move your triangle so that it points at the three primary wedges). What happens if you rotate the triangle and use three secondaries or three tertiaries? Wherever the points of your triangle are, these triads produce classic harmonious colour combinations.

Materials:
- Acrylics in titanium white, zinc white, lemon yellow, cadmium yellow, cadmium red, crimson or Alizarin, ultramarine, phthalo blue or cobalt blue
- Water pot
- Brushes
- Kitchen roll

Try experimenting with some more figure studies using just three colours identified from your colour wheel, using the triangle to identify which hues to use. Mix up the colours first so that you have a puddle of each. You can add white if you wish to work in a transparent way and see what results you can achieve.

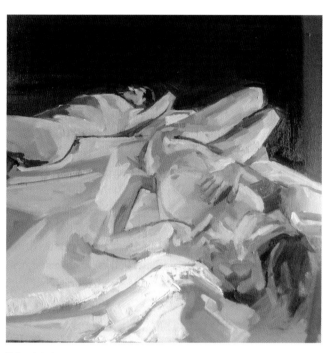

Using triads.

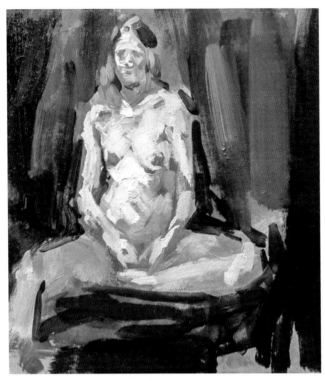

This thirty-minute oil sketch takes the idea of a blue figure. (Who says that the figure should be painted in flesh colours anyway?) Ultramarine here is mixed with cadmium red, and lemon yellow with black and white.

Analogous colours

Analogous colours are those that are adjacent to each other on the colour wheel. These might be regarded as belonging to the same family.

Experiment with producing a figure study in just greens. You might make your green warmer or cooler but you might also mix all the different variations of green from your six primary colours.

Analogous hues. This green figure explores the creation of green from the combination of yellow ochre with black and ultramarine combined with white. Painted on a black ground these dirty colours become beautifully luminous against the dark, hinting at a brooding figure turning away from the viewer.

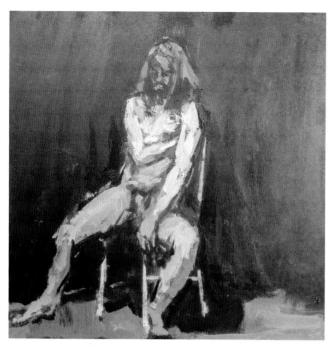

Colour discord. In this small acrylic study of Felix, the figure was painted predominantly in tints, the background shades, reversing their normal tonal order, and the head had fully saturated red used within it.

Colour discord

When you look at the colour wheel, the hues at the top are lighter than the hues at the bottom. Each hue has a relative lightness and darkness. If you change this normal tonal order, making a dark orange, a pale green or violet (for instance), placing this next to a fully saturated colour, this is called colour discord and is often the way that colour is used in Indian miniatures. Harold Gilman and Fairfield Porter both used this device in their paintings.

The figure and space

Saturation creates space. The more highly saturated a colour, the more it comes forward. In tonal terms light comes out of dark, so the subtle manipulation of saturation and value can enhance the pictorial space in your figure painting; it can make that limb come forward or that head recede, as well as creating a convincing space. When the Impressionists started using new pigments that were much more saturated than their predecessors, they explored the full gamut of saturation, experimenting with the richness of coloured shadows and the broken, fragmented nature of light. But in so doing, the pictorial space of their paintings became flattened.

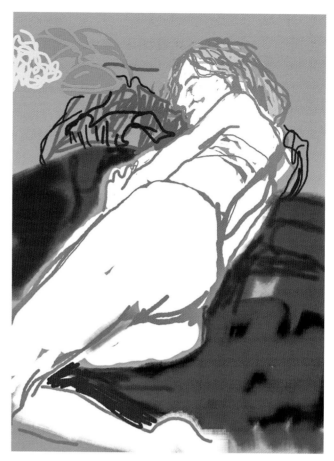

Julian Vilarrubi has been using his iPad in recent years to make digital life paintings.

If you want to push the saturation up in your own painting and get much more excited by the colour possibilities and combination of colour in the figure and the space surrounding it, then your images will become more abstracted and flattened. What happens if you use colour as an abstract entity, to use it in a more poetic, metaphoric or expressive sense?

Kim Frohsin is a contemporary painter who approaches the figure in a very flattened way. Her work owes a debt to Richard Diebenkorn (1922–1993) and the other Bay area figure painters of the 1950s (Elmer Bischoff, David Park and Wayne Thiebaud), whose work hovered between abstraction and figuration. Frohsin's paintings have been painted in palette knife from collage studies. Julian Vilarrubi works from many sources, but has been teaching life drawing for many years since leaving the RA schools in the 1980s. In recent years he has been using his iPad as a sketchbook and his own drawing reveals someone who is equally excited about colour and the possibilities it presents with the nude figure.

Part of a series of paintings made from the work of Victorian photographer Eadweard Muybridge. The black-and-white original is translated into a colour, combining watercolour, gouache and coloured pencil.

LESSON 50
The figure abstracted

In this the final lesson you need to place a large sheet of paper in your studio and divide it into forty-eight boxes. As with the gridding exercises at the beginning of the book, lay a line of masking tape vertically down the centre of the paper to bisect it in two sections. Then bisect each of these in two, and then again so that you have eight columns. Use tape to do the rows as well, initially dividing the paper into thirds and then dividing each of these in half. Into the middle of each, paint a splodge of orange.

Each splodge will be framed with a colour. In the top row yellows, the next row down reds, then blues, oranges, greens and finally on the last row violets. Each column will have a different colour variation of that hue so play around with the hue family, exploring saturation, value and opacity. Think about adding white (a tint), black (a shade), grey (a tone), the complementary (chromatic grey) as well as warmer and cooler versions of each. A valuable trick is to paint your first hue then do the tint then add a small amount of black to create your tone, then clean your brush. Look at your water or spirit – if it is dirty then so too is your colour and eventually you will wonder why everything looks the same. Keep two jars for each: a general one for swishing your brush into to clean and another to add to your paint to thin it down.

Once complete, you have a series of painted grounds into which you can start to make small figure paintings. Consider the idea of negative painting to define the edges of the figure; in particular choose figures that make interesting shapes with the frame. Refer back to your sketchbook and any other reference material that you might have and do not worry about naturalistic colour at all. Instead be playful, allowing your intuition to suggest ideas. Here you might create a figure using an analogous palette of reds and variations around this theme (warm, cool, tint, shade, etc.) stretching the colour into the boundaries of adjacent tertiaries or exploring complementary contrast or the zing effect. Explore layered colour through both opacity and technique. A dragged colour might break up a flat area and a glaze might enliven a dead area of painting. Do not feel that your commitment to a colour plan has to be adhered to. Feel free to change the paintings as you go but more importantly work on a number at the same time. When you have mixed up a beautiful colour try putting it somewhere else on another figure. Allow the paintings to grow

Experiment again with painting up collage paper with some of the leftover colour you have on your palette. Play around with colour with a more intuitive approach, worrying less about the colour of the figure and the tonal transitions across it but instead concentrating on producing a more visually pleasing image.

Simplicity is difficult. A Matisse can look deceptively simple yet it belies the skill needed to balance forms and colour to create the cohesive whole. Looking underneath a painting by any of the artists mentioned above would reveal countless changes of colour, shape and composition. This search by the artist to make the painting work can be agonizing and fraught with doubt and confusion, but when the painting finally comes together it makes the battle worthwhile.

organically, and when in doubt take a risk – try a combination of colours that you wouldn't normally choose. Sometimes as you near the end of a painting session you might explore the colour that is left on your palette. This might yield more unusual colour combinations, but these may surprise you and produce an unpredictable result.

Once you have completed all forty-eight, carefully remove the tape. You will then be able to see more clearly what you have done and you might want to take some of these images further by scaling them up. If you chose to scale up then you need to treat this in a similar way to the smaller studies and not just seek to recreate what you have done on the small scale but allow that painting to develop its own life. This can be a very exciting but also an exasperating place to be. One moment the painting can be full of promise and have momentum; the next moment it can die a death. Sometimes you might try something else out, a colour change and com-positional element altered, in the hope that you can resurrect the painting.

In the end all that remains is the painting. Without standing side by side with the motif and the work, comparing the two, the painting has to create its own reality. They said of Monet that he was only an eye, in that he wanted to transcribe his visual impression onto the canvas, but the Post-Impressionists wanted to return back to the studio to construct their own narratives. Degas was not just an eye: he orchestrated his observations, he brought together the different bits of his research, and designed his images. Most painters of the early nineteenth century did the same. This is a well trodden path. Look closely at Poussin's work and you see the same figure groupings used in a number of paintings, sometimes reversed. You need to consider the painting as a formal entity, balancing the drawing, colour, tonal range and composition to communicate your idea. This means that the painting is not just a record of your encounter with a figure, it is a vehicle to communicate your ideas.

The door has been opened; this book has given you a basic map but the journey you are about to embark on is yours to navigate.

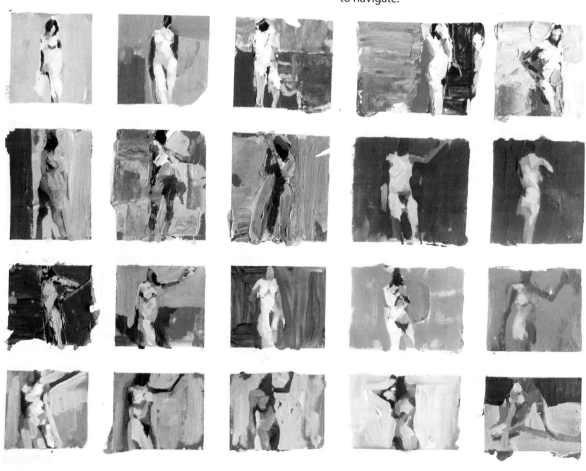

Colour frames.

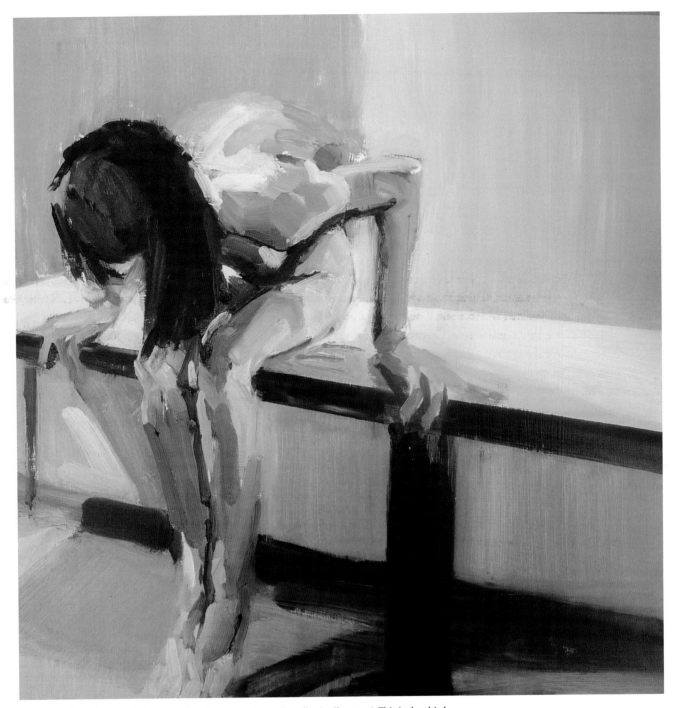

Fold is an *alla prima* oil painting, based on the compositional studies in Chapter 6. This is the third version of the image I have produced, as there is an exciting juxtaposition between the figure and the surrounding space. The first was executed on a surface that allowed me to create a beautiful monotype effect where I would wipe away the oil to an almost invisible film, but later found out that the paint was not adhering to it. The second was made very quickly with a decorators' brush in acrylic and this one painted using a medium sized filbert.

The subject within the figure

o you have one taste in music? Do you possess just one set of albums by the same artist? Does your musical collection reflect the different facets of you: melancholic orchestral music when you feel the weight of life on your shoulders or breezy tunes when you want to sing along to the world? If music can hold onto your emotions then these can be channelled into the figure as well. Anger and frustration can be given focus through a particular medium or approach (something similar to Auerbach attacking the painting with slashing strokes of oil, carving up the canvas and excavating the crevices and form out of the figure).

Maybe in those introverted moments, when you feel like keeping to yourself, the slow attentive approach of egg tempera might suit your mood. Maybe the lyrical use of colour might seem a fitting metaphor for you to visually lose yourself in the meandering curves and planes of the figure and find some poetic response to it.

Every artist could take the same starting point and interpret it differently according to what they want to communicate with the figure.

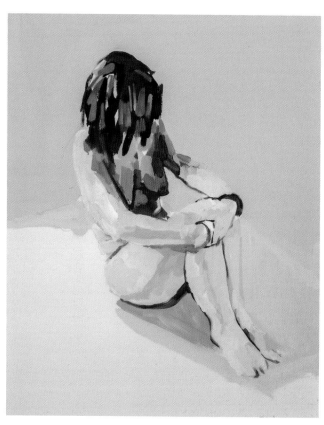

The human figure may be approached from a formal or exploratory point of view.

Formal language

You may be approaching the figure from a purely formal starting point. You may wish to explore its shape, form or its colour. You may be excited by the illusory aspect of painting and seek to achieve the sense of a limb coming forward or the space behind the head. Uglow was very much concerned with these formal considerations with some quirky interests in the geometry of a rectangle and the potential of the figure conforming to a mathematical logic: the diagonal of a root rectangle creating the structure of a pose, or the notion that a figure might be able to become a pyramid or a bridge.

Alex Kanevsky is a contemporary American painter who lives and works in Pennsylvania. Trained at Pennsylvania Academy of Fine Arts, he teaches in the same studios that Thomas Eakins taught in. Kanevsky's work is steeped in tradition: a sound knowledge of anatomy and a masterful understanding of the craft of painting. His work is a visual delight, mixing both highly observed fragments of reality and abstract mark-making.

If you visit his website (www.dolbychadwickgallery.com) you get a chance to peep into his head and he allows you to see the evolution of some of his paintings. Figures appear and disappear, rooms become landscapes, figures become submerged into pools of water. As the physicality of paint builds up a patina of history, these layers are scraped back with a squeegee to keep the surface clean. The trevail of this tool leaves veils of paint that allude to other forms. These suggest journeys of discovery and new solutions to the problem of making a painting that can stand its ground as an entity in its own right.

Kanevsky makes no secret that he uses the camera and the live model as his source material. These are tools to help him see new possibilities: what happens if that colour is changed, if that figure moves to the left or is completely removed? There is something in his process akin to that of the late Richard Diebenkorn's Bay Area figurative work from the 1960s, in that his paintings would undergo a similar process of revision and radical change. With Diebenkorn you were left with a clogged surface – he wanted his paintings to be ugly up close – whereas Kanevsky presents you with a visual delight, sumptuous landscapes of paint. Before and after Impressionism most artists used painting as a place to build reality, taking information from the observed world and orchestrating it to make a construction of fragments and making them whole.

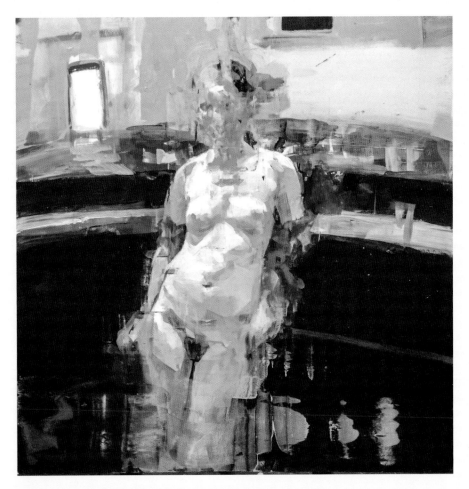

Alex Kanevsky. The head is a tangled lattice of marks suggesting an animated movement. Kanevsky's figure might be standing in a bar or resting in a pool but the top half of the painting suggests a long corridor of a hotel. Whilst there is a drama in the visual contrast between the swathes of black there is a delicate transition of half tones across the figure picking out the light bouncing off the main forms.

If Kanevsky shows you glimmers of his paintings' history through the Swiss-cheese holes of scraped paint, Piers Ottey provides you with a map. At the the edges of every Ottey painting are a series of coloured tabs that reveal the list of colour decisions that he has made during the formation of the work (www.piersottey.co.uk).

Ottey came out of art school at a time when the notion of integrity was all-important. He was taught by some of the Euston Road artists who sought a kind of visual truth in recording life as they saw it. Measurement was a device to pin down visual experience but also a mechanism to bring order to the chaos. Process was all-important: paint what you see and document the history of the making process. In Coldstream, history was recorded through tiny inflections and indecisions of transparent oil. Uglow would cover up revisions and contemplations to provide you with a skin of paint that might be incised with measuring marks, hinting at the history

beneath. Myles Murphy (whose output is tiny but equally finely wrought) was Head of Painting at Chelsea when Ottey was there in the 1970s. With Murphy, abstract passages of colour interplay against fragments of reality seen and absorbed. Like Diebenkorn's Ocean Park series, colour is given the space to breathe and create visual tensions across the space. This balance between abstraction and figuration teeters in Ottey's oeuvre too.

The grid used to enlarge the drawing is another aspect of the paintings' internal logic. The intersection of diagonals, which create the centre of the square, might dictate the placement of a central motif in the work. The subsequent triangles suggest changes to the passages of colour. Each passage of paint is contemplated in terms of its hue, saturation, tonality and surface. Ottey will get you to run your hand over one of his paintings so that you can feel the fourth dimension of his work.

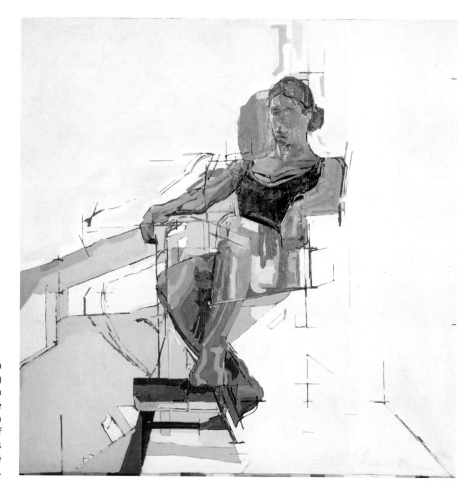

Piers Ottey draws from life and then meticulously transcribes his drawing to the canvas in order that he can accurately scale up the figure. Once complete he continues to paint from life. He insists that he has no way of doing things – every painting sets its own problems to solve – but life painting is from life.

If oil paint is continuously mutable and allows the artist the opportunity to revise and restructure the image, acrylic is not. It dries quickly and can often become plasticized and dead. Brush marks build on top of each other, forming encrustations that become difficult to navigate. Acrylic has a bad press and buyers sometimes value oil more highly. Yet in the hands of someone like Shaun Ferguson, acrylic can be a vehicle of complete expression and virtuoso performance. During his formative years, Ferguson was in awe of Auerbach and Bomberg's visceral troughs of

paint. The desire for this physicality of paint is still evident in his treatment of the negative space. Brush marks allude to intimate space, evocative of place but not specific to it.

However, an earlier hero was Degas and this can be seen in his chiselling out of form. Small marks act as counterpoints to the dynamic tensions of a figure lying down with legs balanced precariously against the wall. Ferguson is drawn to these silent narratives, the moments when individuals engage in the everyday.

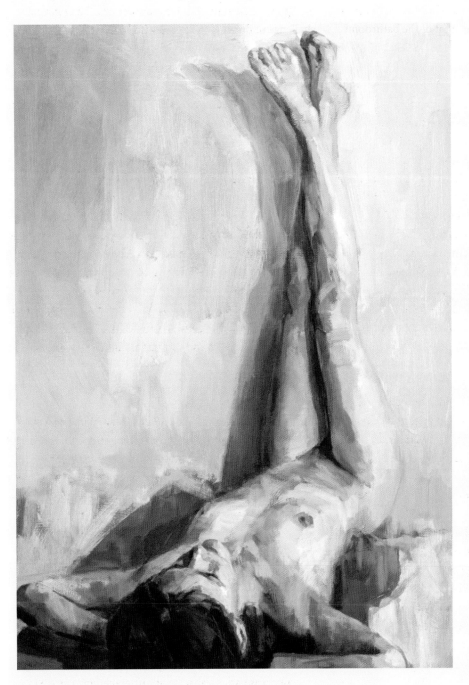

Shaun Ferguson (www.shaunferguson.co.uk). Behind these captured moments are months, if not years, of doubt and revision. The surface is never clogged because it is often sanded down within an inch of its life. To see a Ferguson up close is to view a constellation of colour. When we look to the skies and see the stars overhead, we look back through history. What Ferguson finally allows us to see (because he doesn't let his paintings out of the studio easily) is a glimpse into his paintings past and, at the same time, a moment of wonder.

Emotion

So what about the emotional response to the figure? Love might be an underpinning idea and Bernard Dunstan's paintings of Diana Armfield are tender recollections of rooms and intimate moments. Gwen John's naked portrait has an intimacy but also a vulnerability, a figure stripped of protection and laid open to the world's gaze. But your model may not be an object of desire or some loved one, so you might feel that their personality might be reflected by the way they are painted. How did Bonnard communicate a moment of intimacy between himself and his wife? How can she become more beautiful by dissolving into the light of the bathroom?

Narrative

When you have a figure alone in an image you can think about the painting acting as some kind of portrait or life study. Introduce another figure or an object and we begin to ask questions and enter into a narrative. What happens when the figure is clothed? Sickert's *Camden Town Murder* paintings suggest the punter and the prostitute. Manet's *Olympia* is surrounded by various symbols that tell you who she is and what her role is. She also greets you, the viewer, in the eye, making you part of the narrative too. Kanevsky nudes interact with a vast space – a figure huddled on some boarded floor, a figure swamped by a vast panoramic space.

Style

Is style something to be sought after? When you discuss the 'style' of an artist with someone else you may find you are talking about different things. You may be referring to the motif ('This artist paints the nude; this one paints reflection in shop windows'); or perhaps their colour palette ('This one always paints with those colours') or technique ('Everything is painted in palette knife like this'). If you go back and look again at those web searches and explore the work of some of those artists in a bit more depth, you may find yourself looking at identikit paintings, each image looking the same as the last, using the same technique, the same gimmicks. Searching for the identikit look is not to be sought after. Julian Vilarrubi says, 'When I draw or paint the figure my main preoccupation is to convey something of what the figure feels within the setting they find themselves in.'

Style should not override content. Allow the figure to convey itself to you and be open as to how you explore that. Your work will be much better if it is an honest response to the figure rather than a stylistic imposition.

Ideas

There is a big difference between someone who can read and play music and someone who composes. Do you want to have big ideas? You might be driven to draw and paint the figure for no other motive than wanting the technical challenge of drawing the figure with more accuracy, to pin down your visual experience. You might be content to switch off to the world and not think about anything else, only concentrating on that moment, that space in time. And that might be a good enough reason to continue your exploration of techniques and process.

You have placed at the centre of your own investigation the individual quality and characteristics of the nude and this, as has already been suggested, can be described through a variety of means. As you move away from the mimetic function of painting, you will become increasingly concerned with the way that complex ideas can be explored and communicated through the figure. You have to look at yourself as well as use your sketchbook as a journal to reflect on your own interests. It is valuable to look much more closely at the work of artists that you really admire and ask yourself the question 'Why?' Do this enough times and you might find some common themes emerging.

Kanevsky has said:
> Drawing originates in a completely abstract concept of a line. Lines don't exist. We don't see them. Yet, when drawing we attempt to express form, space, light, etc. through this phantom tool. Looking at a good drawing is like talking to a completely insane person, who nevertheless says some beautiful and profound things.

Shaun Ferguson said:
> Drawing can take many forms, fulfilling different functions. I make numerous problem-solving drawings along the way, which litter the studio floor. These might be trying to figure out a compositional issue or where a line sits next to a block of tone or the directional force of a mark. These are usually dealing with formal design concerns and probably wouldn't make much sense to

anyone else. I make drawings at the very outset which are often crude visualizations of scenarios or gestures which I then use to direct the model. Then there are large charcoal drawings which are stand-alone pieces in themselves.

In general, drawing seems to be a more intuitive process of 'finding out'. It's through drawing that I find the underlying rhythms and abstract relationships, which are the scaffold of the figurative outcome. The speed of drawing short fuses the intellect and allows for invention, speculation and surprise.

Usually drawings and paintings are made for a specific purpose and it is that purpose, that intention, that ultimately finds its appropriate form. However, as discussed in the opening chapter, the hard-won image may indeed be just that. Understanding what one is interested in, and discovering the most appropriate way of achieving this, is something only accomplished by doing a lot of work along the way.

Kenneth Clark's seminal book *The Nude: A Study in Ideal Form* (1956) put forward a series of ideas and approaches to the figure: Apollo, Venus, Idealized Classic Beauty, Pathos, Ecstasy, Energetic Nude, Heroism, Dionysus, Divinity. Some of these ideas now seem a little outdated but perhaps they are more relevant to the art leading up to the nineteenth century rather than work of the twenty-first century. A naked figure could be an erotic motif and the centuries are filled with artists who have produced a kind of painterly form of titillation (François Boucher, Lawrence Alma-Tadema). Once, artists painted the nude as an ideal form, a kind of pictorial hybrid. An alarming array of images of near-naked bodies surround us every day and the camera, with the use of Photoshop, has now taken over the role of the constructed nude, the idealization of beauty dictated by the fashion industry. These near-naked models are apparently blemish-free and create false notions of reality in the young. The female figure has become so objectified we need to be careful. Alberto Mielgo's private nudes talk a lot about desire and pleasure as his models are porn stars. Many contemporary figure artists do not strive for a kind of painterly perfection and instead talk of a darker truth. Chantal Joffe and Marlene Dumas take pornography and turn it on its head. Here figures seem vulnerable and ill at ease with their predicament. Jenny Saville paints a body transformed by the surgeon's knife, a bloodied and bruised landscape of flesh. Sophie Jodoin uses the fragmented body to communicate some of the horrors and fears of contemporary society that are carried out behind closed doors.

Does gender play a role too? What if female artists paint the female nude, or the male nude for that matter? Sandra Fishers painted her husband Ron Kitaj naked in an incredibly tender way. Ellen Altfest paints a penis with meticulous attention to detail, recording every pubic hair and crease in flesh as if she were examining some curious piece of microscopic evidence. There is a tenderness too in Hockney's drawing of his boyfriend in bed or by the pool. There is undoubtedly homoeroticism in the male nudes in Michael Leonard's drawings and paintings of men. Does a heterosexual male artist paint the male nude in the same way as a gay man? Freud's nudes strip the body of this gloss and leave us with the naked portrait: a body stripped of its covering, revealing its corporeality and the varicose-veined certainty of a Dorian Gray demise. The body can hold onto emotion, whether jubilation or distress. Consider the difference between an Anders Zorn or Joaquin Sorolla and an Otto Dix or a Jean Rustin.

The manner in which an idea is resolved creates the outcome, so once you have understood how to make a painting, the next step forward is to understand what it is you are trying to say. Only when the search for style is abandoned and you are driven by the desire to resolve ideas does your work take its own form. Great drawing and painting therefore marries a specific intention with an eloquent language. Try to understand this activity, not as some kind of passive acquisition of technique but as a way of developing your language – a journey from your current point to your ultimate destination.

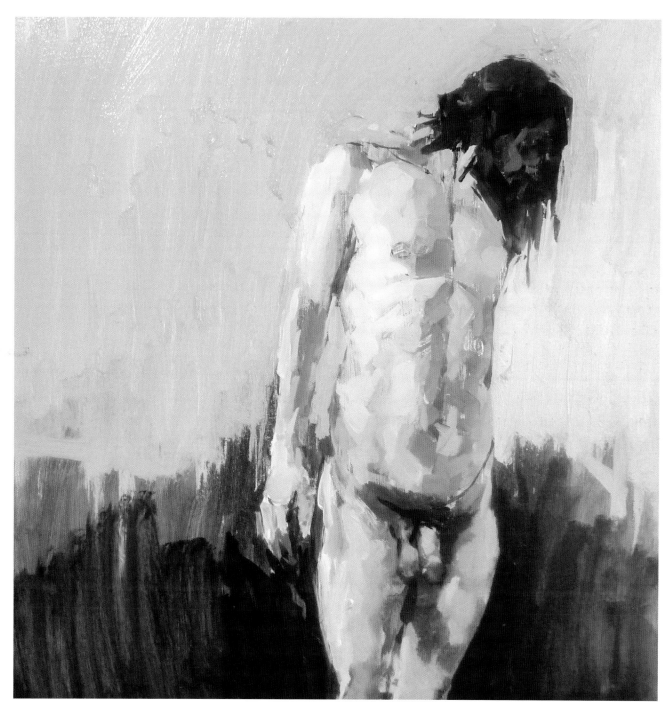

Felix. This painting had been worked on for a year as a still life. I had almost abandoned the painting entirely before I sanded it down and started drawing out the figure using a fine brush. The painting progressed well initially before I realized that some of the drawing was not very good so the painting was scraped back and left to dry. The scrape marks can be seen through the torso. A day later I redrew the figure in paint and worked with a broad brush technique using a soft medium-sized flat. Felix's head was readjusted making it sit on the body and the general feel of the figure reminded me of my earlier male nude self-portraits.

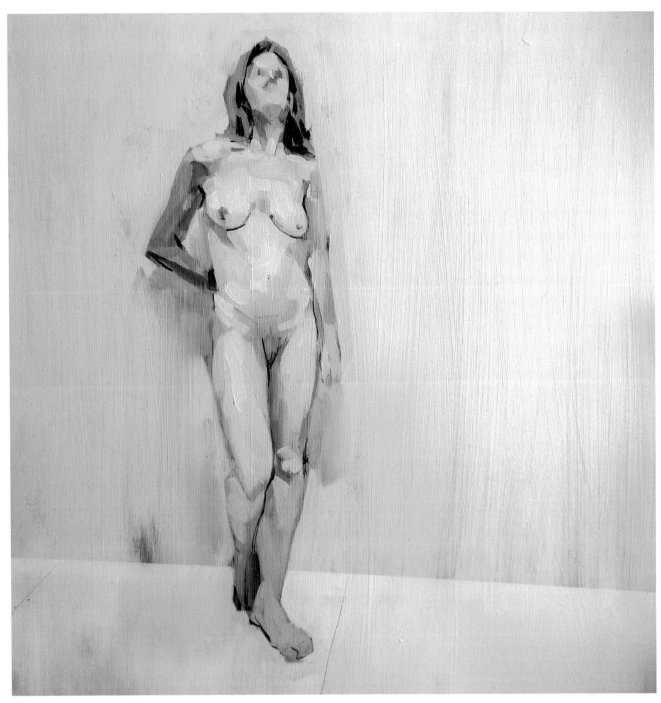

It has long been my ambition to paint in oil with the same directness as my acrylic paintings. This *alla prima* study in oil on a yellow ochre acrylic ground (which can be seen to come through the paint layers) was made with no preliminary drawing. A soft synthetic flat was used to block in the main directions of the figure. I was striving to achieve an all-in-one wet approach and I did not want to overwork the figure, so strived for something more generic using a limited palette of titanium, buff titanium, yellow ochre, raw sienna, raw umber and phthalo blue.

Afterword

When I set out to write this book I had a set of parameters and aspirations for the text. I wanted to create a book that could give the reader some pointers toward achieving the goal of painting the figure well.

One of the problems of figure painting is that there is nowhere to hide. If your measurement, proportions or form rendering are off, then it shows. We are uniquely hot-wired to spot deviation from the norm, so unless you decide to treat the figure in a more abstract vein, the groundwork set out in the early part of the book is vitally important.

Writing this has also involved talking to other artists, and an overriding theme that has come from them is the sheer time they have spent investing in the activity. I discussed the idea of the hard-won image and all of the artists agreed that painting the figure well has been achieved through dogged determination and a lot of hard work.

Whenever I set to my easel I keep seeing the problems I face and keep working towards my goal: to achieve a beautiful figure painting. These challenges never seem to get any easier but make the challenge all the more exciting. Most artists have learned their craft by themselves in the studio but the Internet has opened up this world and made me realize that the problems I set myself are the same problems that other artists face. It has also allowed me to network internationally in a way I would have never thought possible when I was a student.

There is not one method, technique or approach that is right. There are many and if this book has been successful it has encouraged you to explore and find out for yourself. Piers Ottey described a conversation about colour that took place over forty years ago with Norman Blamey. In the end Blamey stated that painting was a mystery; it is certainly an alchemical beast because it can turn base metal into gold and mud into flesh. Painting and drawing the figure is one such mystery that slowly reveals its clues to you.

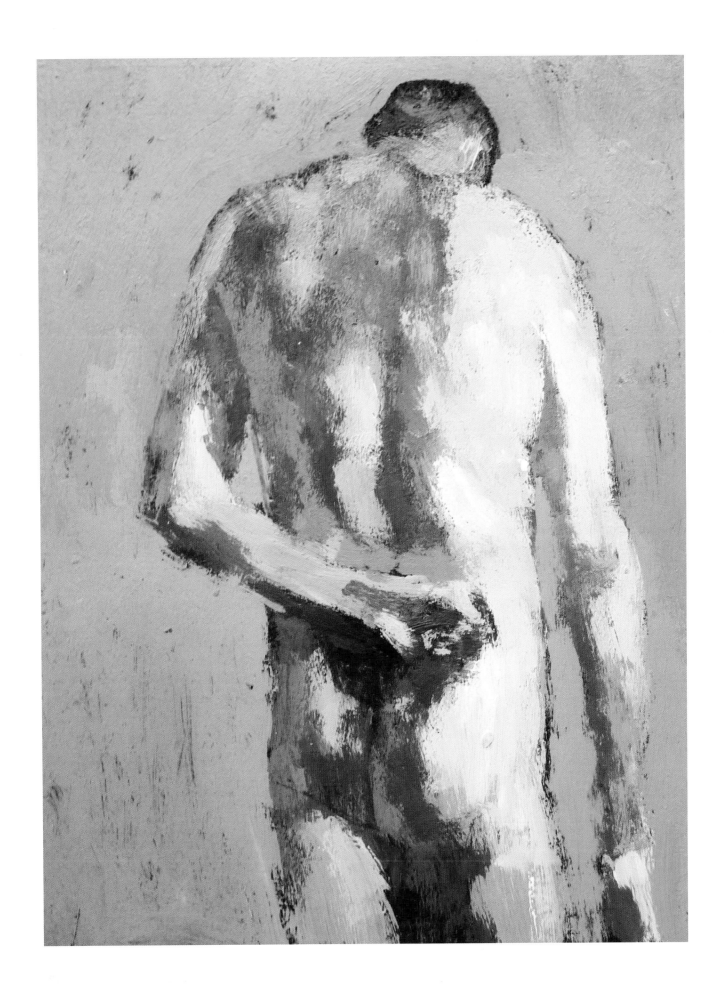

Further reading

Aguirre, P., Azimi, N. and Cashdan, M. (2011). *Vitamin P2: New Perspectives in Painting*. Phaidon Press.

Aristides J. (2006). *Lessons in Classical Drawing*. Watson-Guptill.

Aristides J. (2007). *Classical Drawing Atelier*. Watson-Guptill.

Barcsay, J. (2006). *Anatomy for the Artist*. Little, Brown.

Beer, N. (2010). *Sight-Size Portraiture*. Crowood Press.

Borzello, F. (2012). *The Naked Nude*. Thames and Hudson.

Bowen, R. (1992). *Drawing Masterclass: Lectures from the Slade School of Fine Art*. Ebury Press.

Bridgman, G. (2000). *Constructive Anatomy* (Dover Anatomy for Artists). Dover Publications.

Comini, A. (1995). *Nudes: Egon Schiele*. Rizzoli.

Connolly, A. (2011). *Painting Portraits*. Crowood Press.

Edwards, B. (1993). *Drawing on the Right Side of the Brain*. HarperCollins.

Esten, J. (1999). *John Singer Sargent: The Male Nudes*. Universe Publishing.

Jarman, D. (1993) *Chroma: a Book about Colour*. Vintage.

Kantor, J. and Zabel, I. (2007). *Vitamin P: New Perspectives in Painting*. Phaidon Press.

Kaupelis, R. (1992). *Experimental Drawing*. Watson-Guptill Publications.

Lampert, C. (2007). *Euan Uglow: The Complete Paintings*. Yale University Press.

Lee, S. (1986). *How to Draw Comics the 'Marvel' Way*. Titan Books Ltd.

Loomis, A. (2011). *Figure Drawing for All It's Worth*. Titan Books Ltd.

Lucie-Smith, E. (1985). *The Male Nude: A Modern View*. Rizzoli.

Mullins, C. (2008). *Painting People: The State of the Art*. Thames and Hudson.

Pearce, E. (1992). *Artists' Materials: Which, Why and How*. A&C Black.

Postle, M. and Vaughan, W. (1999). *The Artist's Model from Etty to Spencer*. Merrell Holberton.

Raynes, J. (2001). *How to Draw the Human Figure: A Complete Guide*. Parragon.

Saxton, C. (1982). *Art School: An Instructional Guide Based on the Teaching of Leading Art Colleges* (A QED book). Papermac.

Schide, F. (1957). *An Atlas of Anatomy for Artists* (Dover Anatomy for Artists). Dover.

Simpson, I. (2003). *Drawing, Seeing and Observation*. A&C Black.

Speed, H. (1987) *Oil Painting Techniques and Materials* (Dover Art Instruction). Dover.

Ruskin, J. (2007). *The Elements of Drawing*. Bloomsbury Publishing, Ebury Press.

Woods, B. (2003). *Life Drawing*. Crowood Press.

This was one of the first in a series of male nudes painted in acrylic using a black ground. You can see the ground coming through the outer edge of the figure. I used two mirrors in a small bathroom studio so that I could see myself from behind and employed a drybrush and scumbling technique.

Index

Related titles from Crowood

978 1 84797 088 6

978 1 84797 824 0

978 1 86126 598 2

978 1 84797 357 3

978 1 84797 906 3

978 1 84797 264 4

978 1 86126 854 9

978 1 84797 177 7

978 1 84797 182 1